Valérie Belin

Huis Marseille, Museum for Photography, Amsterdam

Maison européenne de la photographie, Paris

Musée de l'Elysée, Lausanne

Valérie Belin

Steidl

Introduction

Els Barents

William A. Ewing

Jean-Luc Monterosso

The retrospective exhibition *Valérie Belin* provides, for the first time, a comprehensive survey of the work produced by this French photographer over the past seventeen years. Her oeuvre now consists of roughly twenty series, each of which is made up of at least two and no more than twelve images. The majority of these series have been photographed in a solid and highly contrasting black-and-white; the three most recent ones are in colour. These series or groupings all have one type of subject – portraits or still life's – and define each other through generic variations in form. Belin's work, however, is not about a sub-division into genres, nor about an interpretation of types of people or objects. Her aim is much more specific but also more intangible than the encyclopaedist's. With these generic variations in form, it is neither the individual nor the aesthetic qualities of a face or an object that constitute the building blocks for her series. On observing such groupings of particular types of people or objects, we notice the subtle differences in detail that initially seem arbitrary and thereby inconsequential. Considered from a visual stand-point, these linear groupings work superbly, even though one could perhaps speak of a fairly random sequence from a scientific point of view. Valérie Belin herself seems to have a particular predilection for the permanent process of metamorphosis to which the individual and the object are subjected in their social environment. And that is something entirely different from the forms, pure in an aesthetic or ethnic sense, from which the visual and Western-oriented vocabulary has derived its distinct types so far.

Belin's work also proves to be an intensified and still reflection of the motley media parade that rushes past the eye every day. With this she maintains a certain balance between both extravagant and unobtrusive phenomena, which fuels the slightly explosive mix that presently characterizes the relationship between culture and nature. There are, for instance, swollen and gleaming masses of bodybuilders' muscle, which affect the body's shape to an absurd degree. There are transvestites in the ambiguous process of transformation between male and female, and the bizarre differences in detail that exist among the various lookalikes of Michael Jackson, underscoring the absence of his 'actual' physiognomy.

Then there is the tension that prevails among all the series: the alarmingly negligible differences between a depiction of a live model and that of a celluloid mannequin. On the other hand, there are also light-hearted and apparently trivial things such as lap dogs, bags of potato chips and fruit baskets. Crucial to the work of Valérie Belin is her grip on reality

and the sense of alienation that this generates. Her work seems, at first, to be one *grande parade*, involving a great variety of characters and consumer goods. The participants attract and repel each other until they manage to position themselves in a delicate balance between animate and inanimate matter, momentarily frozen, as it were, in a *danse macabre*. Across the board – in view of Valérie Belin's entire body of work – one can hardly escape the conclusion that the hybrid links between living and dead matter are both unprecedentedly monumental and extremely disquieting.

The uniform manner of photographing employed by Valérie Belin – everything and everyone is isolated from the surroundings and shot against a white or a black background – increases the comparability of the images. This is a classical way of working that has its origins in the nineteenth century. Having a monochrome canvas as background, she usually photographs in her studio. All distracting details of the environment are eliminated and space is created for a neutral staging, this putting the entire focus on the figure. Because of this, perspective and scale lose considerable expressive power, while the black-and-white further heightens the contrasts. Although the work of Valérie Belin has indeed been linked with the blunt, straightforward way in which the Pop artists took their motifs literally from the street, her themes and methods go far beyond the one-dimensional confrontation that put Pop Art on the map during the sixties. She herself has confessed having a greater affinity with the subdued tension brought about by a reduction of form, as evident with the approach of Minimal Art, and with the suggestive, biomorphic forms of sculptors such as Tony Smith.

With this Valérie Belin makes an essential distinction. For her, popular culture is never an end in itself, but she wishes to come to terms with its phenomena. Here, again, she is primarily interested in the insidious process by which today's popular culture imposes its forms of behavioural codes on young adults in particular. In that endeavour Belin opts for a philosophical approach. On the basis of antithetical positions, those between models and mannequins, for instance, or a lookalike of Michael Jackson in relation to a mask, she raises the discrepancies between a formal resemblance and a credible assumption of this.

In addition to these formal contrasts, Belin also works with other, more or less intuitive, or associative groups that either complement each other or define each other. This applies most to the objects that she photographs: to the crystal mirrors and sculp-

tures, to the wrecked cars, the pallets crammed with discarded computers, and to the dresses from the collection of the Musée des Beaux-Arts et de la Dentelle in Calais. In a certain sense, it can also be said about her bodybuilders and the raw meat hanging in cold storage, and even about the traditional Moroccan wedding gowns that are so lavishly decorated that the brides themselves are almost buried beneath them.

Belin's camera transforms each of her characters into an effigy as well as an icon of its type. In this process a reversal of values takes place. The portraits lose personality, whereas the objects actually seem to gain life. In the hands of Valérie Belin the magic of photography appears to have lost none of its powers whatsoever. The image of this body of work that emerges in retrospect is certainly no *déjà vu*; nor is it a souvenir of some fleeting moment. Her choices have been exceptionally consistent, just as the quality of the image has constantly been of a very high level. This oeuvre therefore yields both an added value and an extra dimension. Mirrored in Belin's camera, real life and virtual life seem able to interrelate on a similar level without any interference. Being the star and wanting stardom gives rise, in two respects, to such an attitude and physical transformation that the real can hardly be distinguished from the unreal any longer. It is an impressive but, at the same time, horrifying sensation. The creed of popular culture is indeed optimistic and dynamic, yet essentially just as much authoritarian in terms of its imposition of rules concerning clothing and consumption. The characters selected by Valérie Belin for her series all share the fact that they are greatly influenced by popular and media-genic culture. So much, in fact, that the photographer has not even needed to seek refuge in the manipulation of the image. Though it may appear to be so, that is not the case: mentioning this is important. Belin's visual powers are real in every sense. As an artist and photographer *pur sang*, she does not transgress the limits of the *métier*. No more than minimal retouching, traditionally done in photography, has been needed at most.

The exceptional strength of this body of work leads to the conclusion that uniformity and interchangeability are indeed working us into a corner in all sorts of ways. But what remains etched in one's memory is the mix of robust power and fragile refinement with which Belin's photographic sculptures manage, in stature, to dominate the walls of a museum.

Valérie Belin, or the skin of things

Régis Durand

It would be possible to approach the work of Valérie Belin through a study of skins – the (literal) skins of the humans or humanoids that she photographs, and the (metaphorical) skins of her images in general, which all attempt to grasp surfaces, envelopes, fine integuments (a transparent film, a reflection, a shininess, a weave). Everything is, in a sense, a matter of skin, and of the way in which these skins catch the light, the way their texture, their grain, come to life under the eye of the lens.

That is the paradox of these images which are imposing in their size, and often massive, full-frame, which seem to come towards us with great forcefulness in a dialogue that is not unlike the one we have with sculpture.

For there is, of course, in modern and contemporary sculpture, a constant concern with surfaces and their complex relation to the volumes they define – or that define them, of which they are the point of resolution, where the thrust or attraction of that volume are at their greatest. And we know about the use that many artists make of this constant tension between volume and surface: Brancusi, for example, who indeed used photography to grasp the way in which the smoothness of surfaces and the reflections that it generates endlessly prolongs and multiplies the thrust of the volume, and makes it changeable like light and time; or Tony Smith, whose surfaces seem on the contrary to point us to an intrinsic opacity, a black hole whose attraction they nevertheless resist by turning towards what is outside them; or, again, Larry Bell and those glass cubes that, as the artist says, are 'just surface and light'[1]. These complex relations draw their meaning in a sculptor's work from the field of possibilities that are available to him, which he can freely play on or abstain from playing on: matter (its weight and bulk), the material (its finish, its extent), the inscription of the work in space and the relation it induces with the beholder. For a photographer, the field of possibilities is obviously of another kind. The photographed *object* may well have all the characteristics of an object in sculpture, but the result of a photographic operation makes it into something quite different: it does effect a regulated substitution, a switching that takes it into another world than the phenomenal one of sculpture. It regulates, for example, the question of distance and frame, instead of the beholder's necessarily physical experience of sculpture. It inscribes an object, not in depth and the 'theatre' of phenomena, but in a surface with which the beholder will be confronted, in a kind of face-to-face.

One might say: it is the same for certain works by sculptors in two dimensions, the

big canvases of Richard Serra, for example, or the 'Tar paintings' of Bernar Venet, which convey the perception of mass, of its threatening weight, by other means than physical presence. And what we witness in the case of Valérie Belin is indeed something analogous – although the analogy is soon contradicted by the particularity of her approach.

For the mental and visual operation that she effects through the intermediary of photography consists in bringing towards us – with a certain violence and the sense of an intrusion– the object in question, which thus seems to enter our space, instead of us entering its space. Her photographs seem to capture the energy of a moving mass, an impact – sometimes a literal one, as with the wrecked cars, or in the deformed bodies of bodybuilders. This feeling results from precise technological choices that generate a tension between surface effects and the intrusive illusion of a volume. The object thus appears to us as a great, worked surface, but a surface that is somehow not a *tableau*, and that evokes a kind of *écorché* – a surface that is flayed but whose skin has immediately been put back, so that nothing or almost nothing is manifest, except for a slight lifting, an almost unconscious perception of the flesh under the skin, of the volume under the surface.

This 'lifting' is no doubt due to the fact that the surface in question is grasped in its slightest details, but without any resulting flatness (levelness would be more exact) in what we see. For there is – I cannot for the moment find any other way of saying this – an art of making visible or, at least, palpable, what this surface rests on. This may be the result of a revelatory transparency authorised by the technology of photography. In the *Chips* series, for example, the optical precision is such that the screening of the printed lettering on the packets is revealed whereas we sense nothing of their contents. Here we are in a kind of infra-thin, a kind of microscopic cross-section in a living environment whose secret life is explored by the photographic 'scalpel.'[2] Belin seems to position herself at the exact dialectical switching point that Walter Benjamin observed in *The Work of Art in the Age of Its Technological Reproducibility*, where he draws a parallel between the filmmaker and the surgeon. For 'the equipment-free aspect of reality' is possible, precisely, only if we renounce a global image in favour of 'the most intensive interpenetration of reality'.[3]

We have the same feeling when we look at the mannequins, except that the depth, however slight it may have been before, here seems to be denied by the resistance of the support, and that we must make do with the grain of the different skins and the play of

their respective qualities. Shop-window mannequins, living models, black women – all have different ways of catching the light, of revealing what is behind these surfaces of skin, be it the plasticity of life or the rigidity of the artificial. Or of not really revealing anything and leaving a lingering doubt.

For one of the questions that seem to engage Valérie Belin is precisely that thin zone of uncertainty and reversibility. Not that she is trying to create illusion in and for itself; rather, she is trying to grasp the minimal characteristics of an appearance of life, of a belonging to a species, on the fringe of things. Take for example a mask. Its nature is never in doubt and yet, when it is studied attentively by the camera the way a face can be, we come to ask where it is exactly that this persistent impression of life comes from: there is a bitterness, a petulance that are ready to come to life when grafted on to the wearer's face. Or, again, those carapaces worn by Moroccan brides, which turn them into bright, insect-like creatures and colonise their masked bodies in a metamorphosis that leaves only the face untouched – untouched, but still crushed, too, by the ornamental carapace, and no longer the triumphant seat of the subject's identity, as in traditional portraiture. The suppleness, the tension, the infinite sum of small imbalances that are the signs of life, are perceptible here only by default, by a substitutive tropism of our own gaze engaging with this becoming-insect.

The skin-clothing is often the site of these tensions: dresses/carapaces or dresses/shrouds in the case of those admirable dresses in Calais lace photographed in their 'caskets-cum-coffins' setting and still seeming to tremble with an absent life – like effigies of the dead, or rather, like *transi* figures[4], that in statuary, may correspond to that indefinite zone between life and death[5]. And what is the oiled and powdered skin of the bodybuilders if not a kind of integument, placed on the hypertrophied, monstrous mass of the musculature?

A recent set of works on shop windows[6] makes it possible, I think, to specify this use of a 'skin', of an infra-thin zone in which visual elements are condensed. Here, too, technical determinants are used in the service of an idea of space that is possible only through photography. These shop windows are photographed with the maximal depth of field allowed by the view camera, with the result that everything is on the same plane of clarity: the objects contained in the window, the 'stage' on which they are arranged, but also what lies behind and in front, like multiple reflections produced by the glass. All this, both inte-

rior and exterior, is compacted in a thin, virtual space, like a kind of 'skin' corresponding to the depth of field habitually used by Valérie Belin, just enough for the object to be present in its totality. Here, the object is a kind of patchwork, a complex film made up of multiple layers, of scenes within the scene, of 'ghosts'. This effect is reinforced by the very nature of the objects, most of which evoke absence (clothes awkwardly presented), or seem superannuated, like the ghosts of a bygone era, but an era not distant enough to have become part of history). The use of this compression is in some ways reminiscent of the work of Lee Friedlander, for example. But the differences are obvious: Friedlander produces a virtuoso composition of layered and interlocking signs, which exude the feeling of an energy, of endless resourcefulness. In contrast with this optimistic profusion, Belin's work evokes the fragility of that which appears only within certain, highly specific parameters – images from the era of generalised hyper-relativity and virtuality.

The minimal depth here does not produce the same 'radiographic' effect as in the case of the packets of *Chips*. It is more a matter of defining a field of operation or a field of experience. As with the bodybuilders and the wrecked cars, the subject is positioned precariously, in a kind of virtual 'box' defined by the available depth of field (the difference is that the bodybuilders and wrecked cars were set in an illusory box that only just contained them, whereas here it is extended horizontally and vertically, but the structure is identical).

The recent colour portraits extend this meditation on artificiality – or, more exactly, on those zones where the identity of the photographed subjects becomes indeterminate. Here, too, there is an investigation of the external envelope. The portraits in the earlier series, as we have seen, also played on this epidermal zone. But they did so with an extremely precise attention (Belin describes it as 'anthropomorphic') that cast doubt on the distinction between animate and inanimate. Here the doubt remains, but the logic behind it is no longer that of cloning, which haunts the earlier series (shop-window mannequins modelled on the bodies of real women, real women who try to look like an ideal model, a stereotype, people who transform themselves into others – transsexuals, clones of Michael Jackson, etc.).

This logic (a type spawning clones, the 'prints' derived from it) is now reversed. Instead of the subjects trying to look like a model, it is the photographer who detects (or brings out) in her models common features on the basis of which she constructs a virtual

stereotype of which singular subjects are merely the avatars. This process in a sense doubles photographic logic by adjoining to it a logic that one could describe as experimental – in particular, the logic that governs the creation of virtual images. Where classical photographic representation, like the science of the same period, sought to identify similarities and differences in order to assign each subject its exact place in the table of bodies and 'species', computerised science samples from the real the elements needed to constitute a model from which it is possible to make avatars – fictive and shifting 'incarnations' that designate 'the appearance or the image that an individual will adopt in order to represent himself in a virtual universe'. We are closer here to *The Matrix* than to August Sander… The search for knowledge no longer consists in 'peeling away' the layers of an external appearance (its 'skins') one by one in order to attain the truth of a subject but, on the contrary, in entering into the game of illusion, in mimicking the infinite capacity for multiplication of simulacra. But only in mimicking it, because to simply reproduce it would be sterile. Thus the photographer settles for a limited number of examples in each series before swapping one subject for another, and so moving forward in her subtle exploration of the interplay between resemblance and illusion. And it is very much a question of swapping, of an endless play of exchange: one skin, one tatter, one 'discard' for another.

Here, Belin is exploiting the capacity of photography to produce images. Certainly, these images bear a particular relation to an object that they evoke by their markedly analogical character. But they also contain, sometimes in a contradictory fashion, another dimension, another logic that calls into question the very idea of resemblance, to the benefit of the endless chain of simulacra, of avatars, of factitiousness.

The new portraits of models bring this feeling of unreality very much to the fore, especially if we compare them to the earlier portraits in black and white (*Models I*, 2001). These, as we have seen, played on the indistinctness of animate and inanimate, and on the idea of limitless cloning. The new portraits go further. Because the lighting is lateral, one side of the face is in the dark, giving the image an irregular outline, and cancelling any effect of volume. The colour is gentle, unsaturated, with a few brighter touches, giving the impression of a potentially 'liquid' image, of the kind you sometimes get with those virtual ectoplasms that we see mutating at great speed in certain films or video games.

The *Black Women II* series (2006) seems at first glance the opposite of this artificial universe in which the models are simple supports with no real identity, simply waiting for

the one that they will be asked to present. Here, on the contrary, the young women look very distinctive, spectacular and even baroque, what with their extraordinarily elaborate accessories and makeup (false hair, coloured lenses, various jewellery and adornments, etc.). These women have literally reinvented themselves, pulling themselves out of anonymity and giving themselves an image that is personalised to the point of extravagance. Ultimately, however, they embody another face of artificiality: not the passive and standardised artificiality of the mannequin, but the kind that stands out and clamours for attention. Nevertheless, in a different way, this striving also makes them into figures that are fundamentally inexpressive and stand out only by virtue of secondary features. The paradox – and this is no doubt what interests Valérie Belin – is, for one thing, that inexpressiveness and artificiality can have two such contrasting faces; and, for another, that they confer on these models a power of expression that goes beyond their individual existence. Clones of a celebrity create variations around an image/referent to which they must be as faithful as possible. The young women have no referent, and it is this very absence that is the basis of their capacity for transformation. In this sense they are children's dolls, which come alive only through the outfits put on their inexpressive body, itself a plastic object that has no identity, only an obscene neutrality. Setting out to produce originality in a standardised world by means of their accessories and make-up, they nevertheless remain smooth and inexpressive, and ultimately unreal.

1 Cf. interview with Henry-François Debailleux, *Libération,* 8/9 July 2006, p. 39

2 On the question of the 'flatness' of photographic images, it is well worth reading the recent book by Eric de Chassey, *Platitudes—Une histoire de la photographie plate* (Gallimard, 2006). In Valérie Belin's work, the photograph only pretends to be flat, or rather, to have a paradoxical levelness. In this respect, too, it remains in the register of false appearances.

3 'Hence the presentation of reality in film is incomparably the more significant for people of today, since it provides the equipment-free aspect of reality they are entitled to demand from a work of art, and does so precisely on the basis of the most intensive interpenetration of reality with equipment.' *From The Work of Art in the Age of Its Technological Reproducibility* (third version, 1939), in Walter Benjamin, *Selected Writings*, vol. 4, 1938-1940, Cambridge, Mass./London, Harvard Belknap, 2003, p. 264.

4 The *transi* tomb appeared in northern Europe in the late Middle Ages, and contrasted the perishable human body, on the cusp of decay, with the earthly honours of the deceased (*transi* being an abbreviation of transitory).

5 Hermann Melville, it will be remembered, was fascinated by the notion of 'life-in-death', the ideal site of which he found in whiteness – or rather, 'whitenesses', for they are many and varied. These for him were the equivalent of that infra-thin medium whose specific use in photography I have tried to describe here.

6 This series is not reproduced in the book.

Crystal 1

(Untitled)
1993

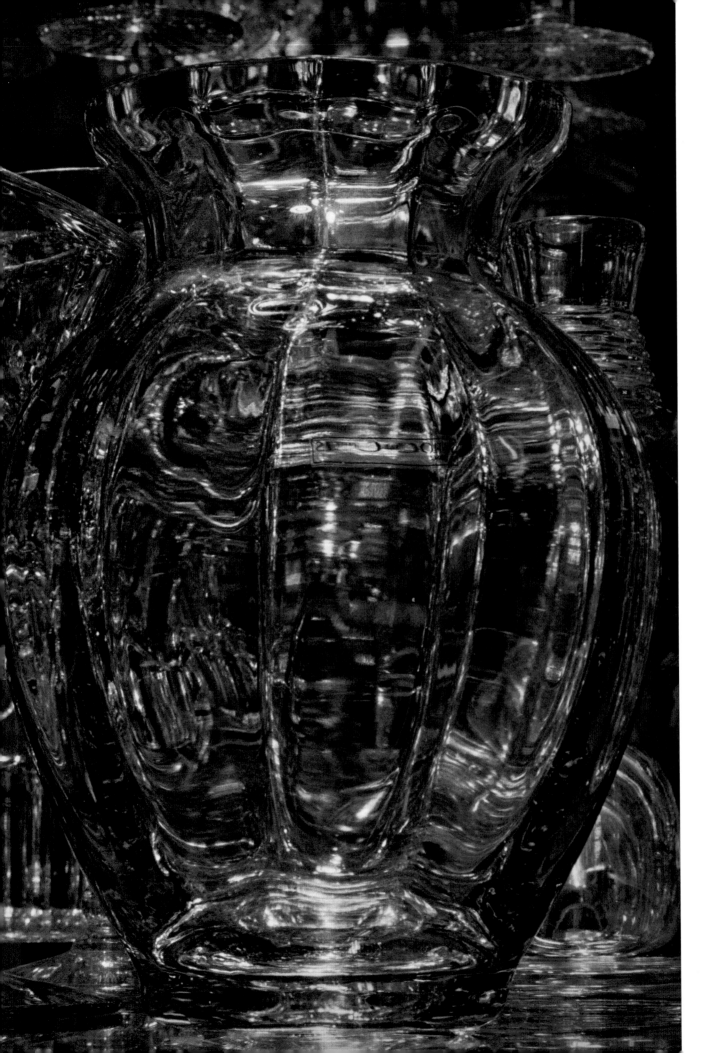

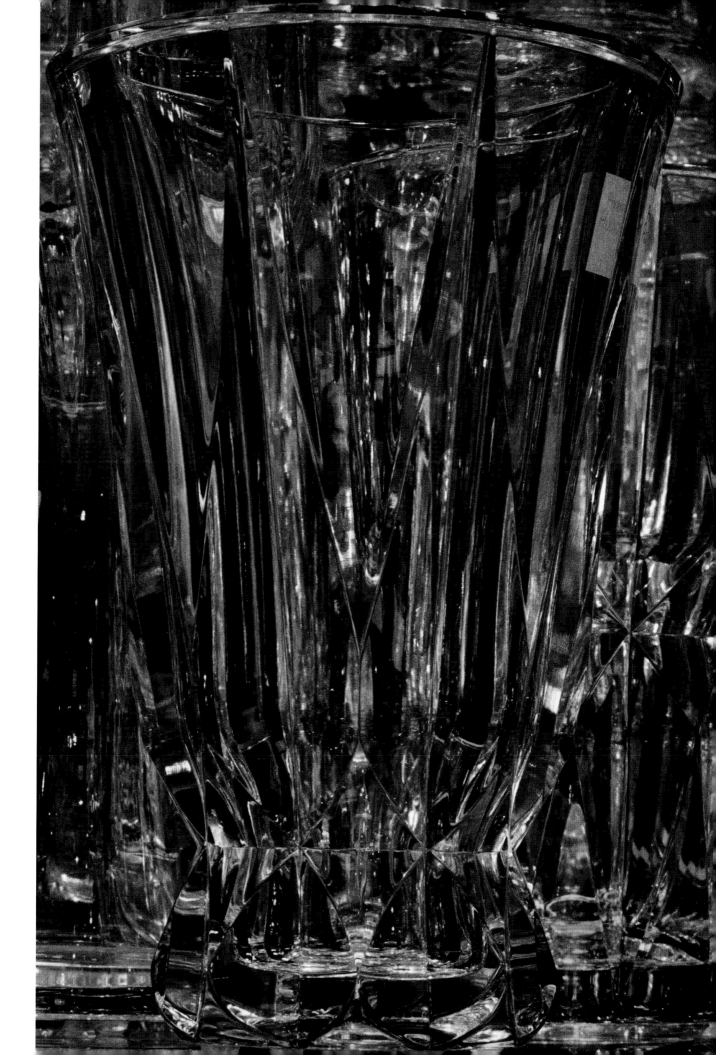

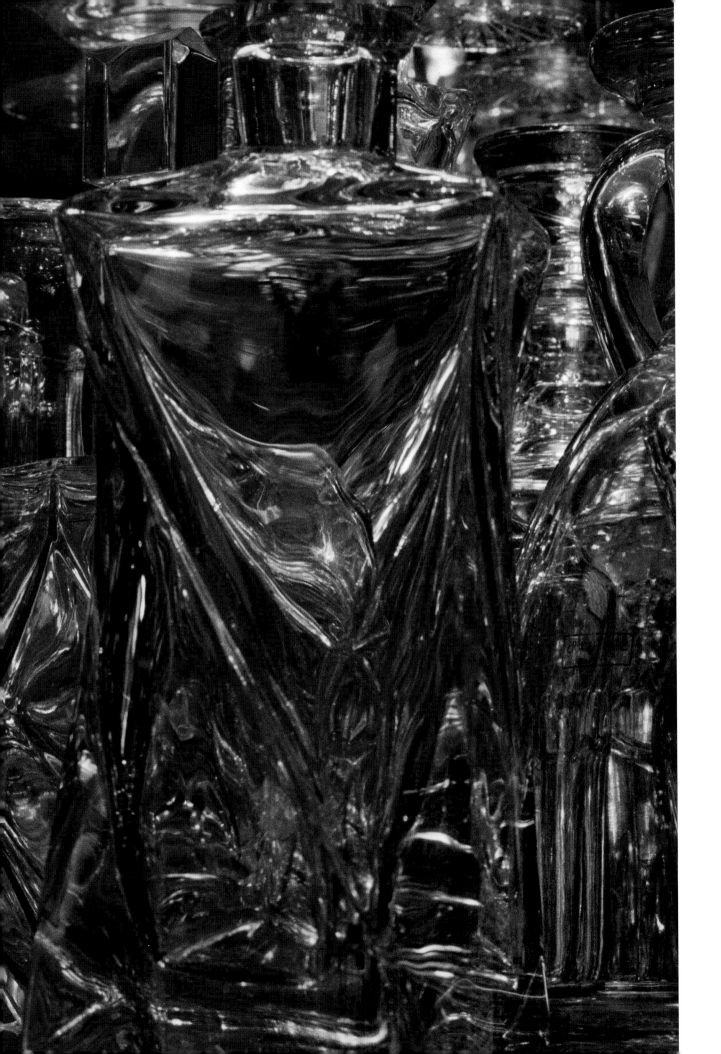

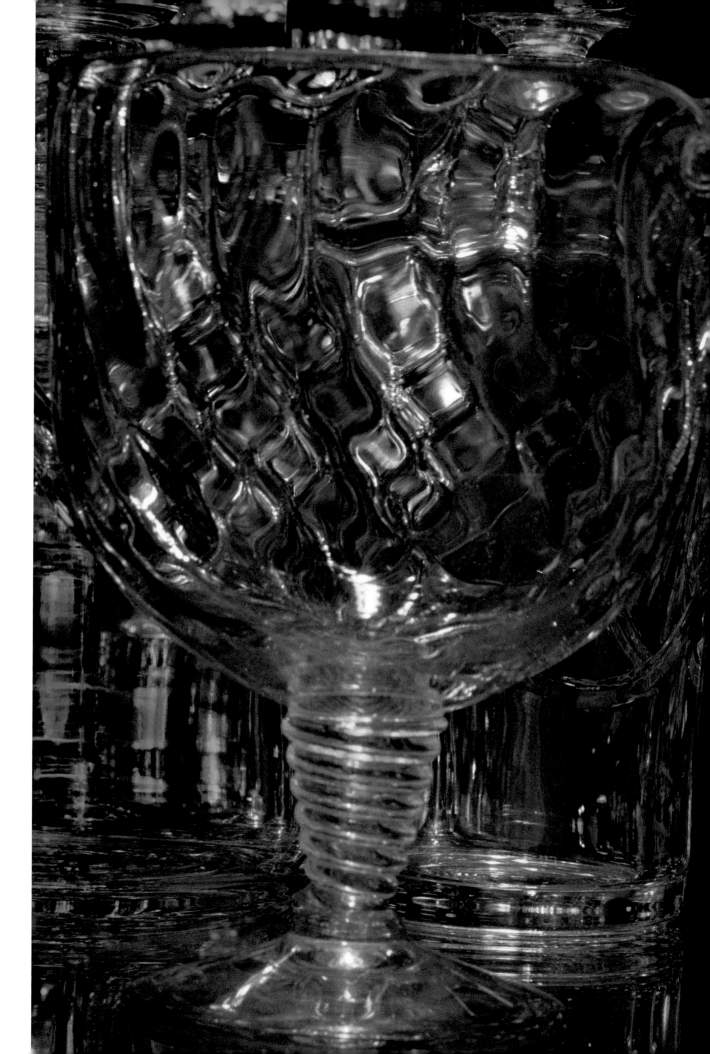

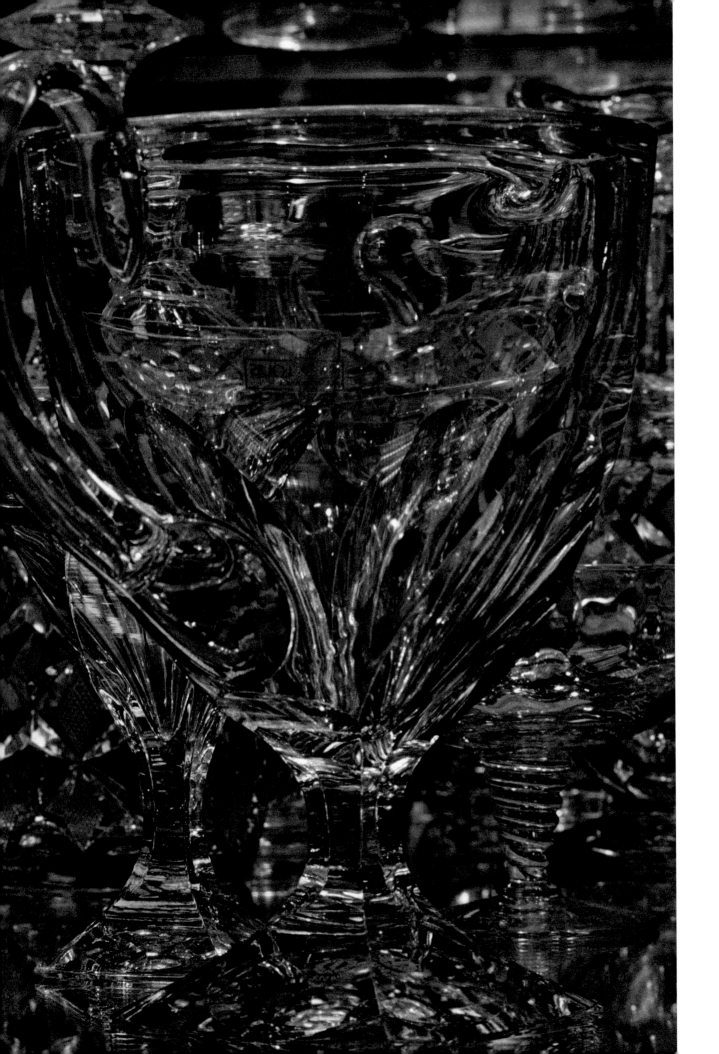

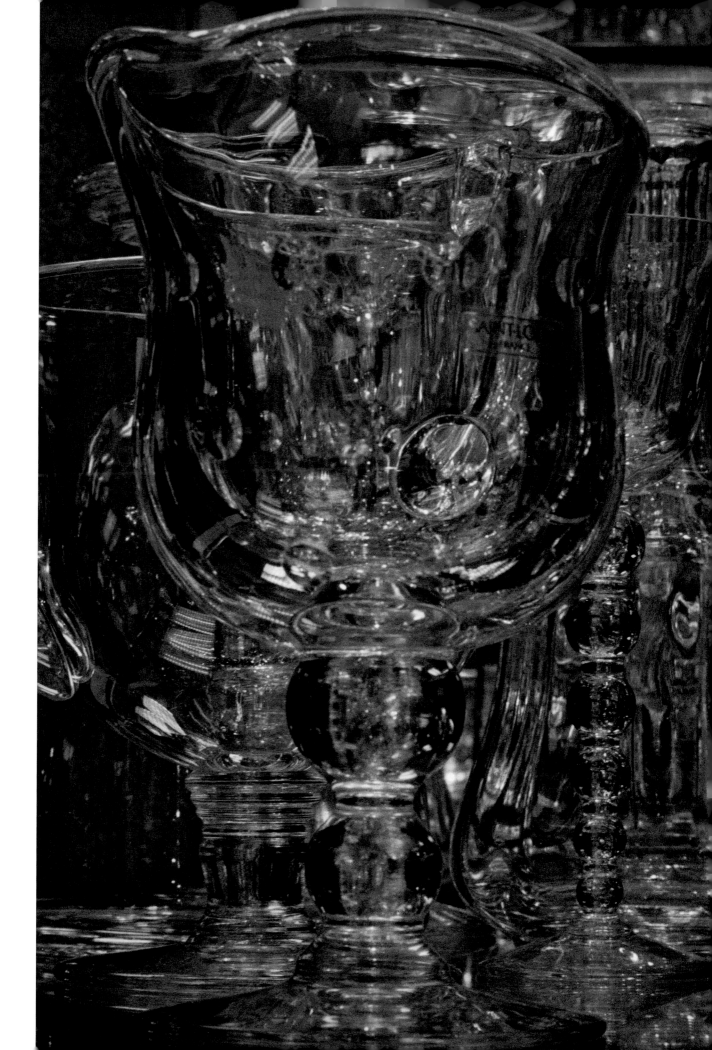

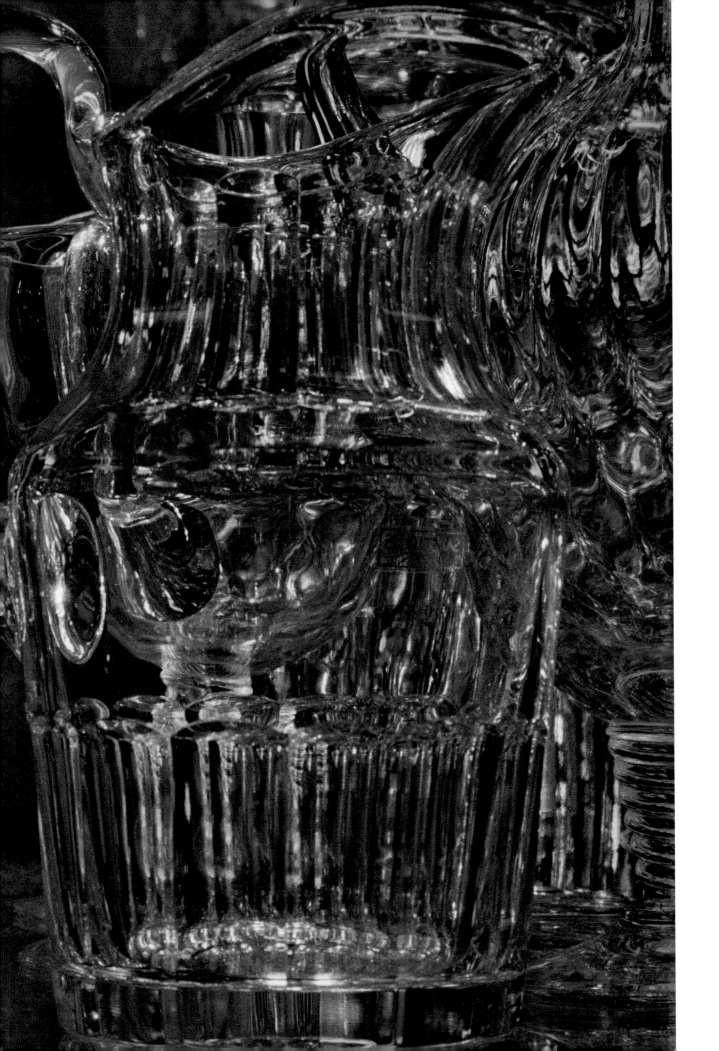

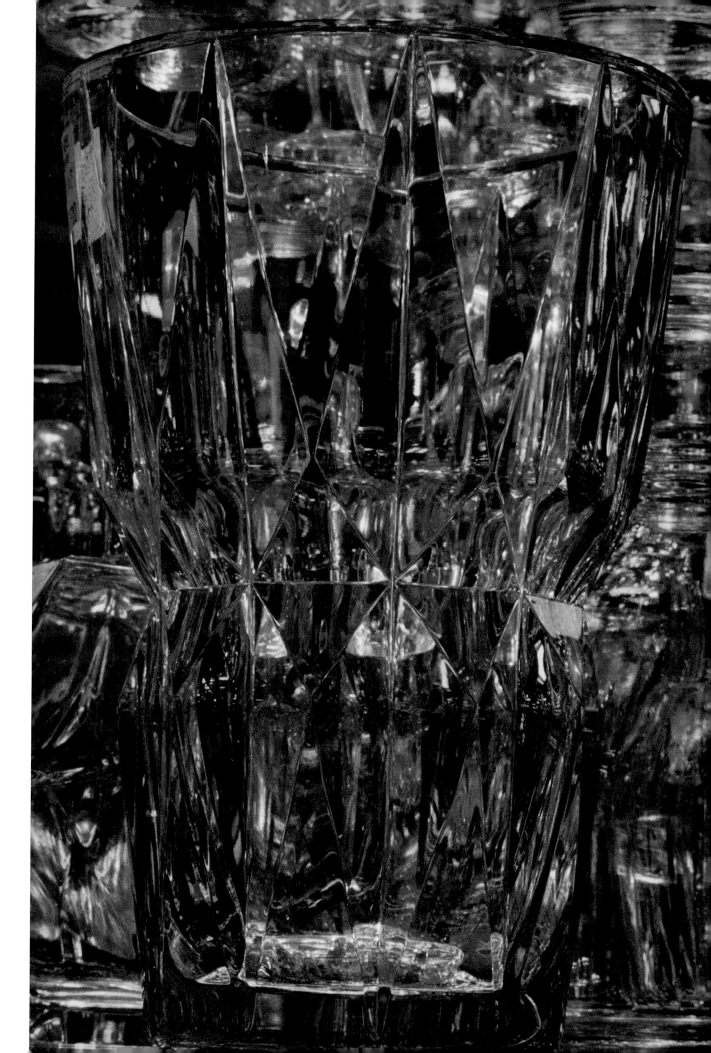

Crystal II

(Untitled)
1994

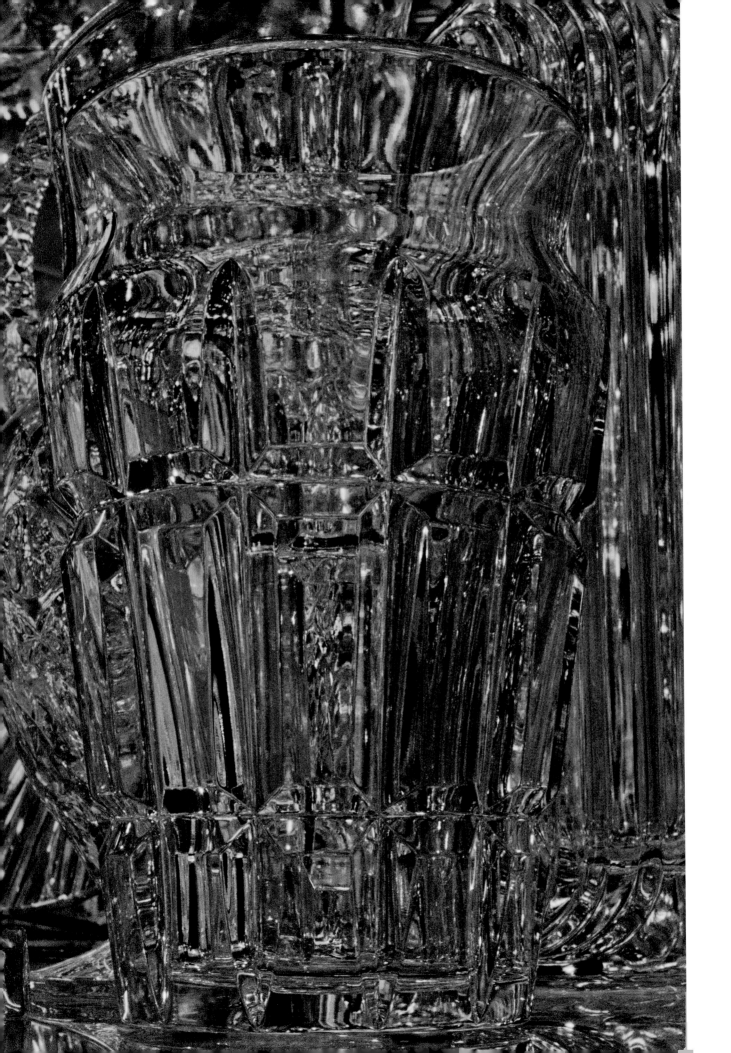

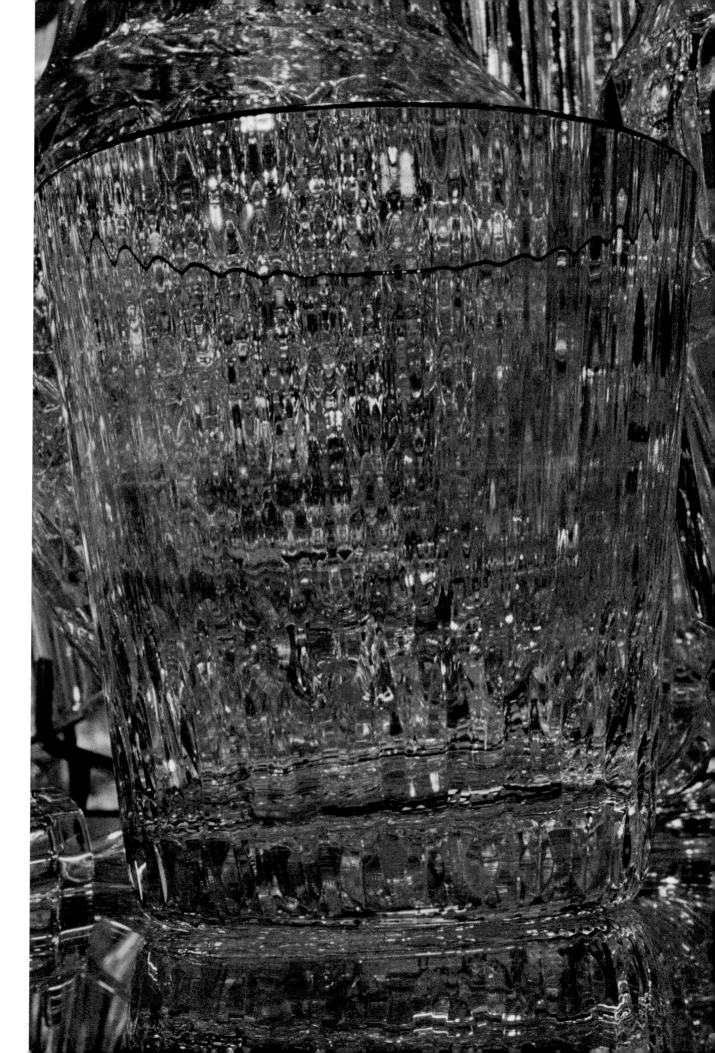

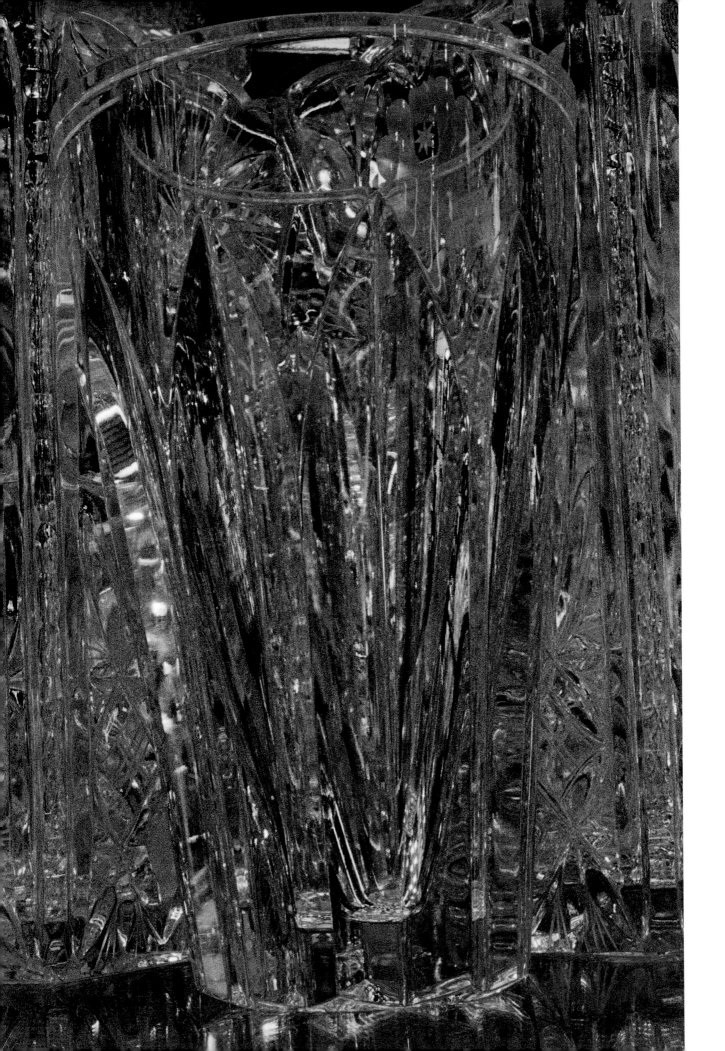

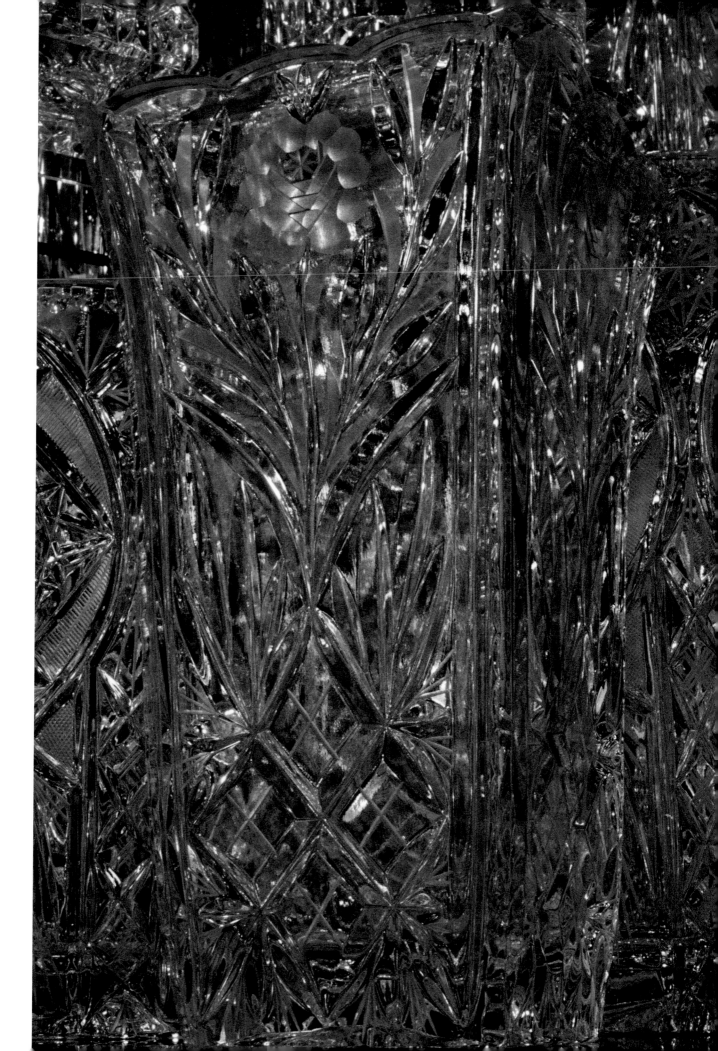

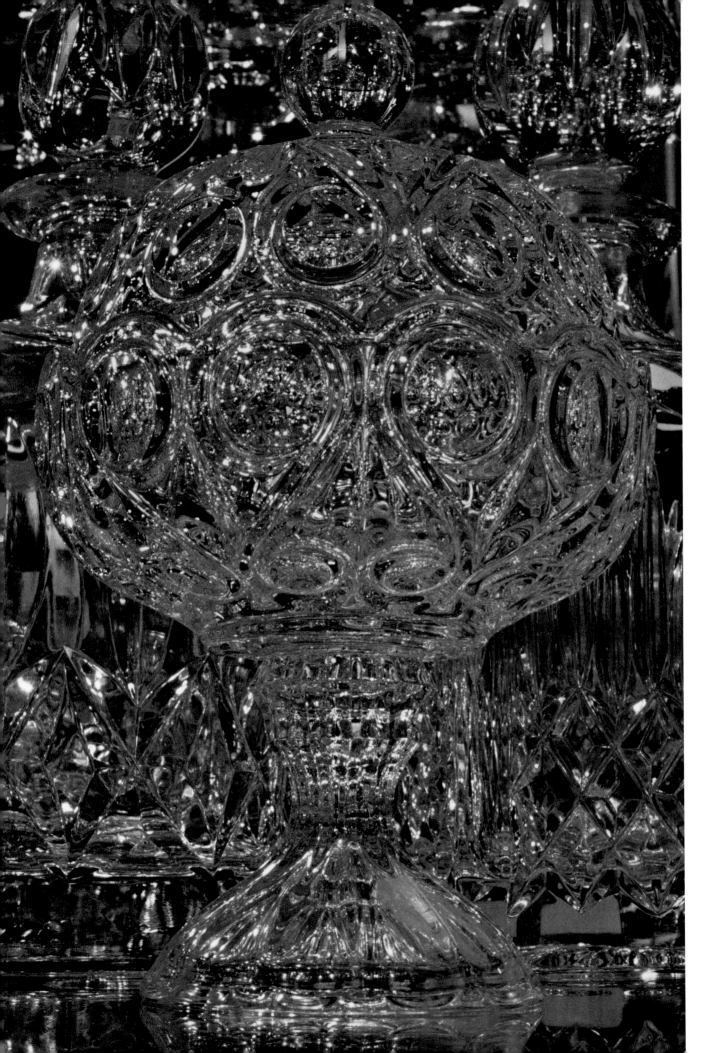

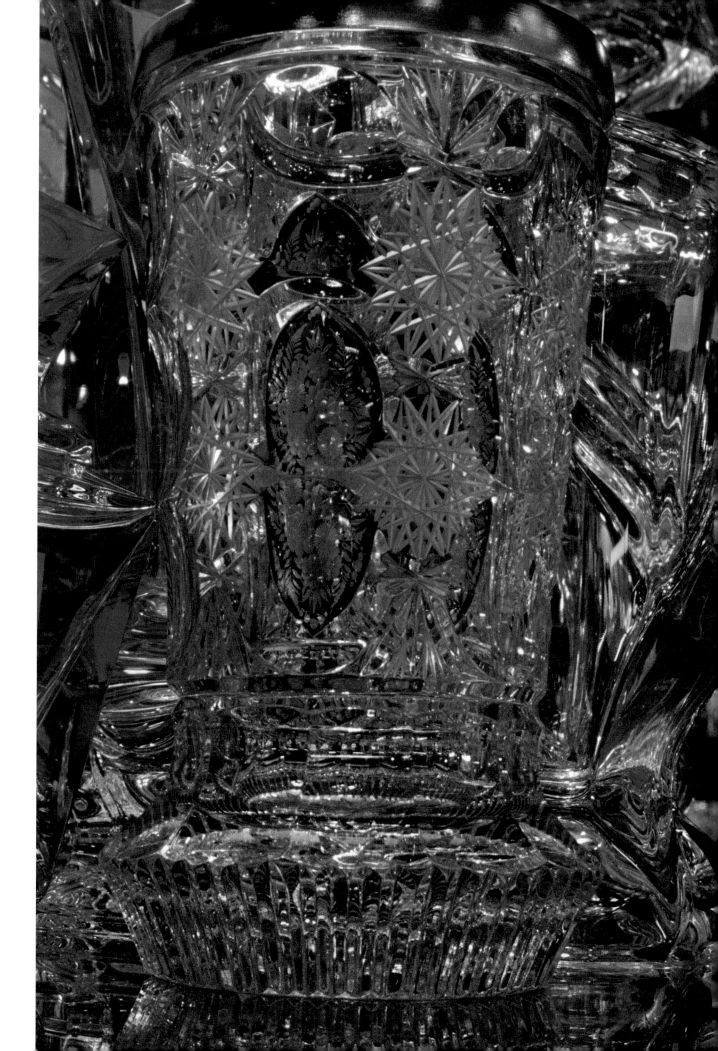

Silver
(Untitled)
1994

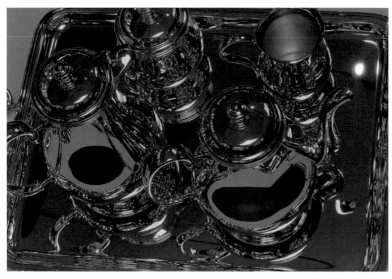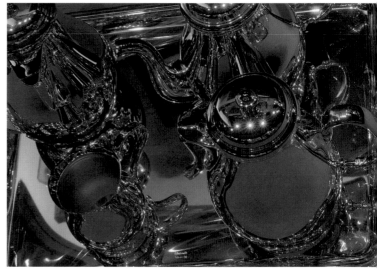
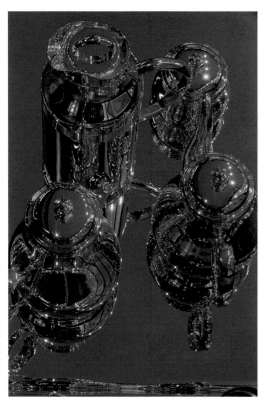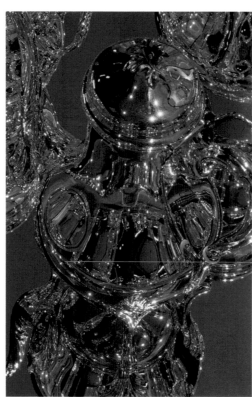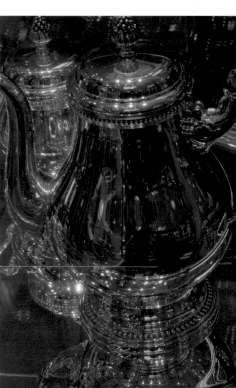

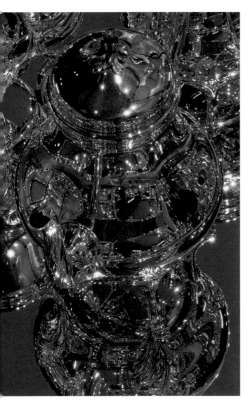
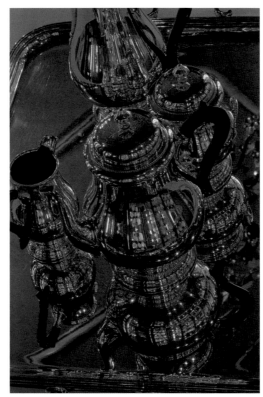
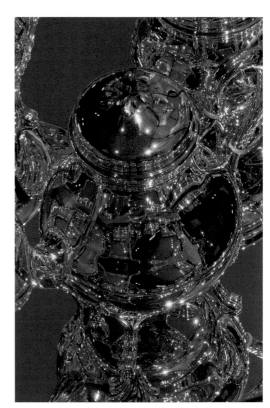
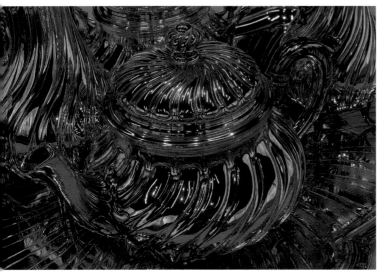
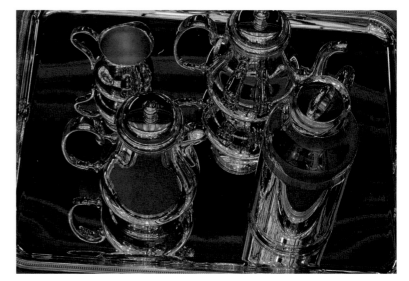

Dresses
(Untitled)
1996

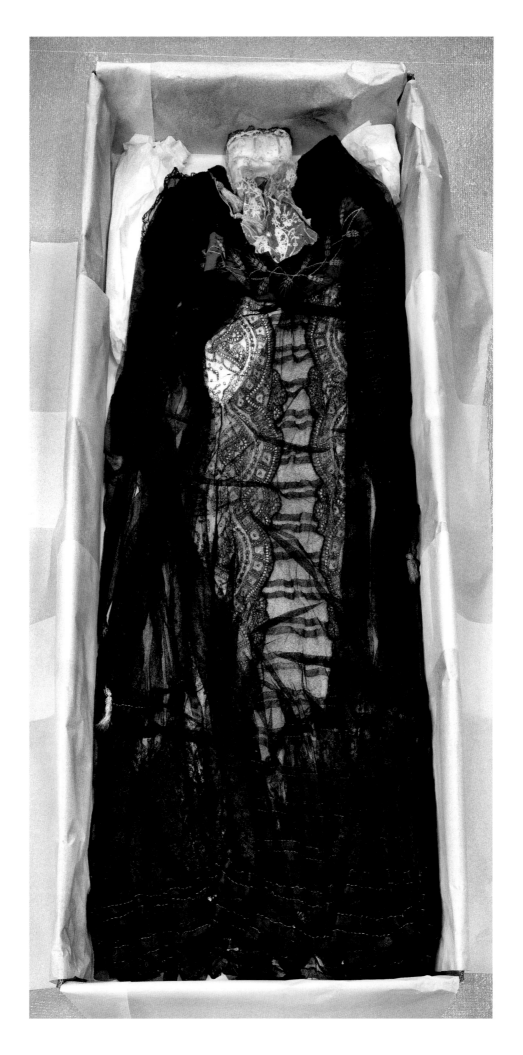

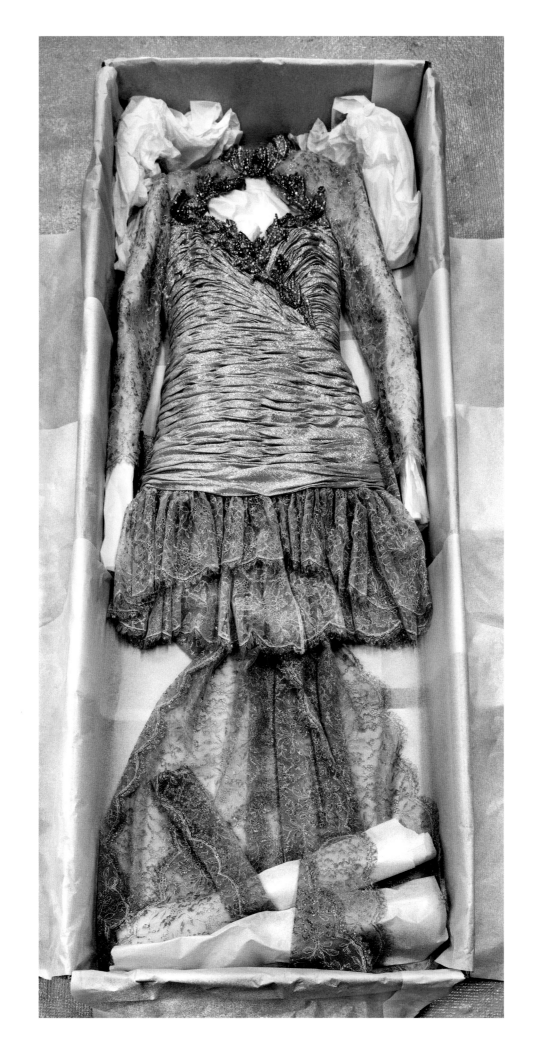

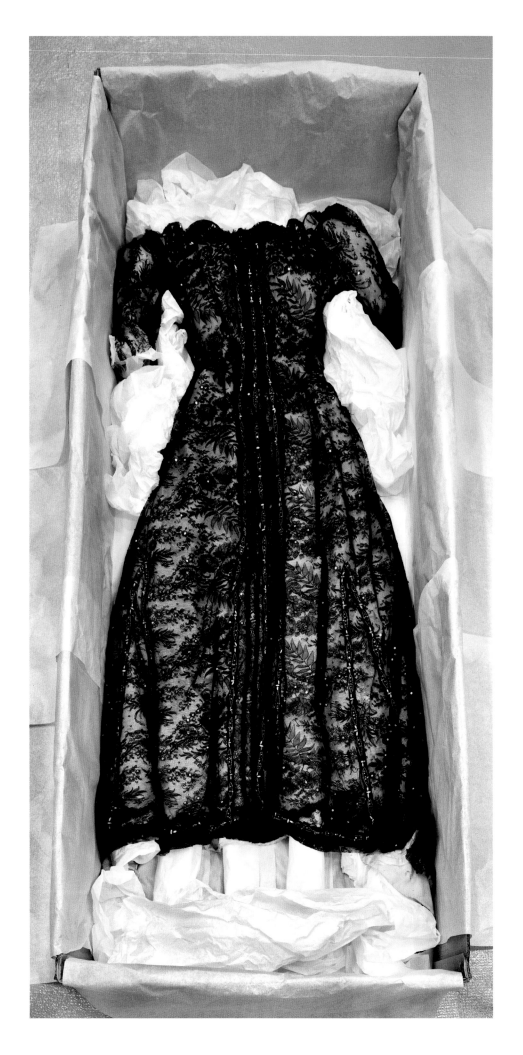

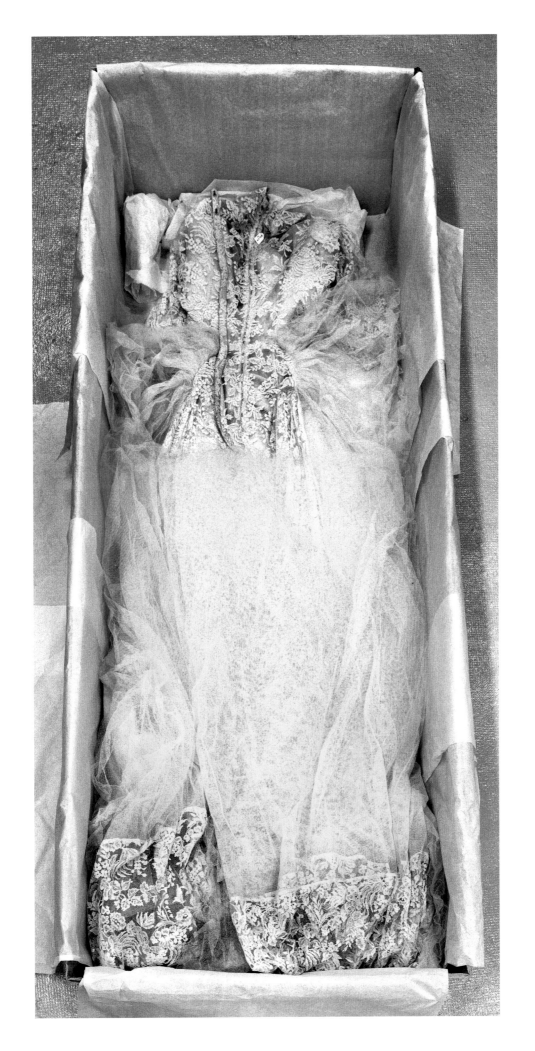

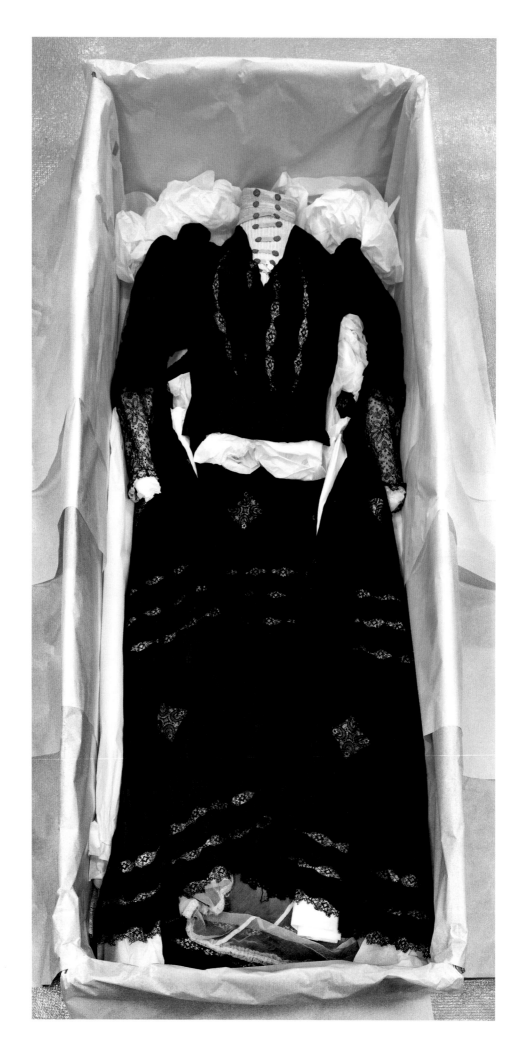

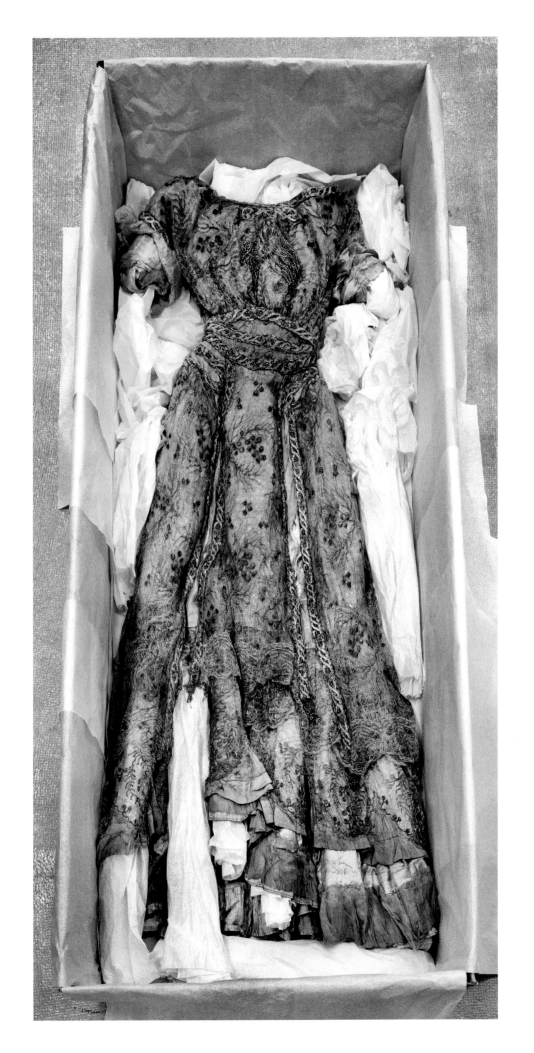

Venice I
(Untitled)
1997

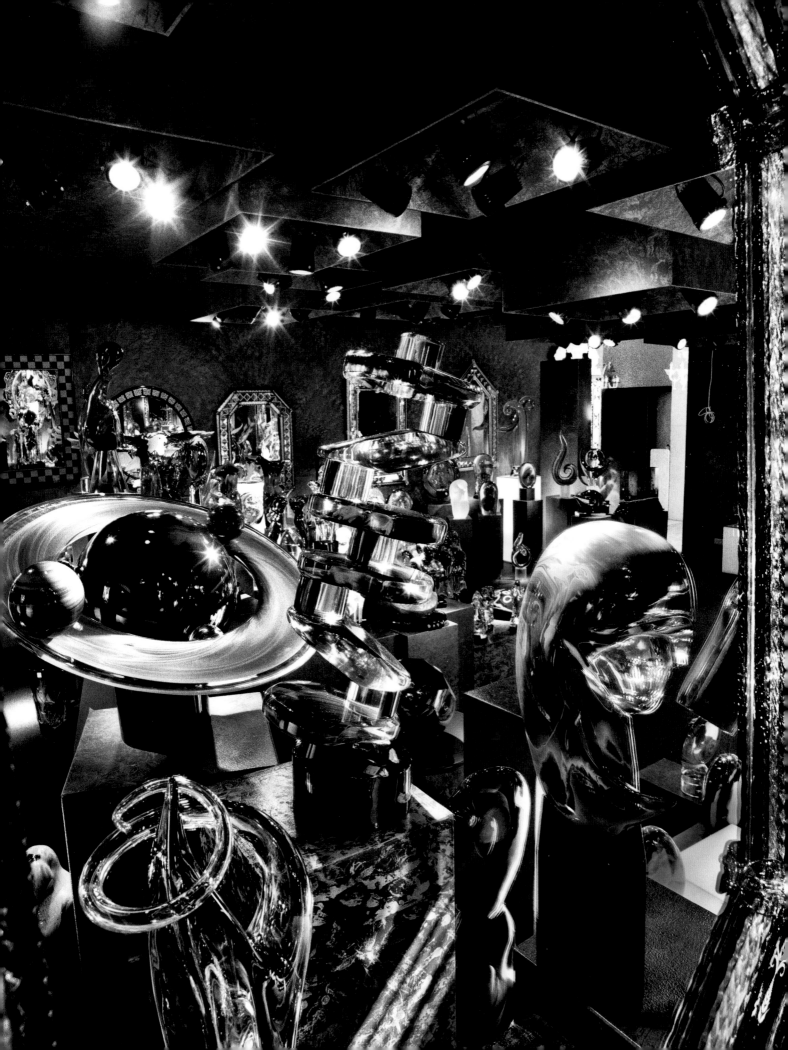

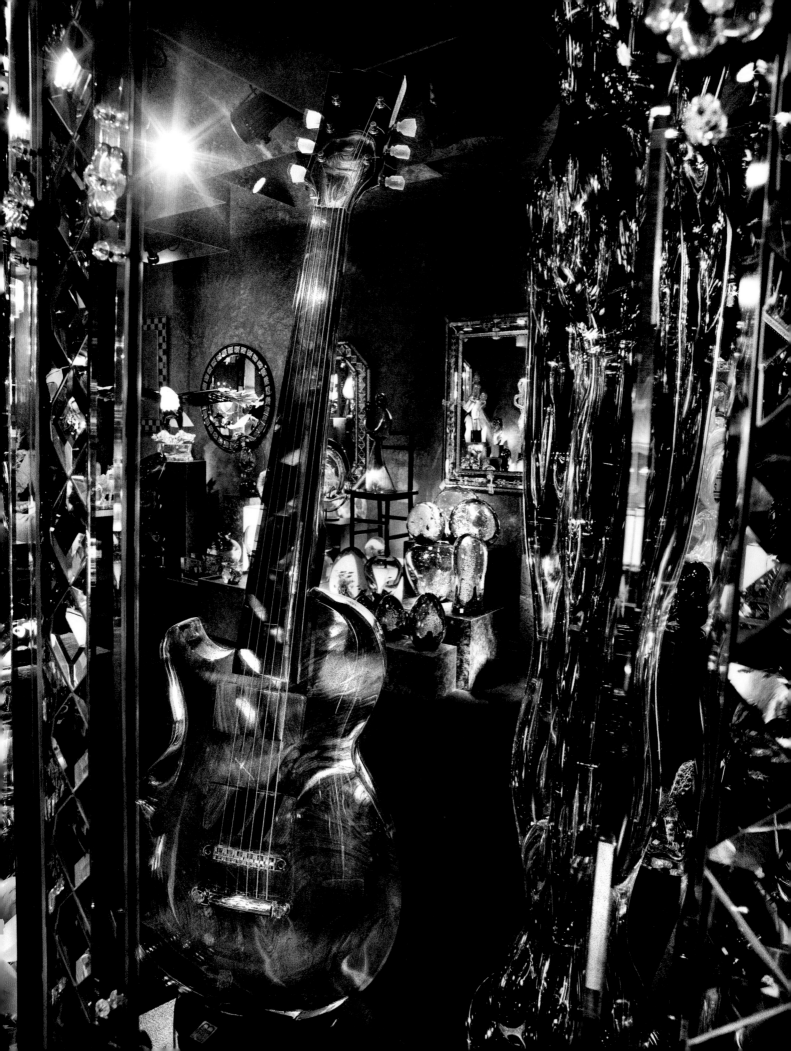

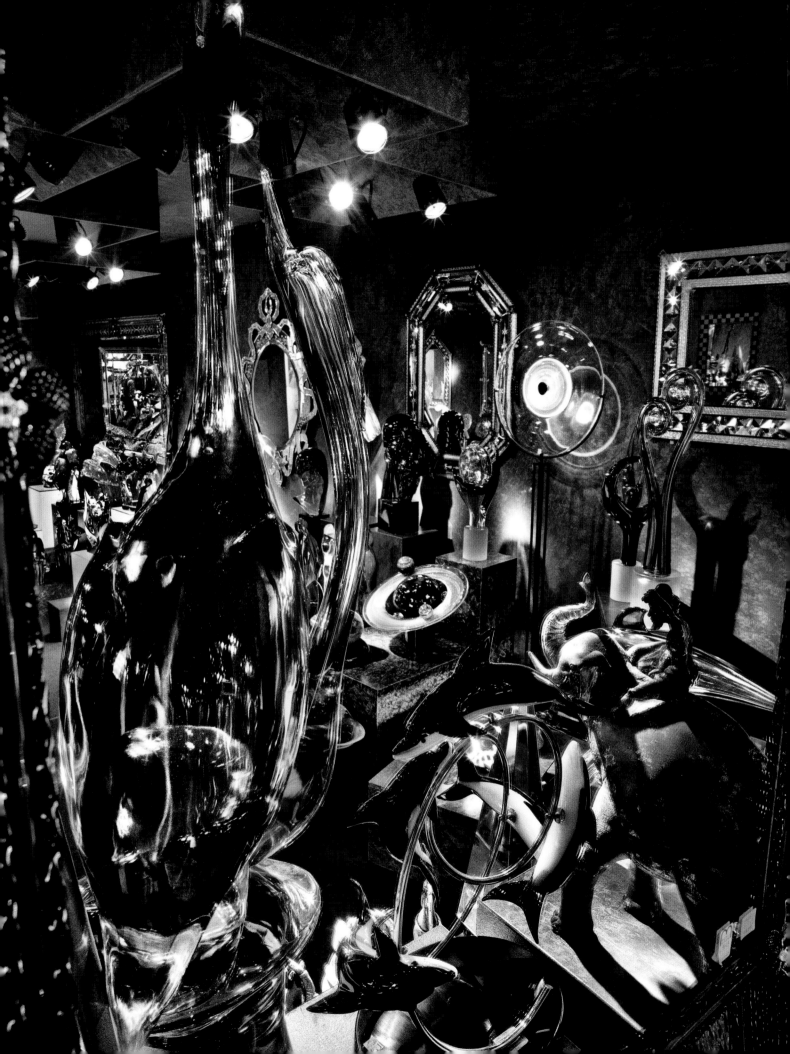

Venice II

(Untitled)
1997

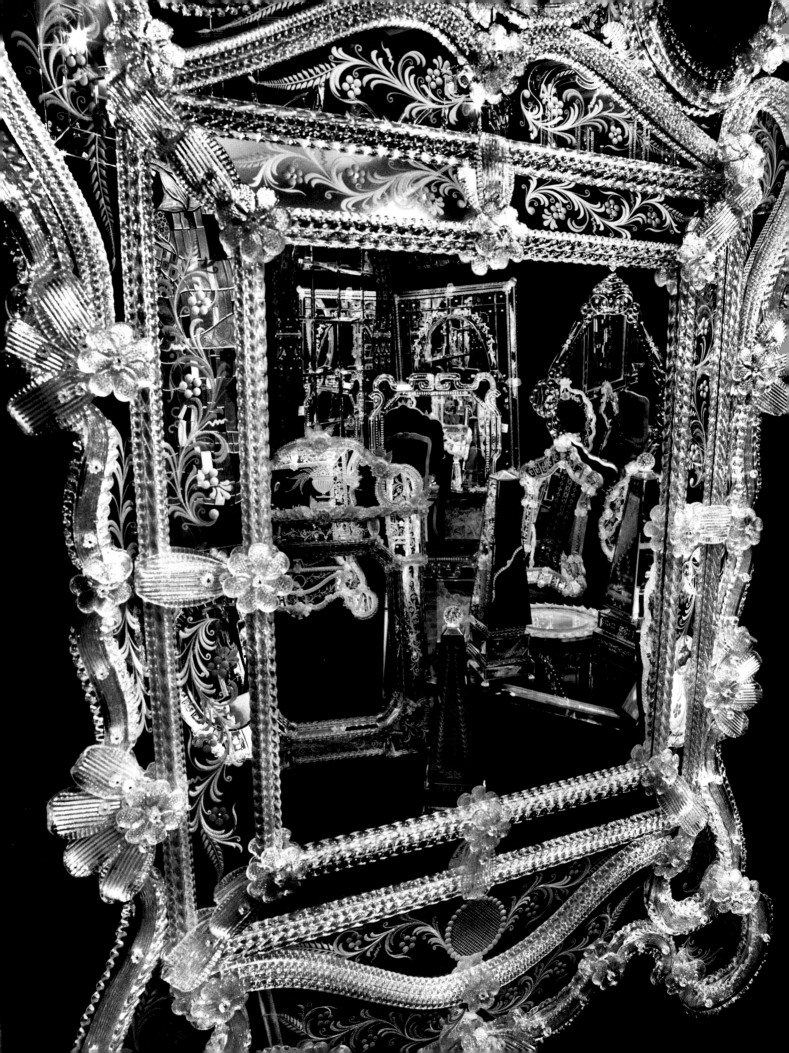

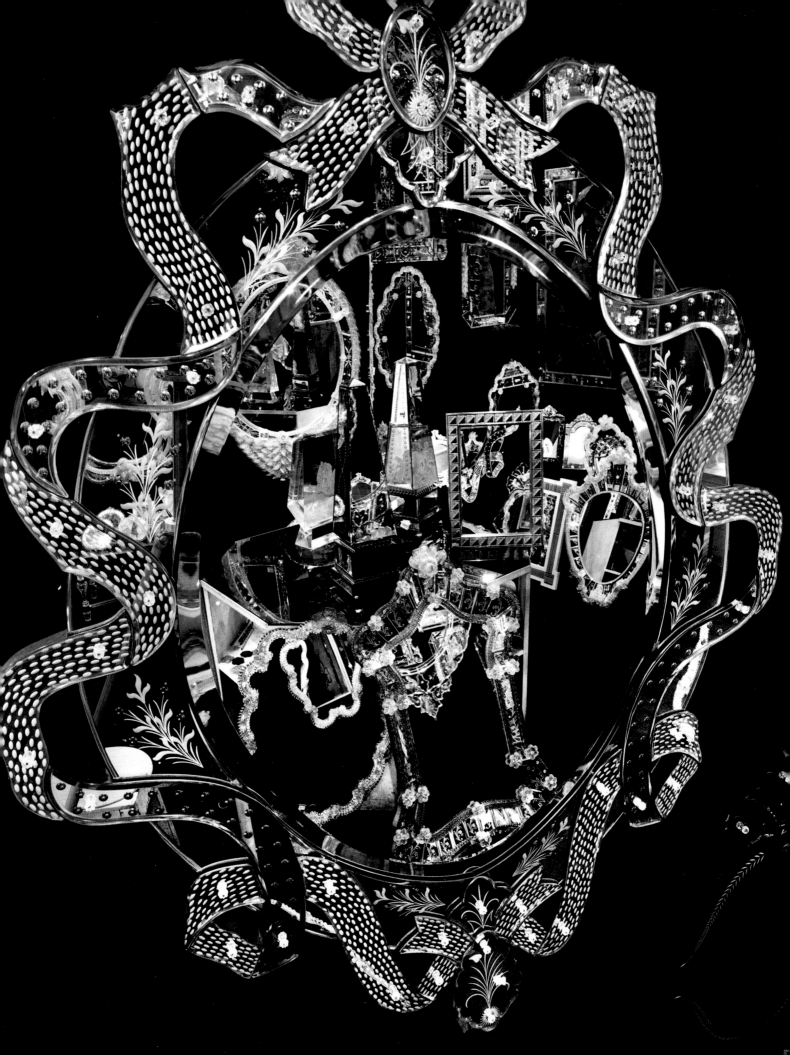

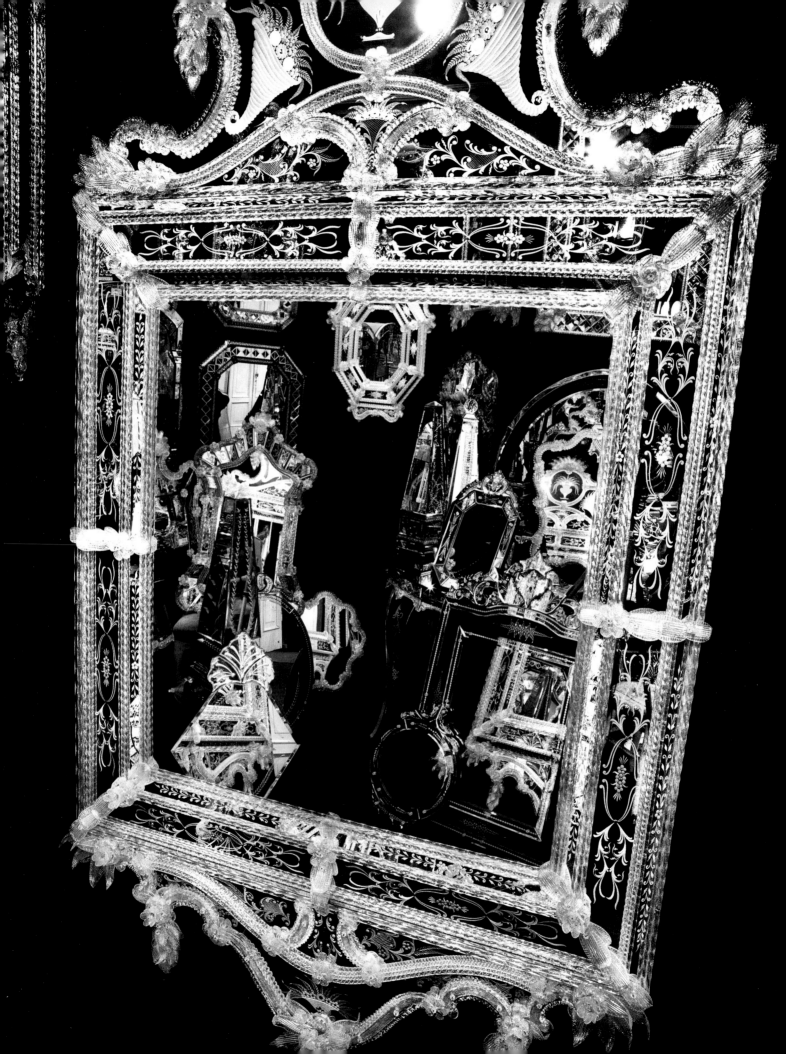

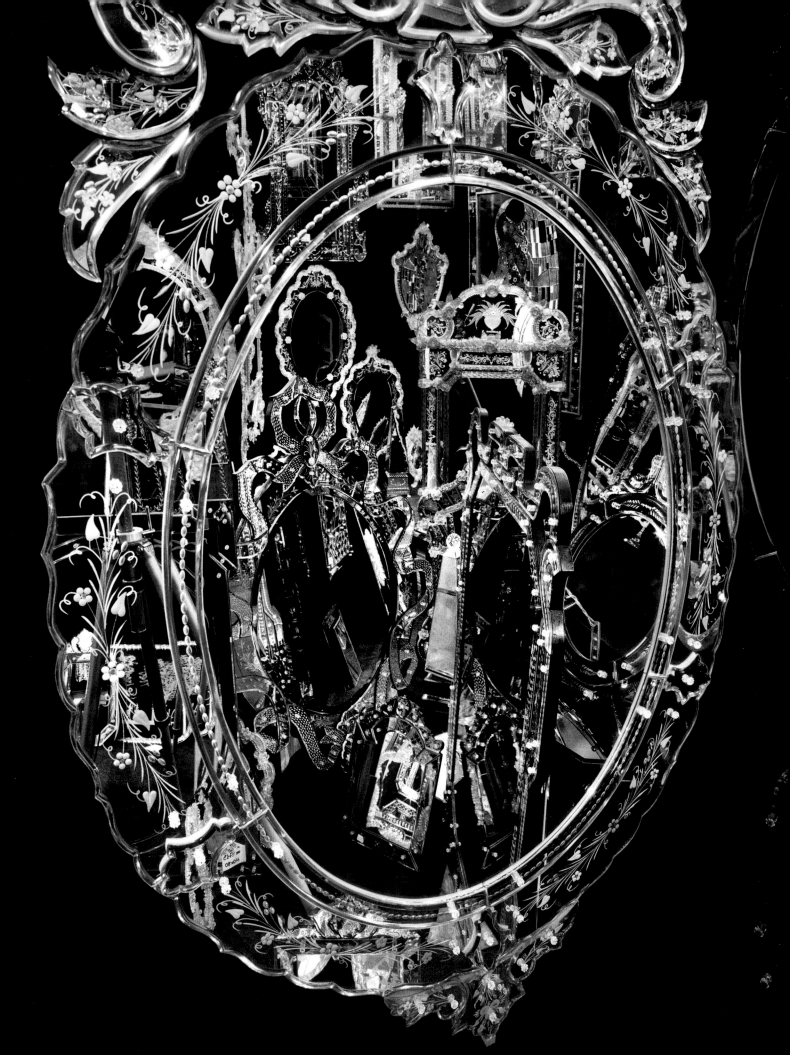

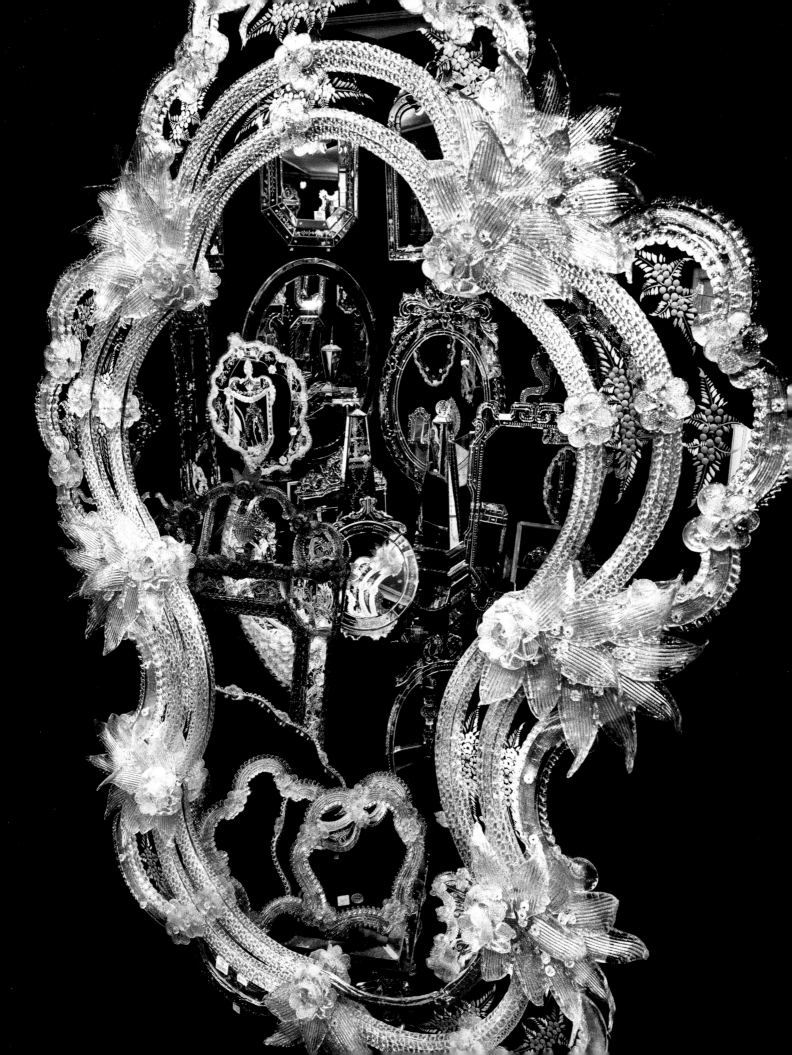

Meat
(Untitled)
1998

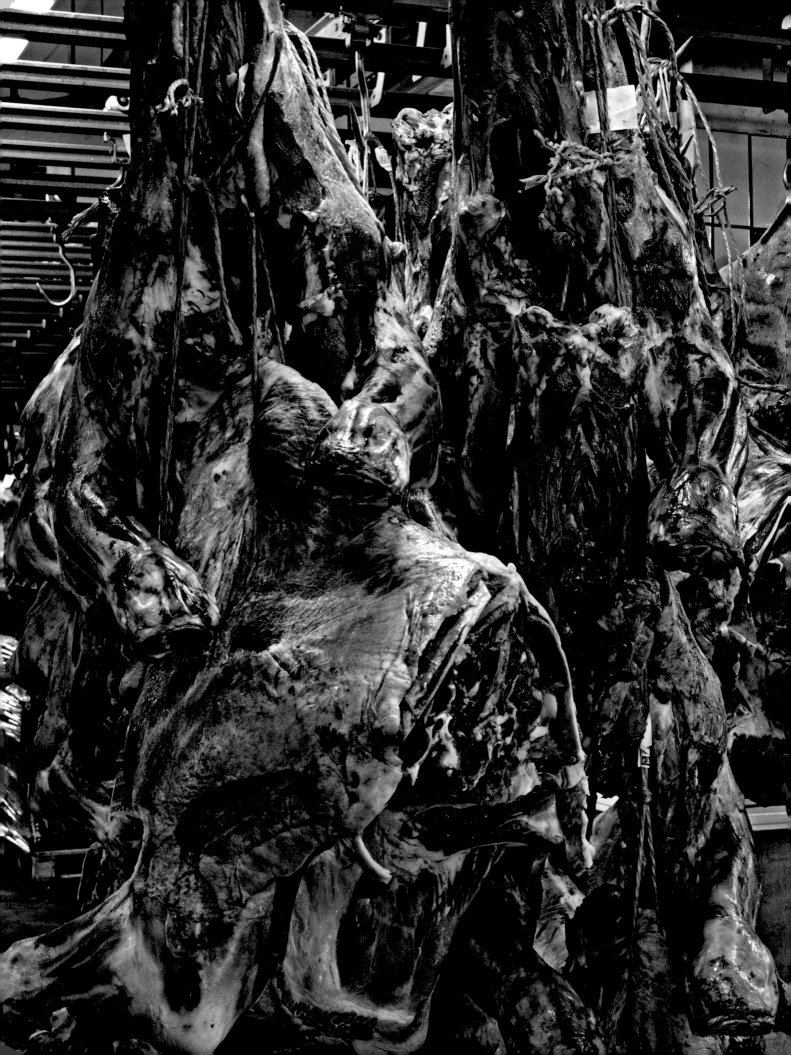

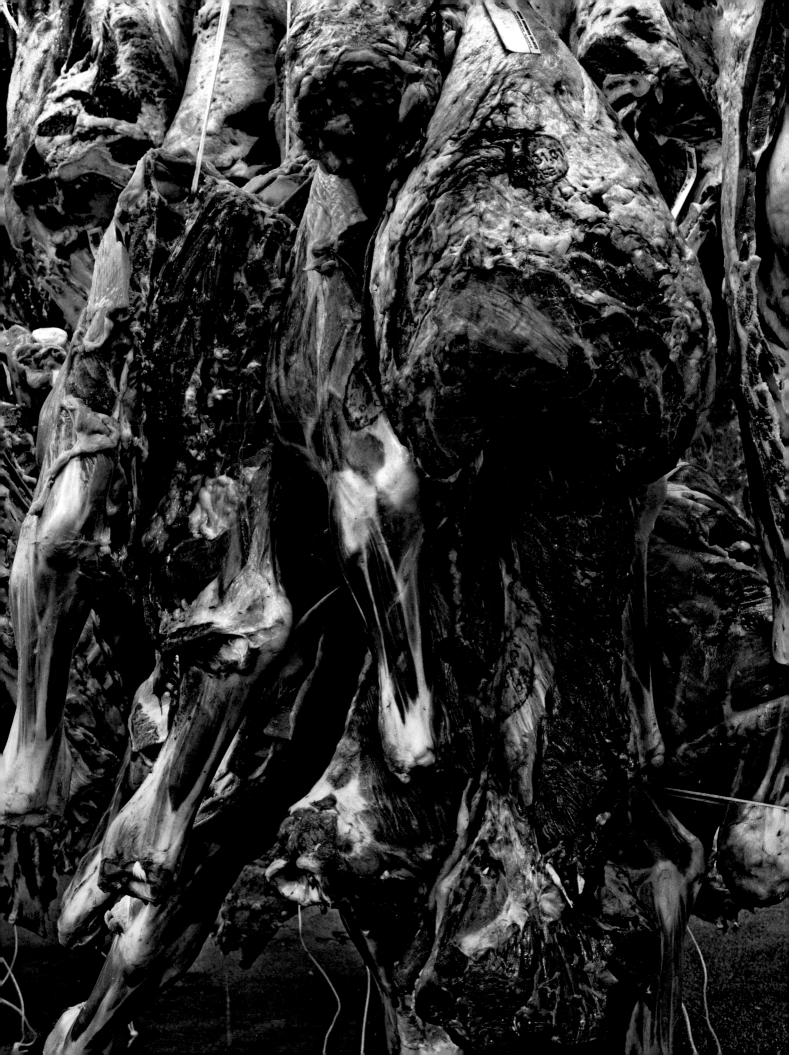

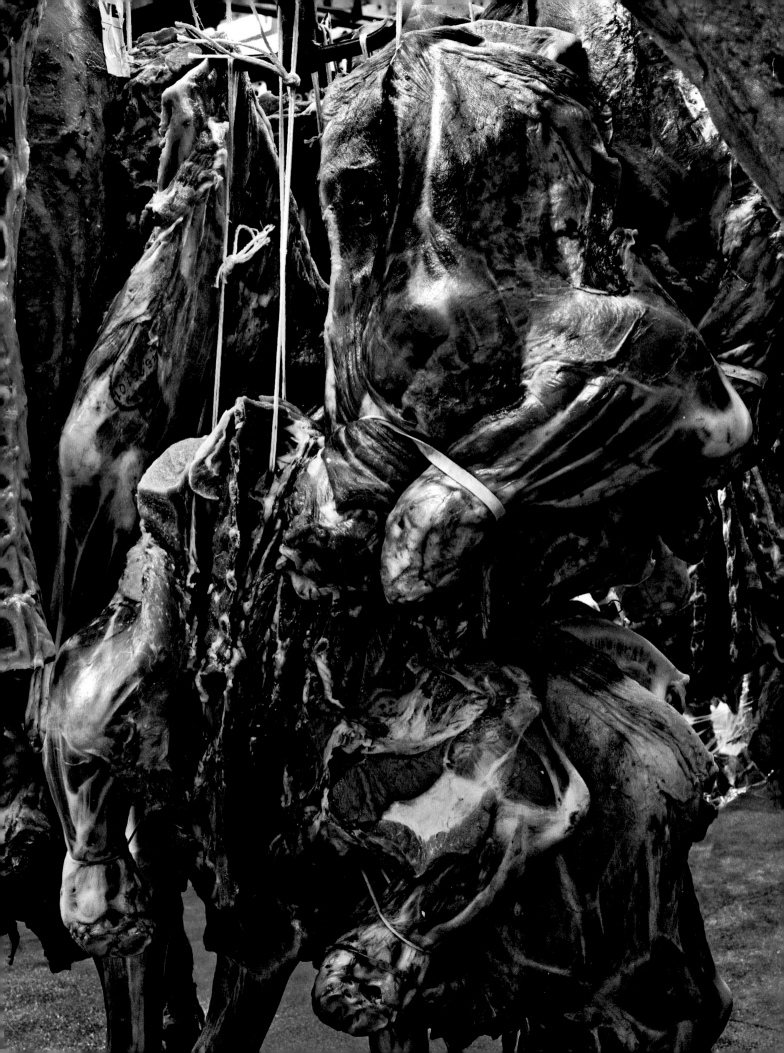

Cars

(Untitled)
1998

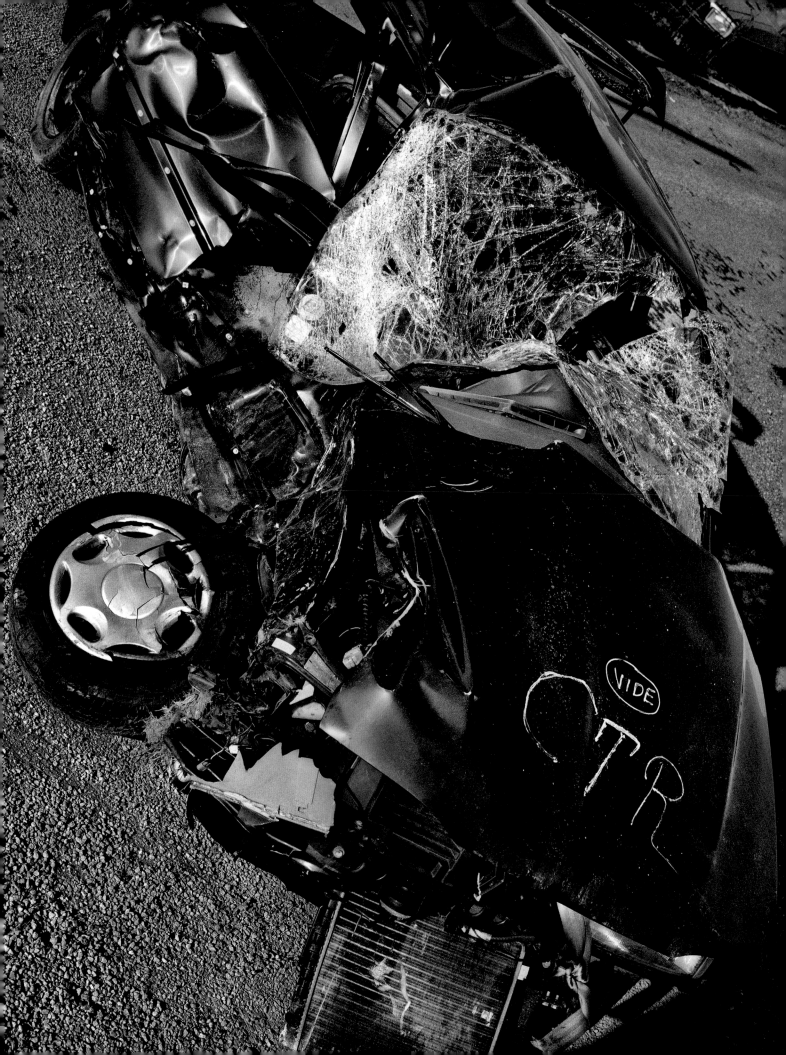

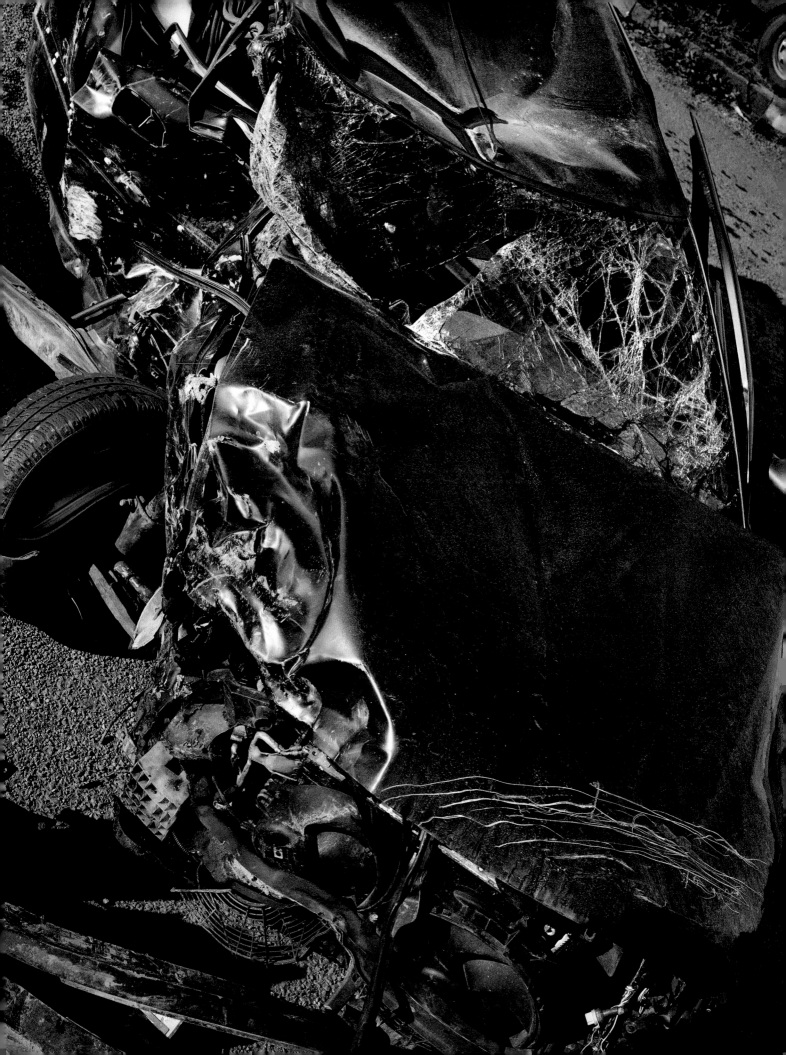

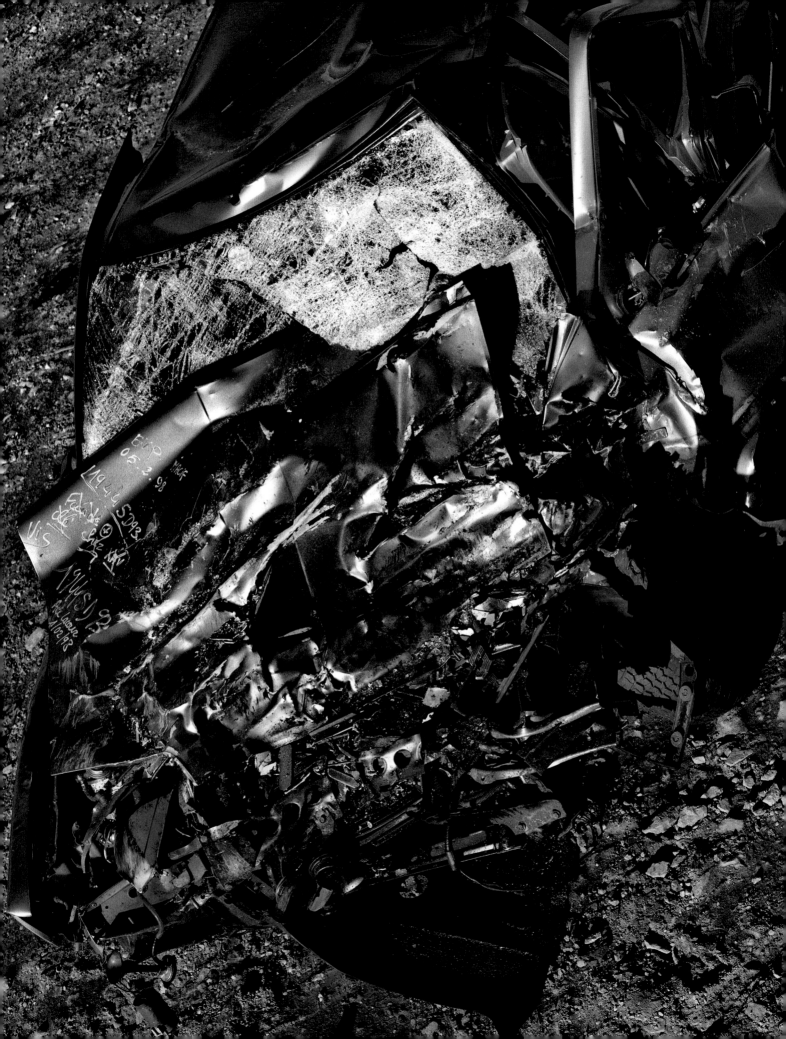

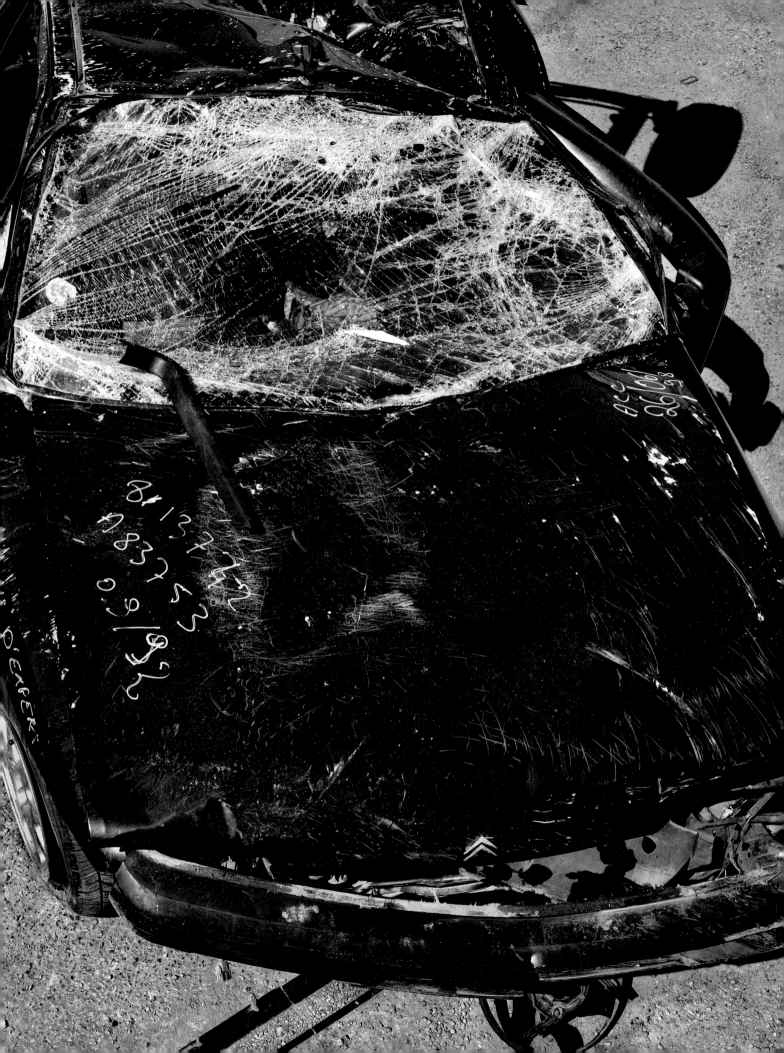

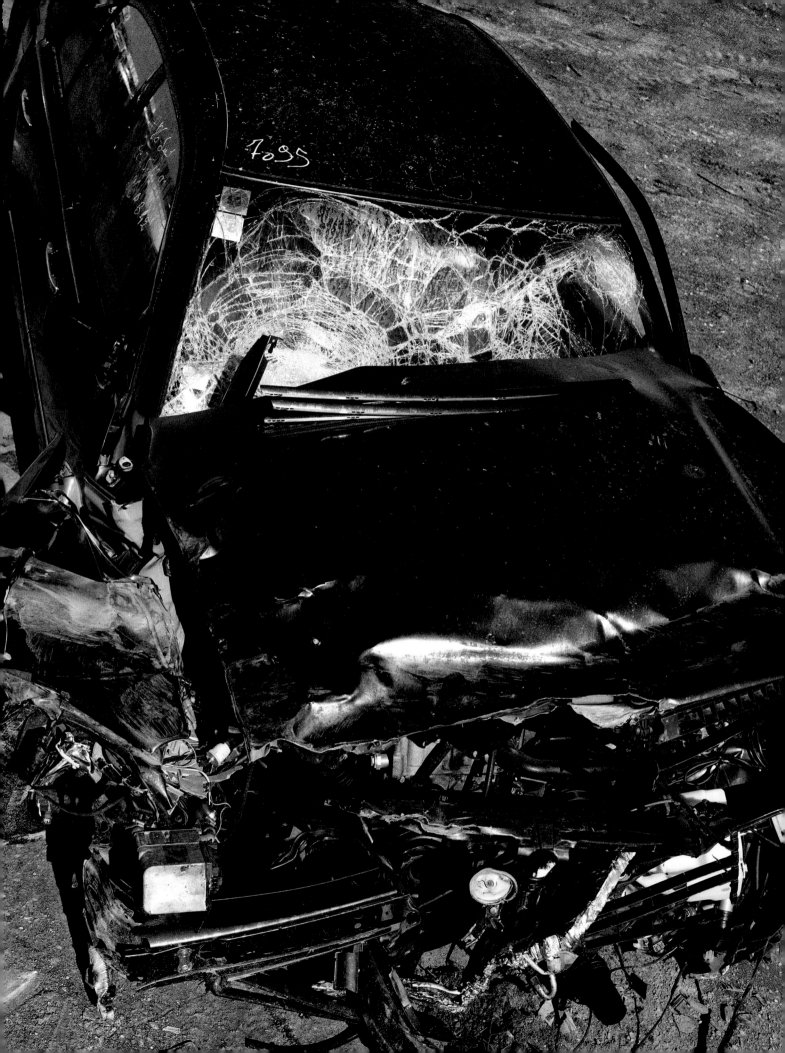

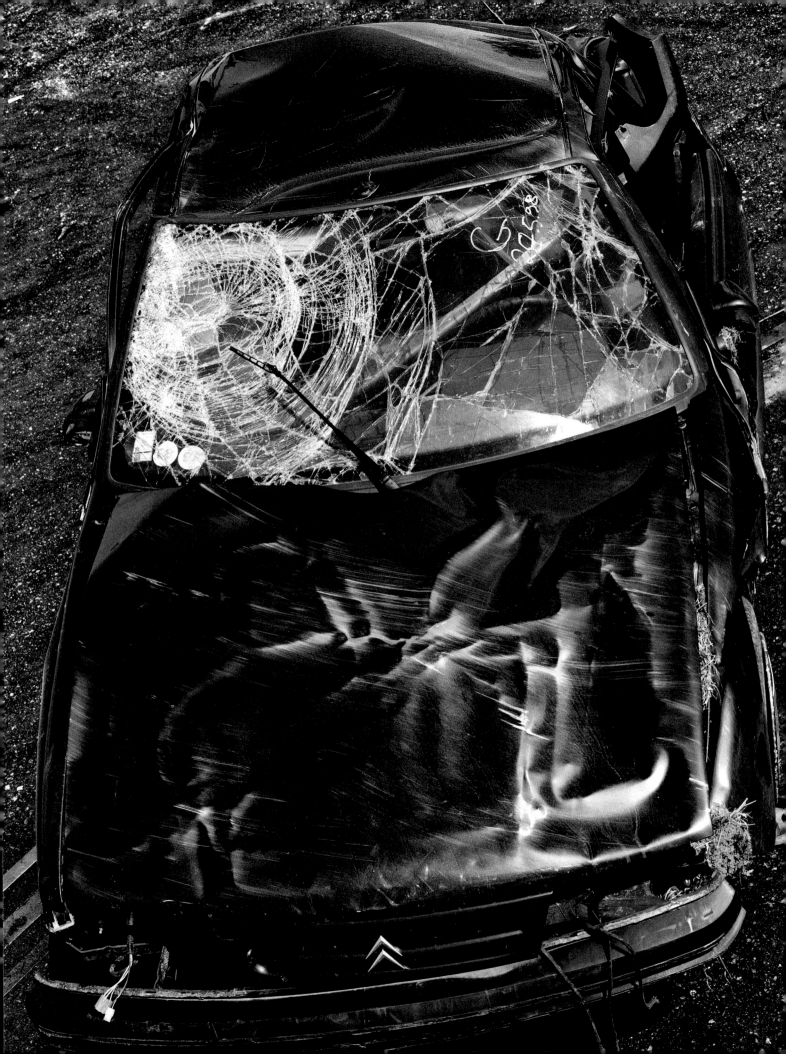

Body-builders

I

1999

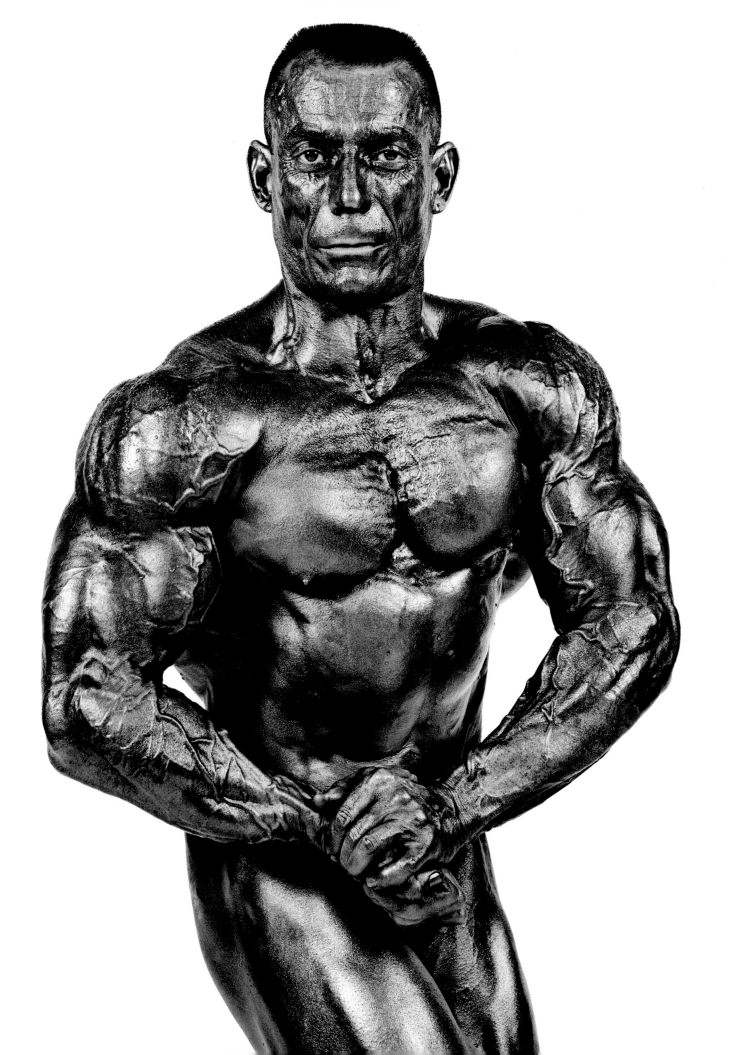

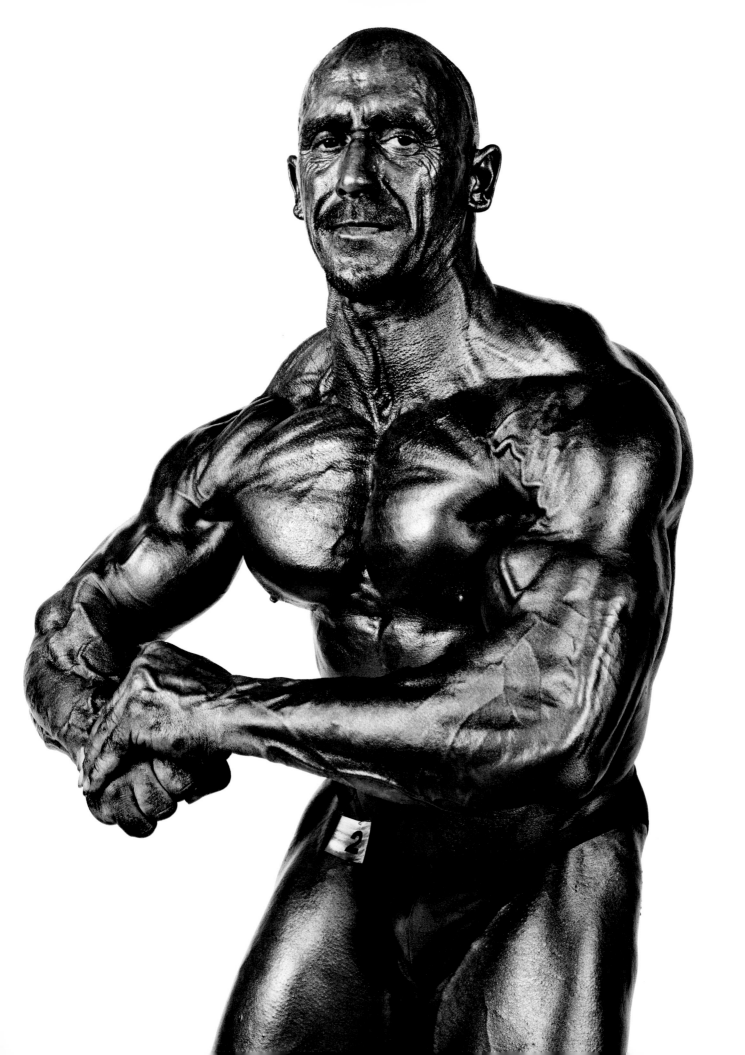

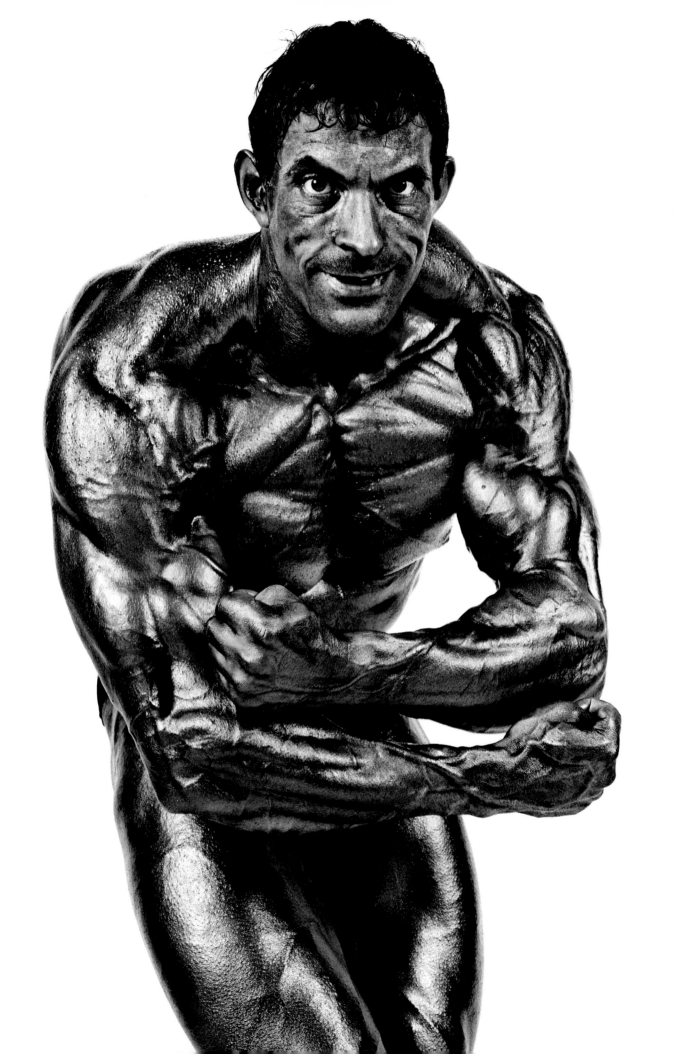

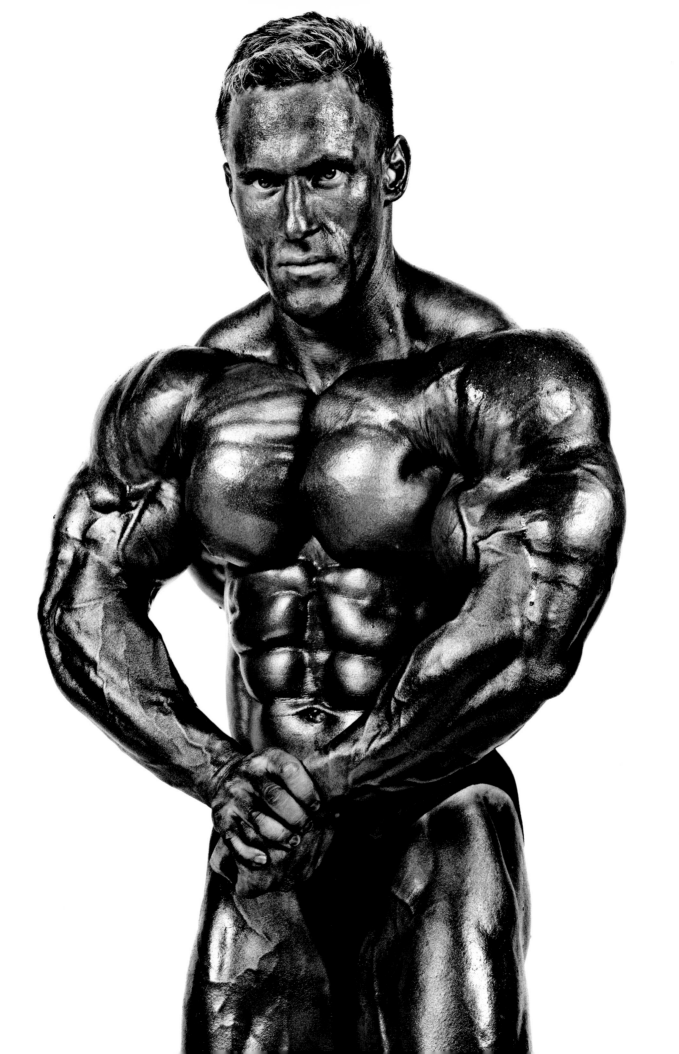

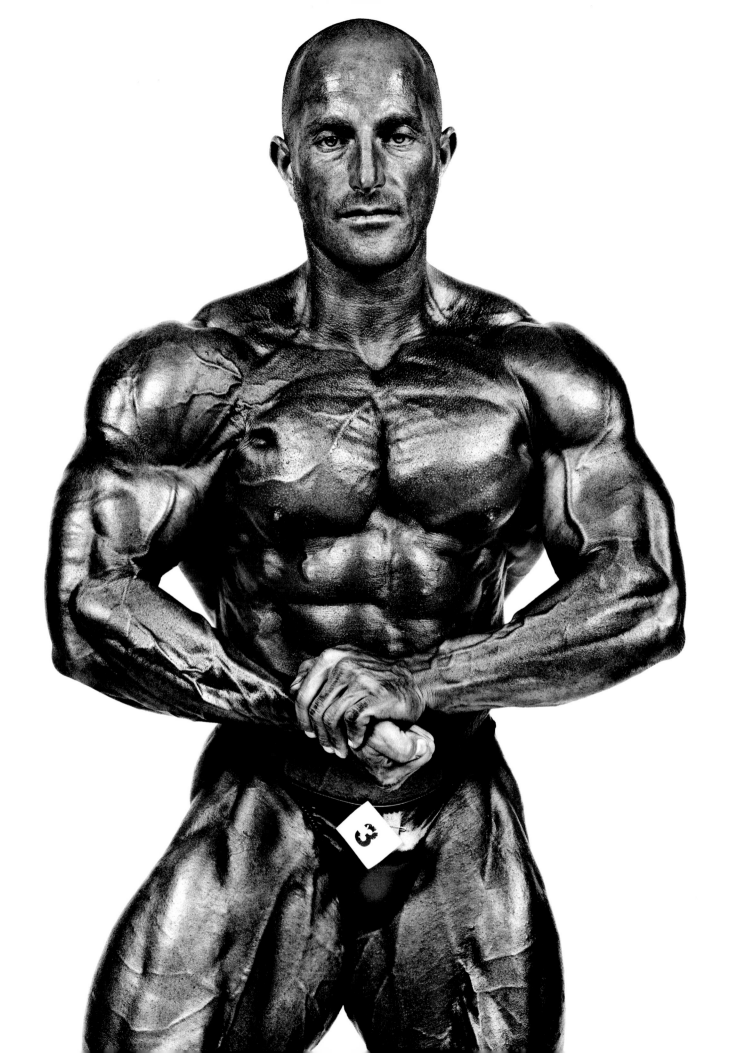

Dogs
(Untitled)
1999

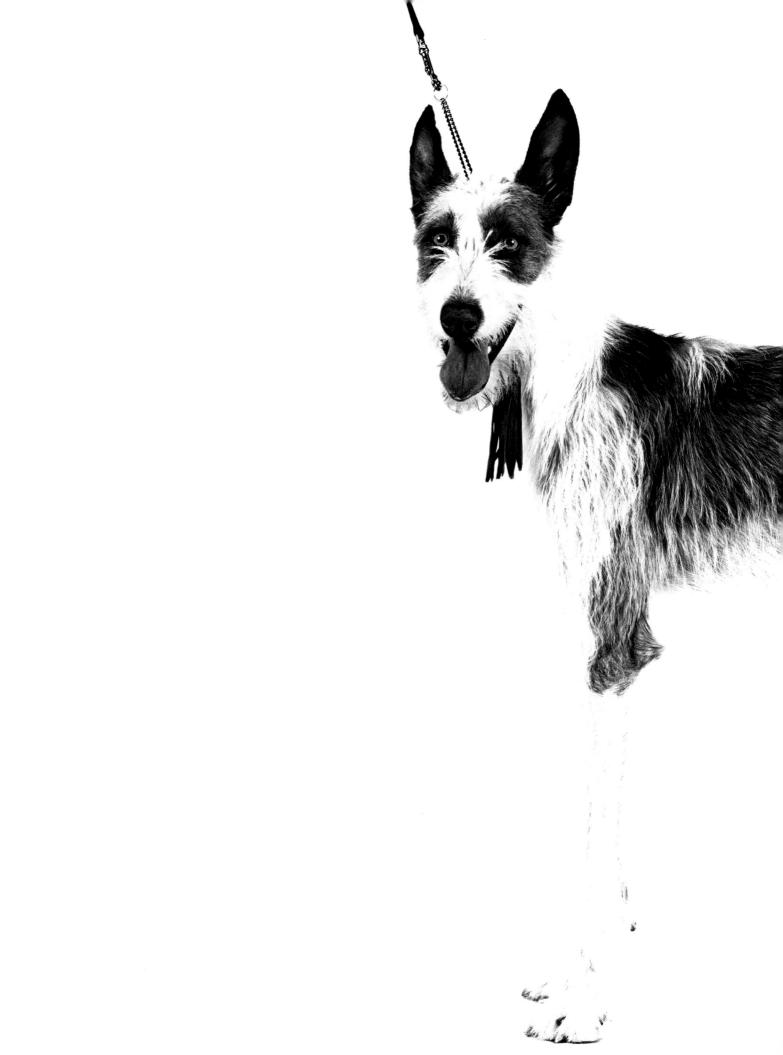

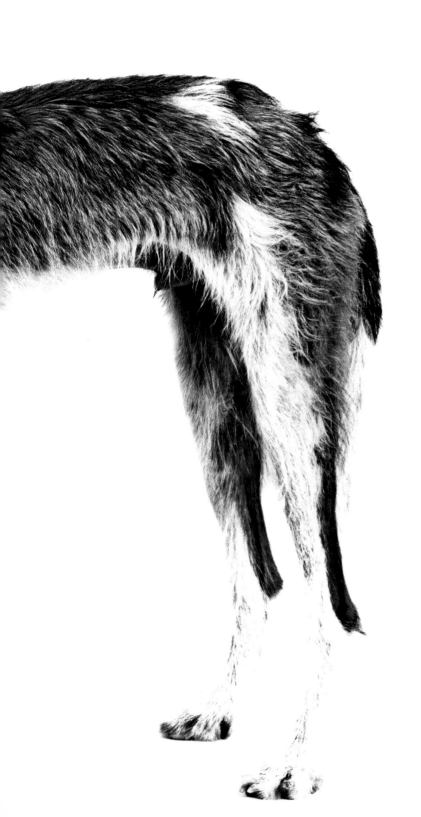

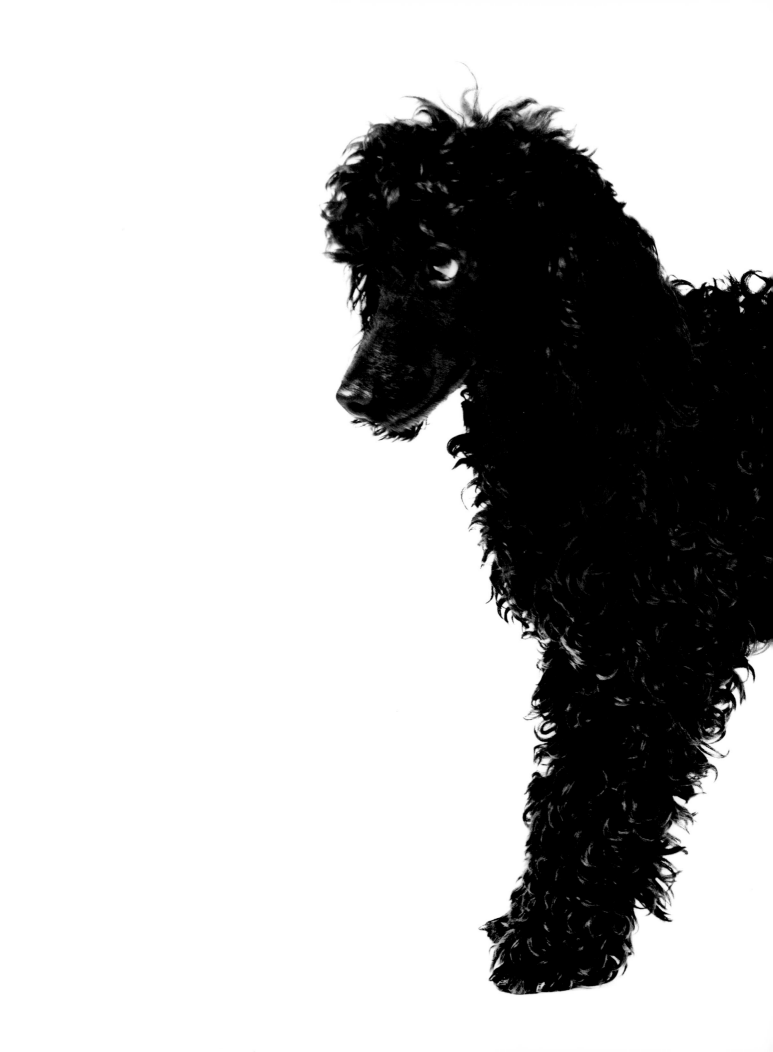

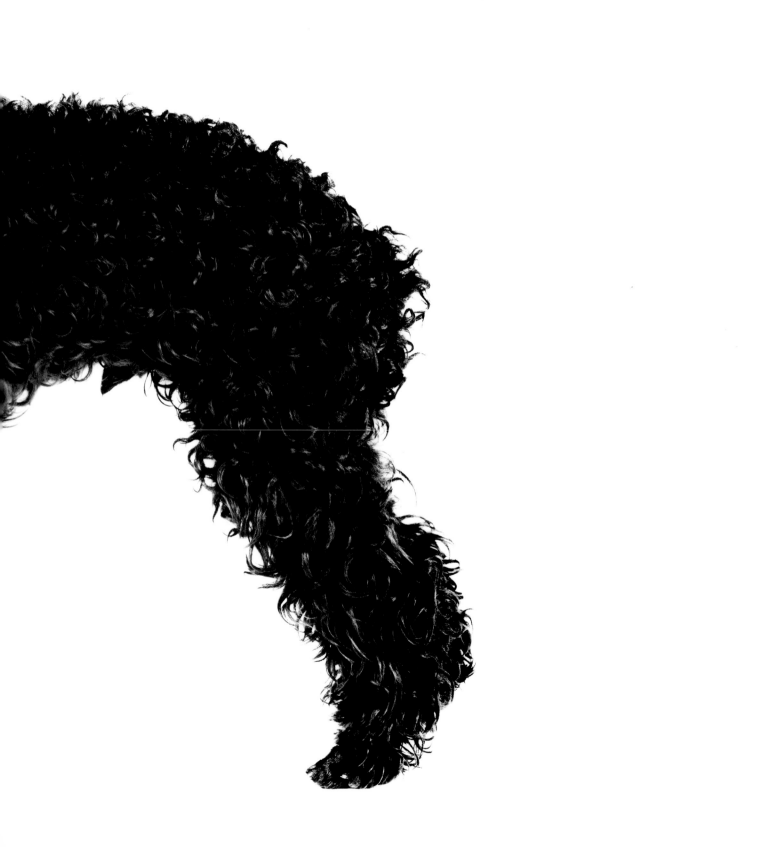

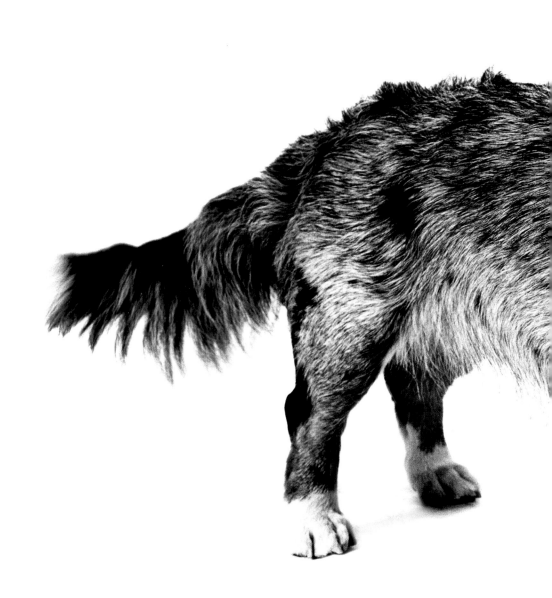

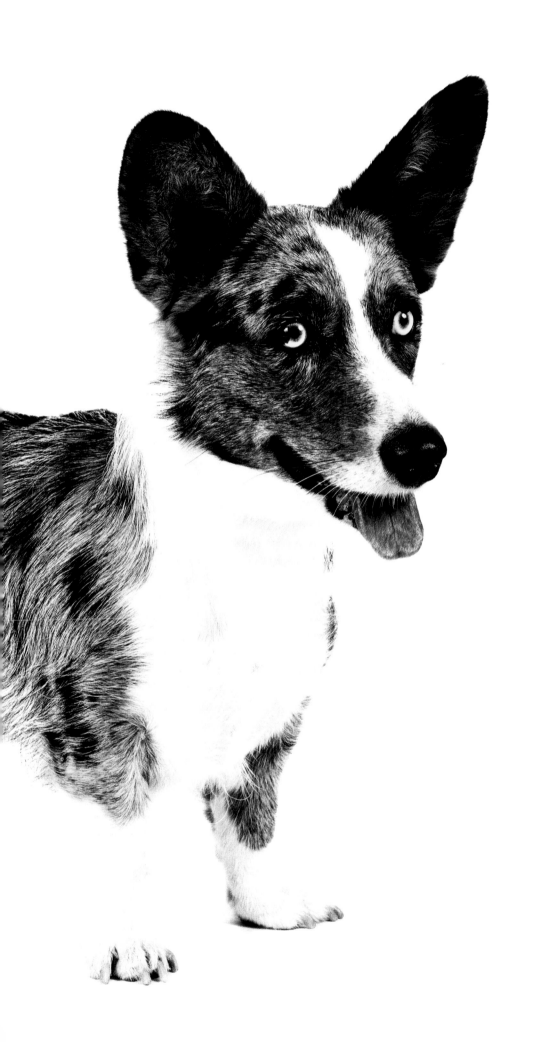

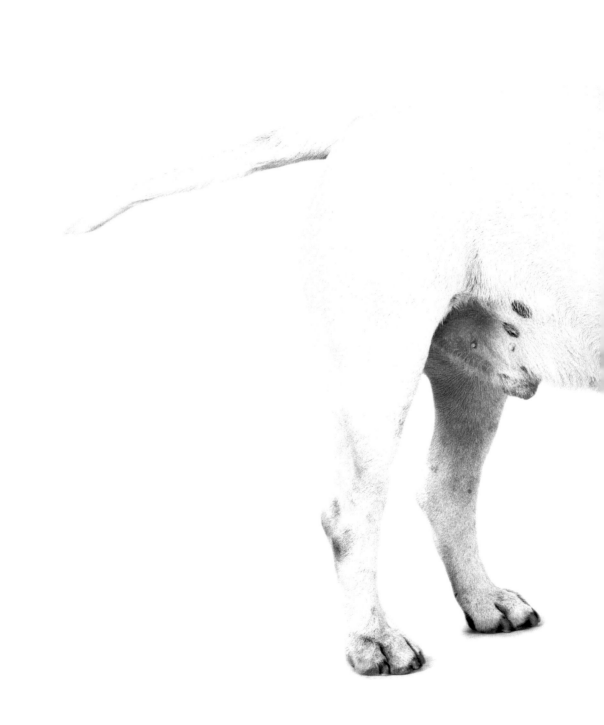

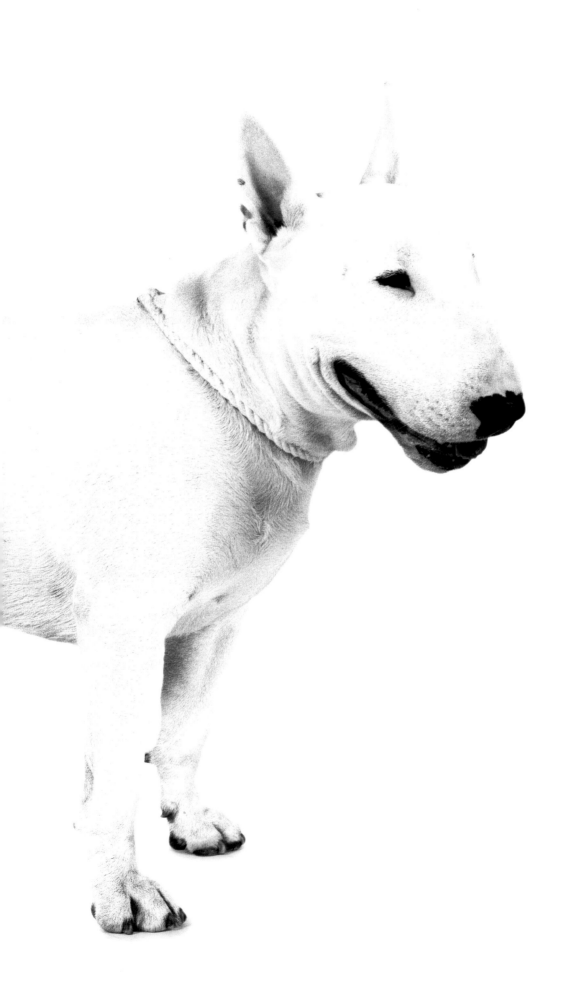

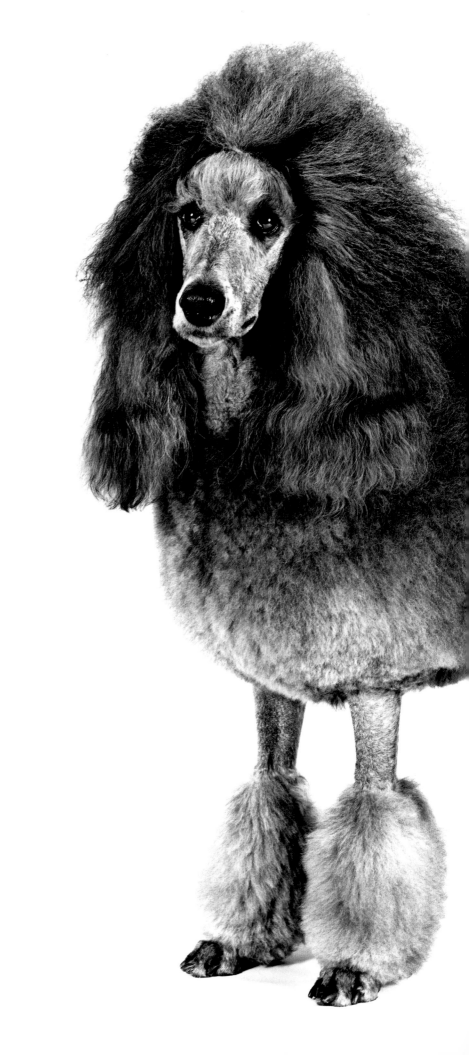

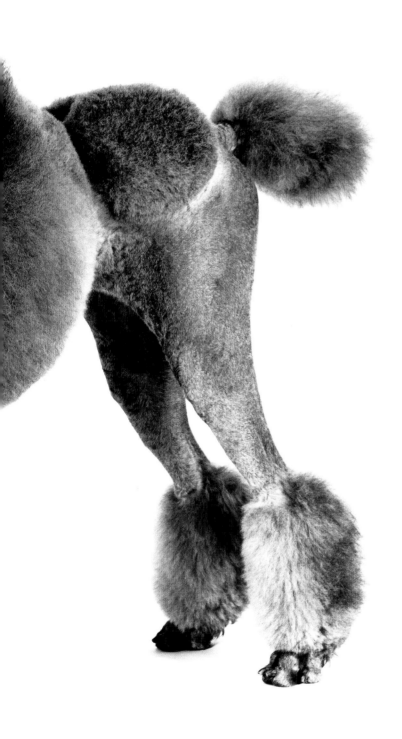

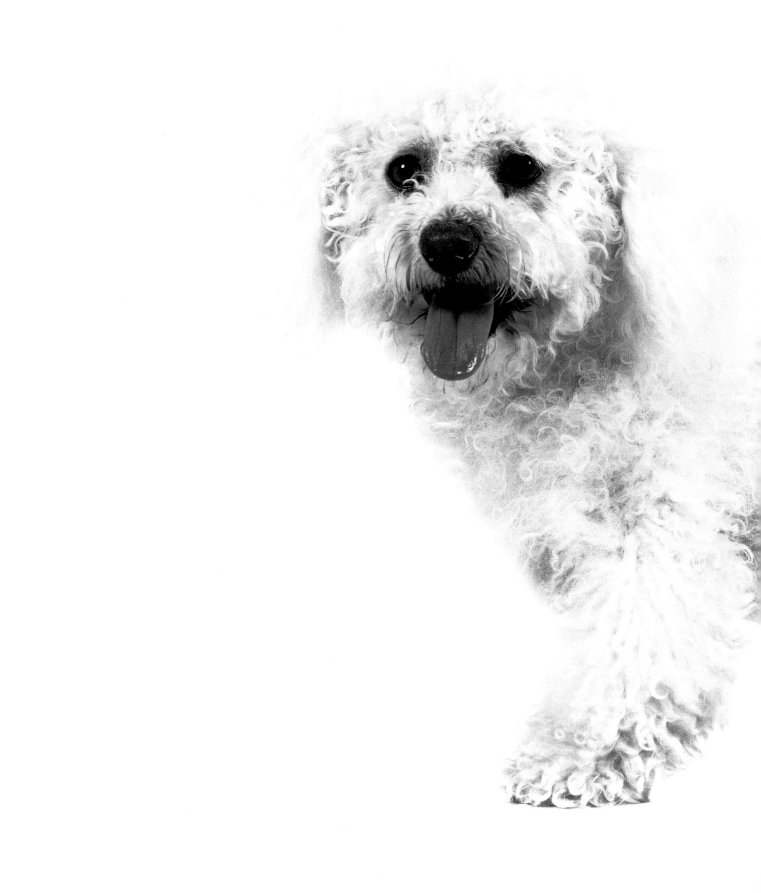

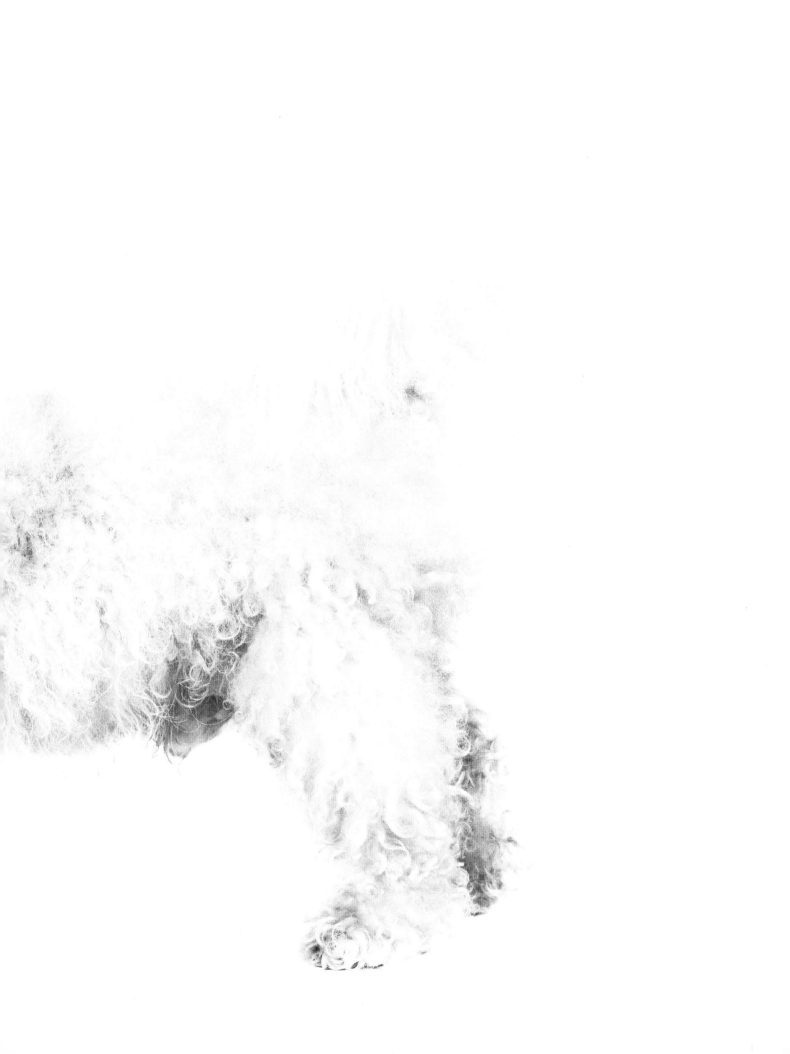

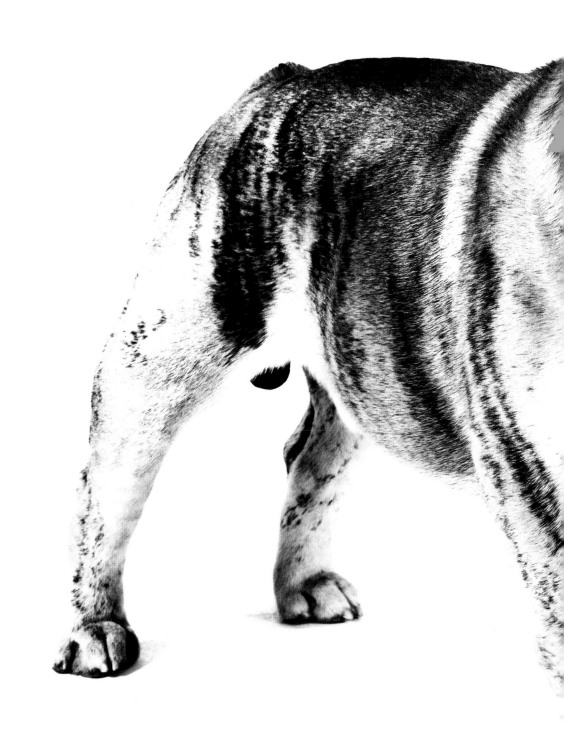

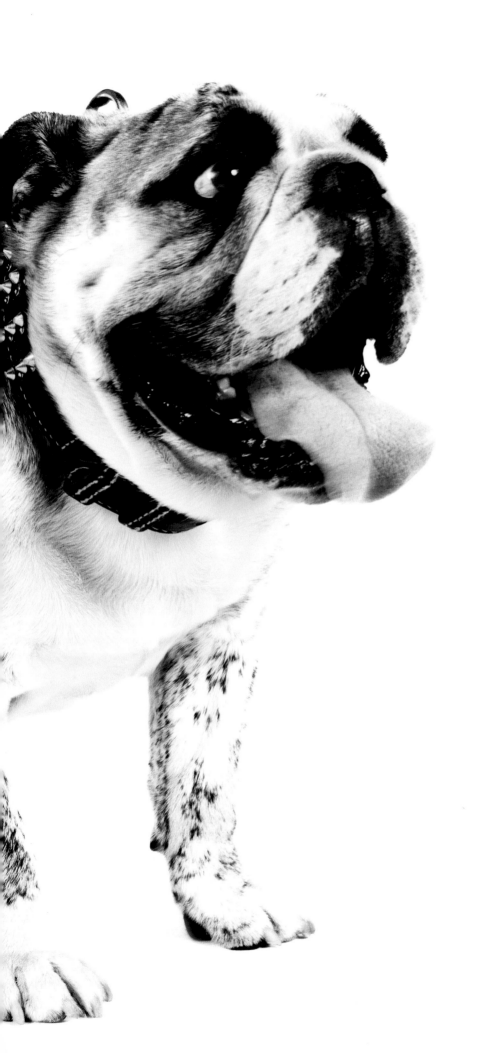

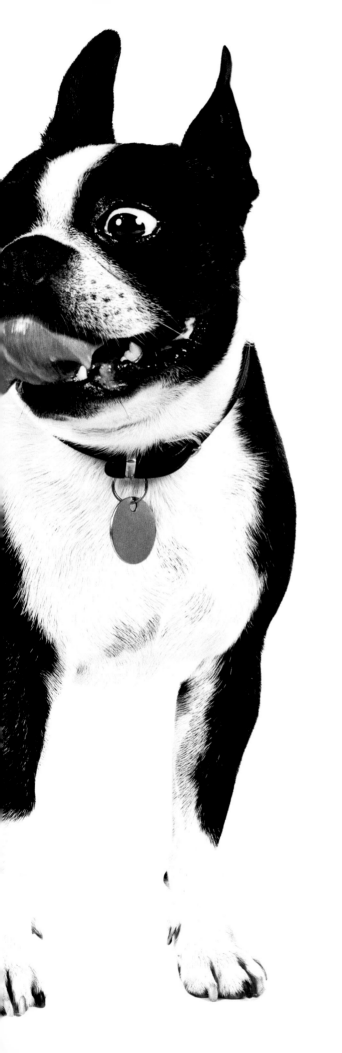

Body-
builders

II

1999

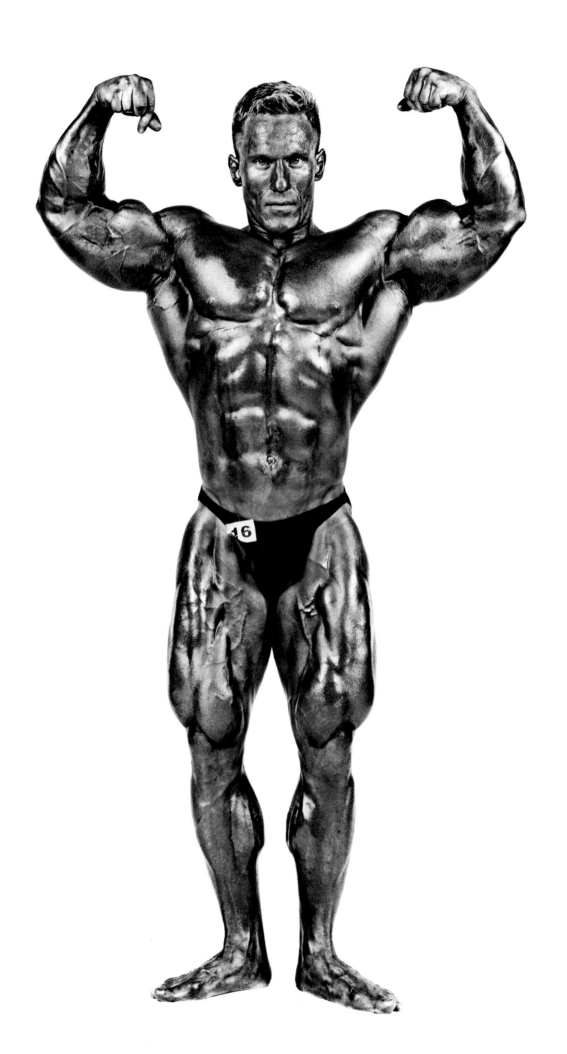

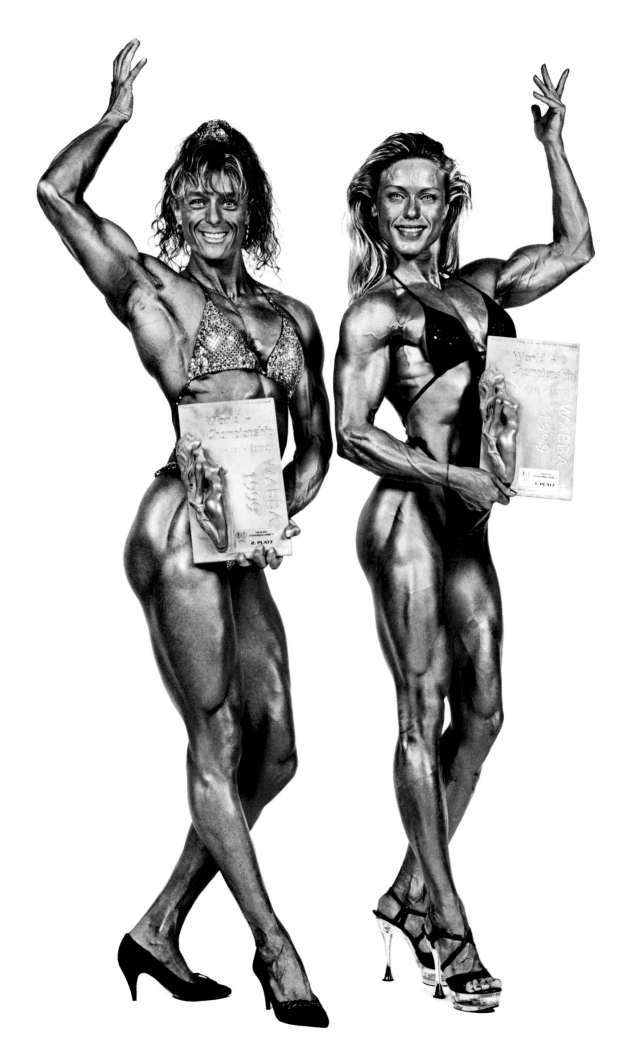

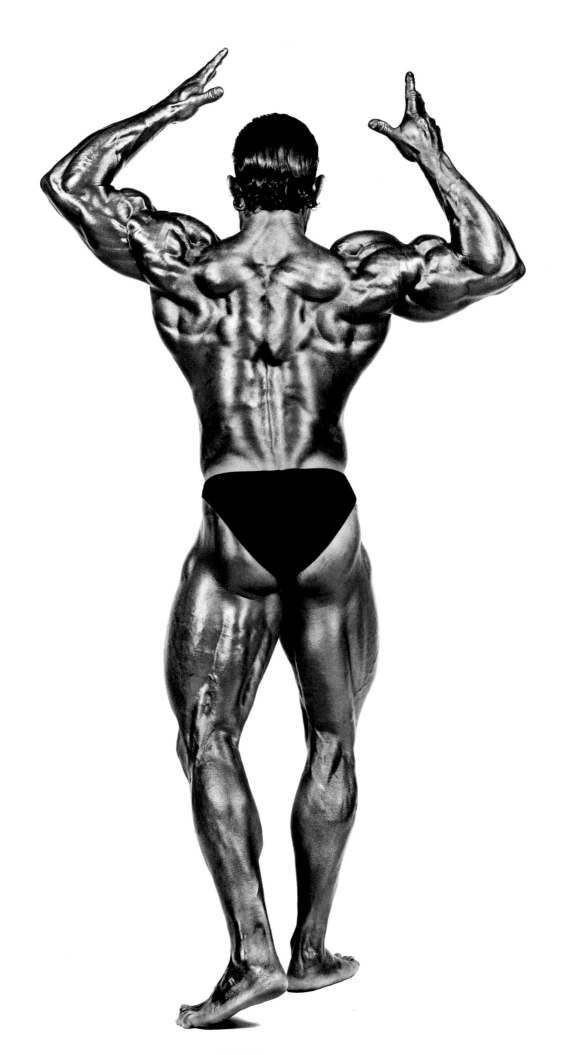

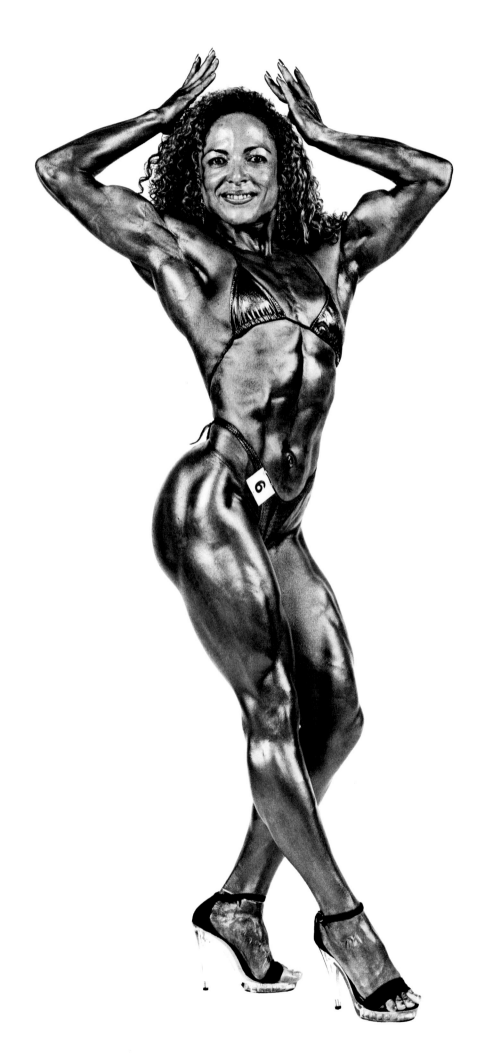

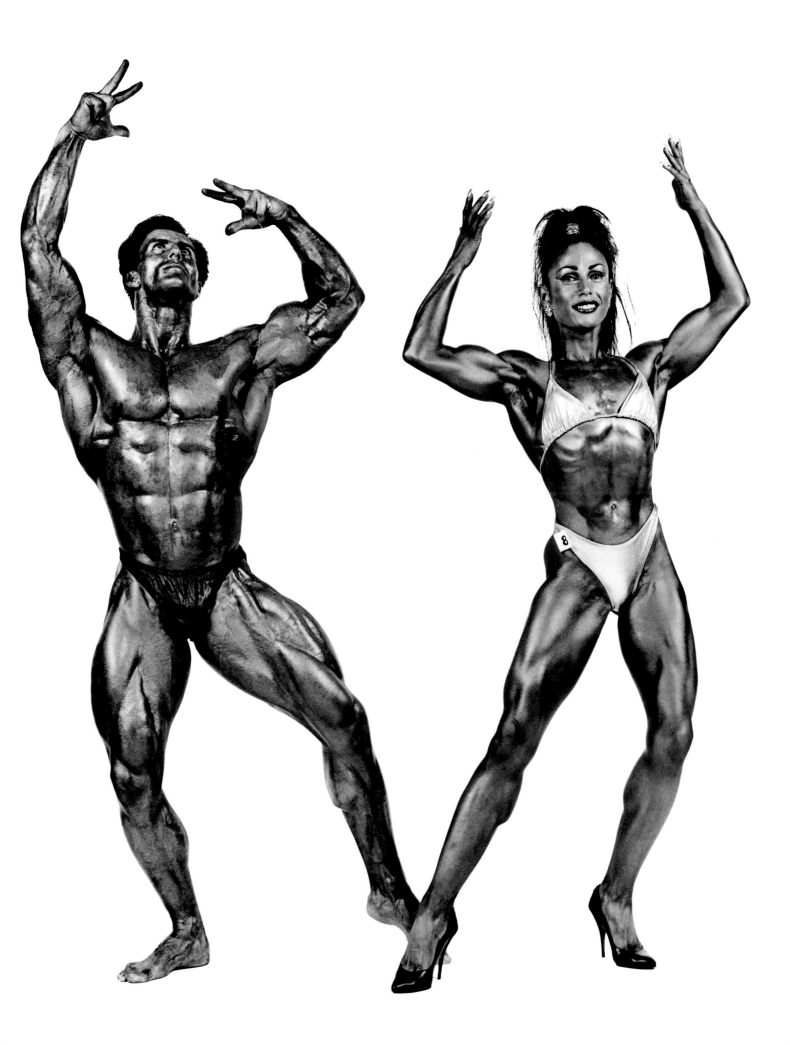

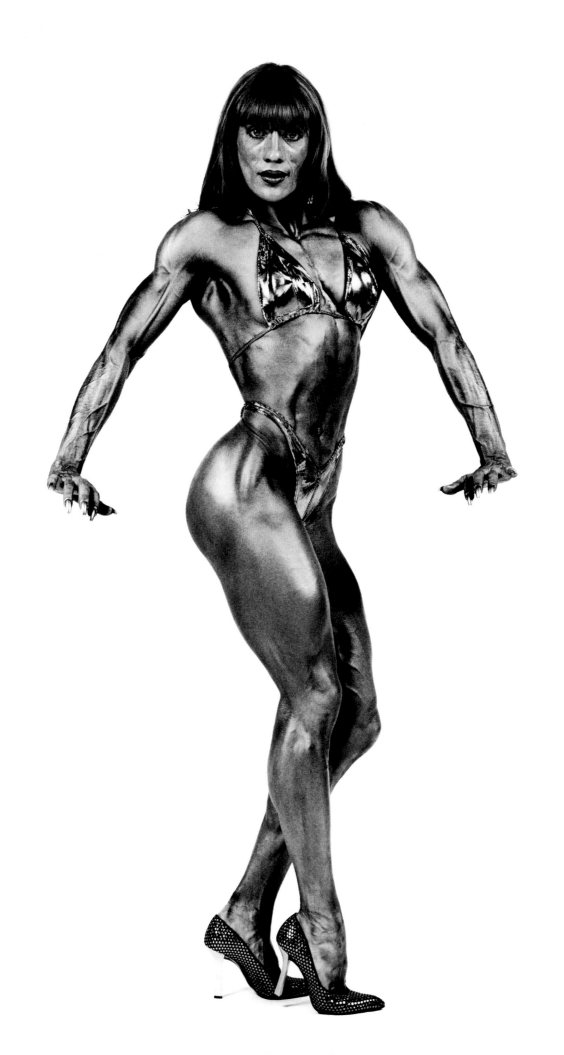

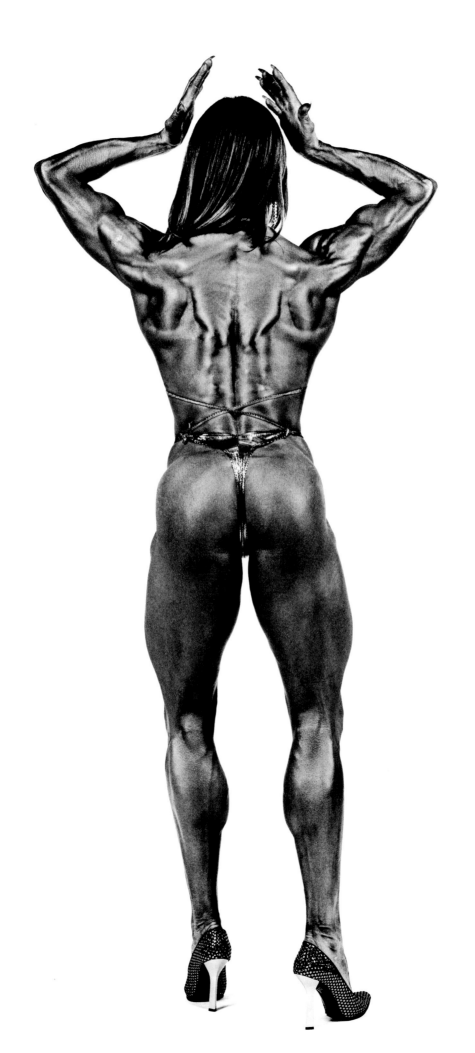

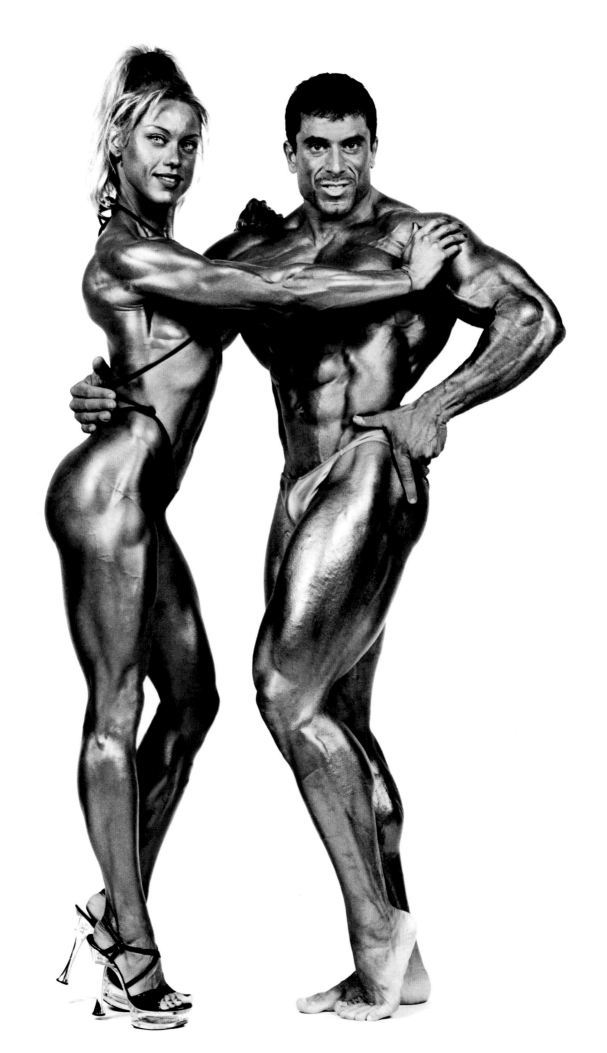

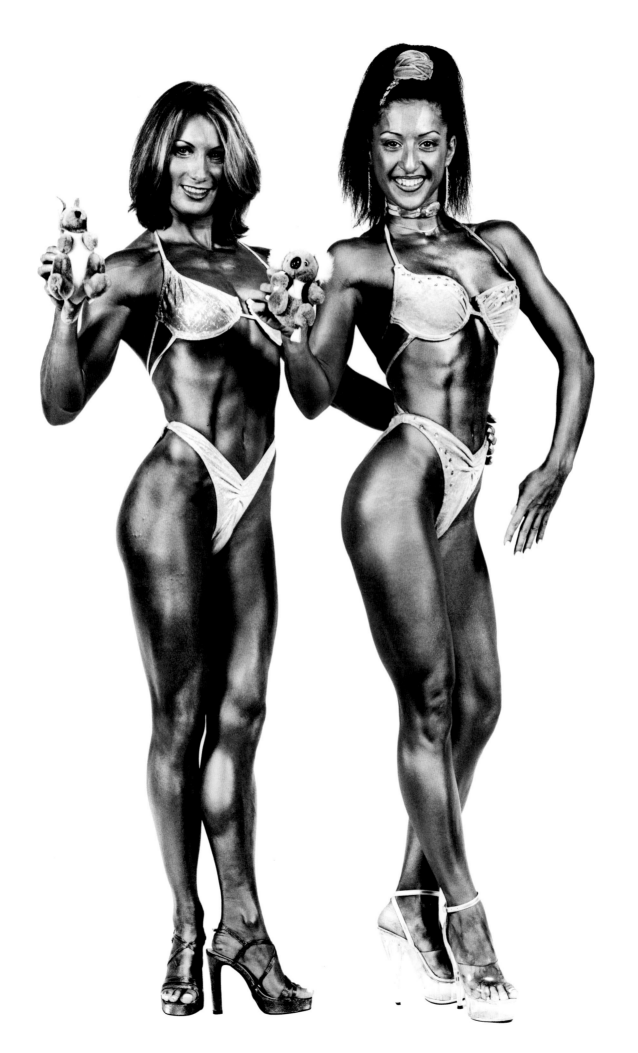

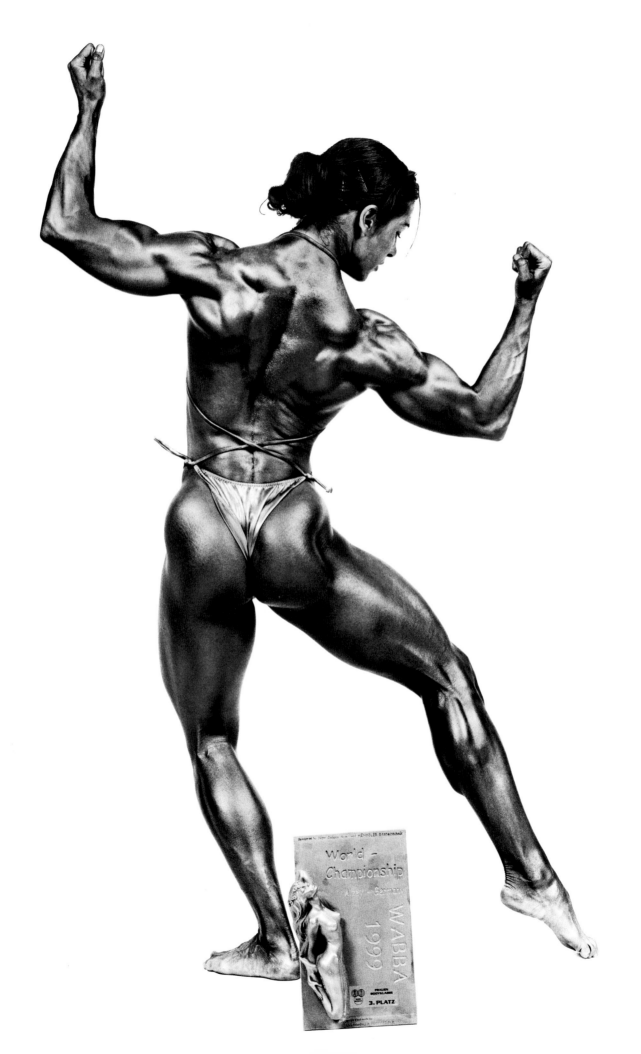

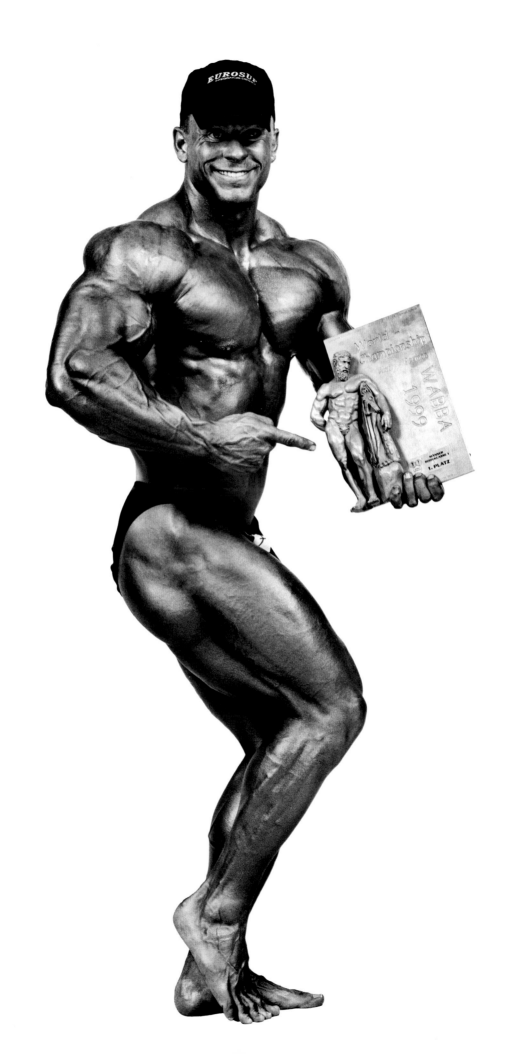

Moroccan Brides

(Untitled)

2000

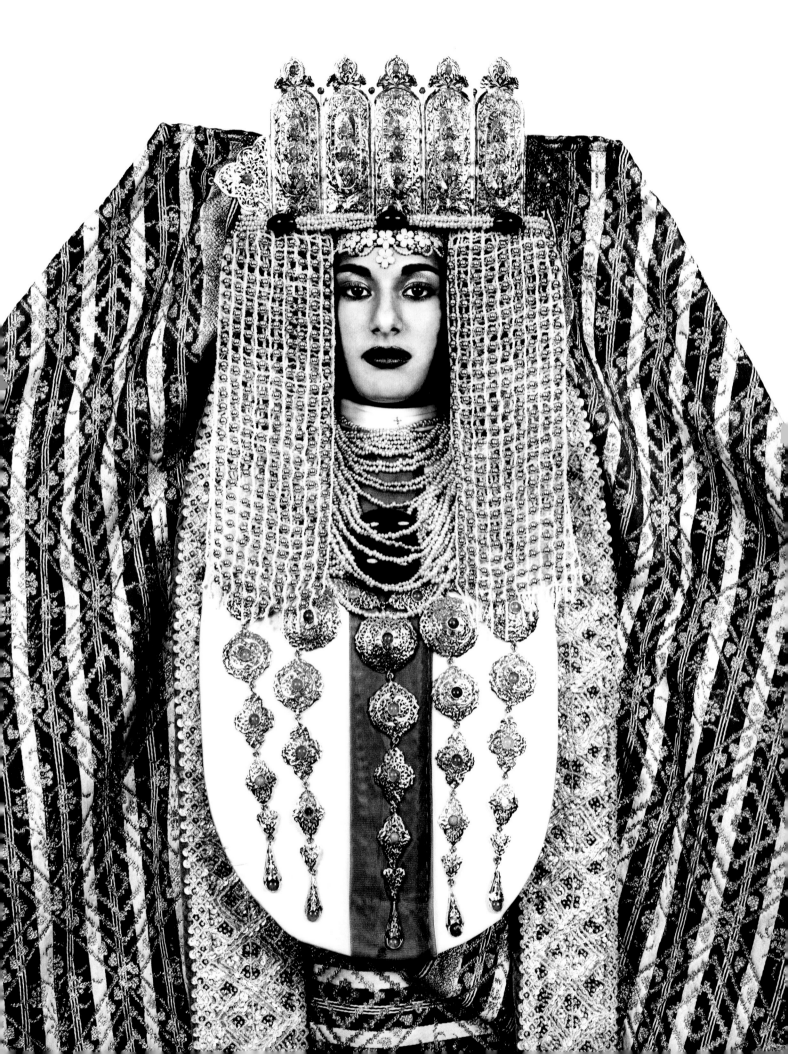

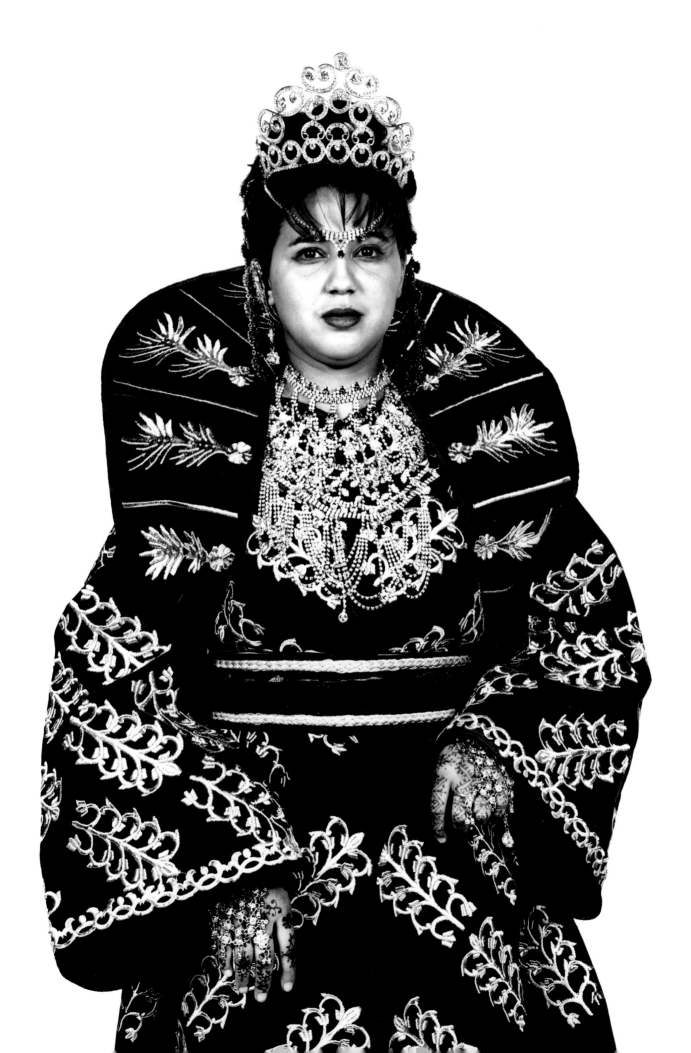

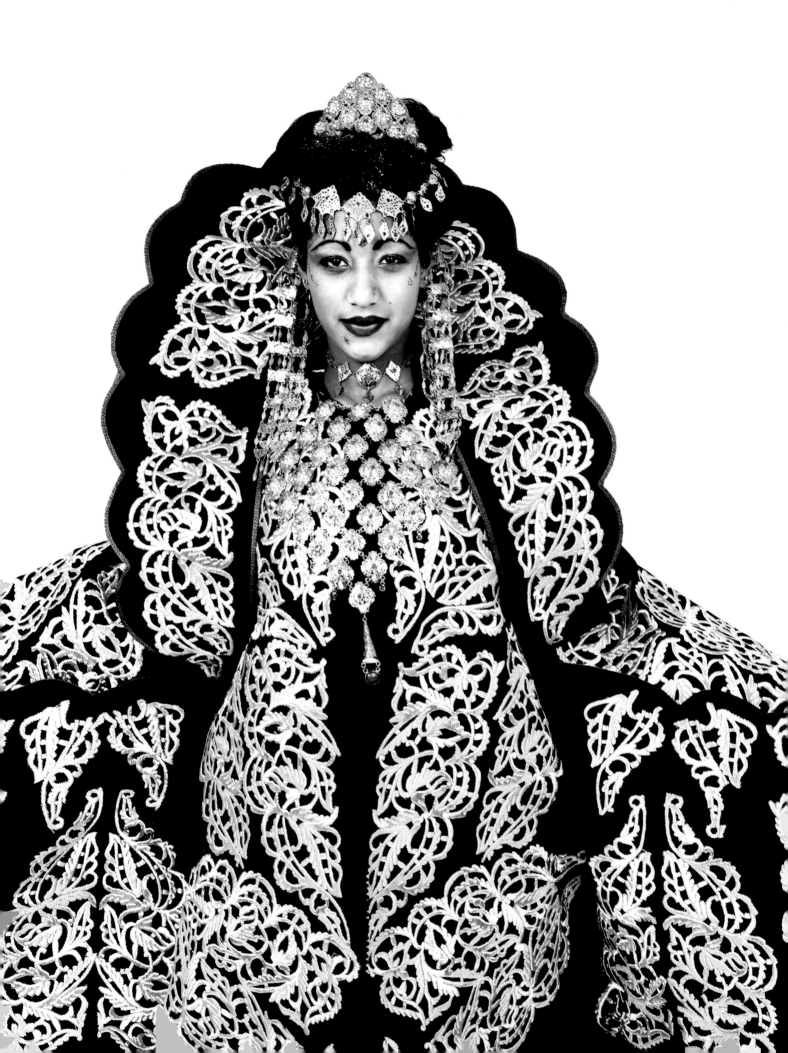

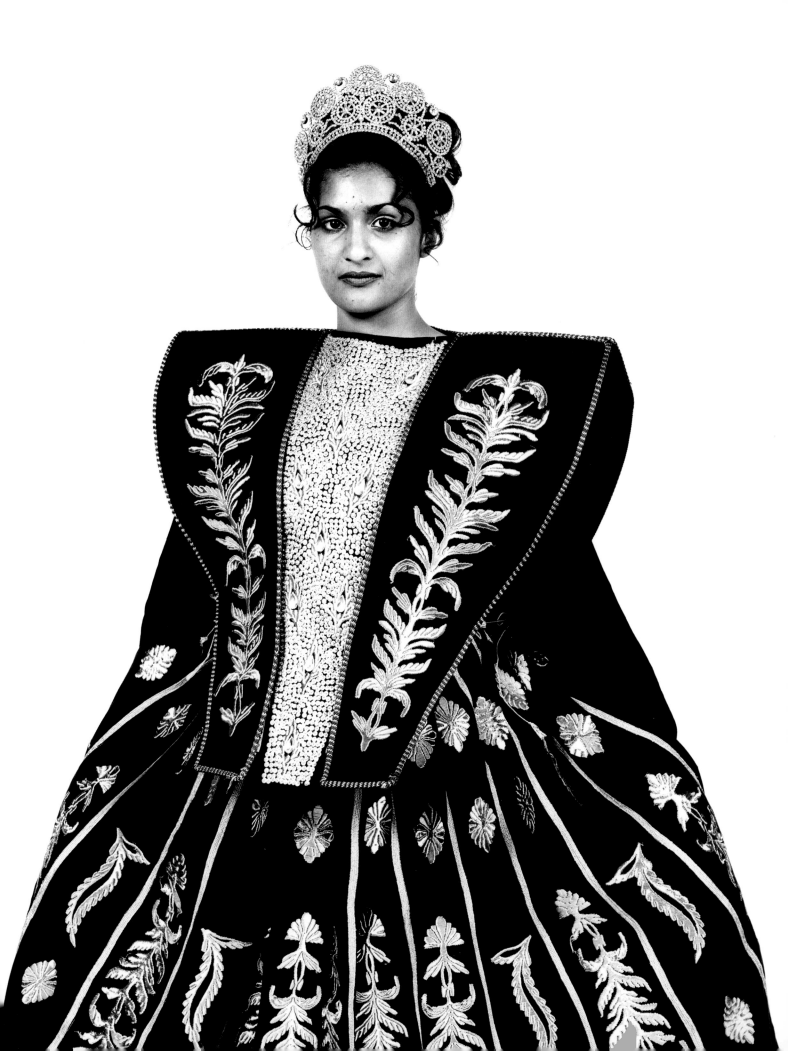

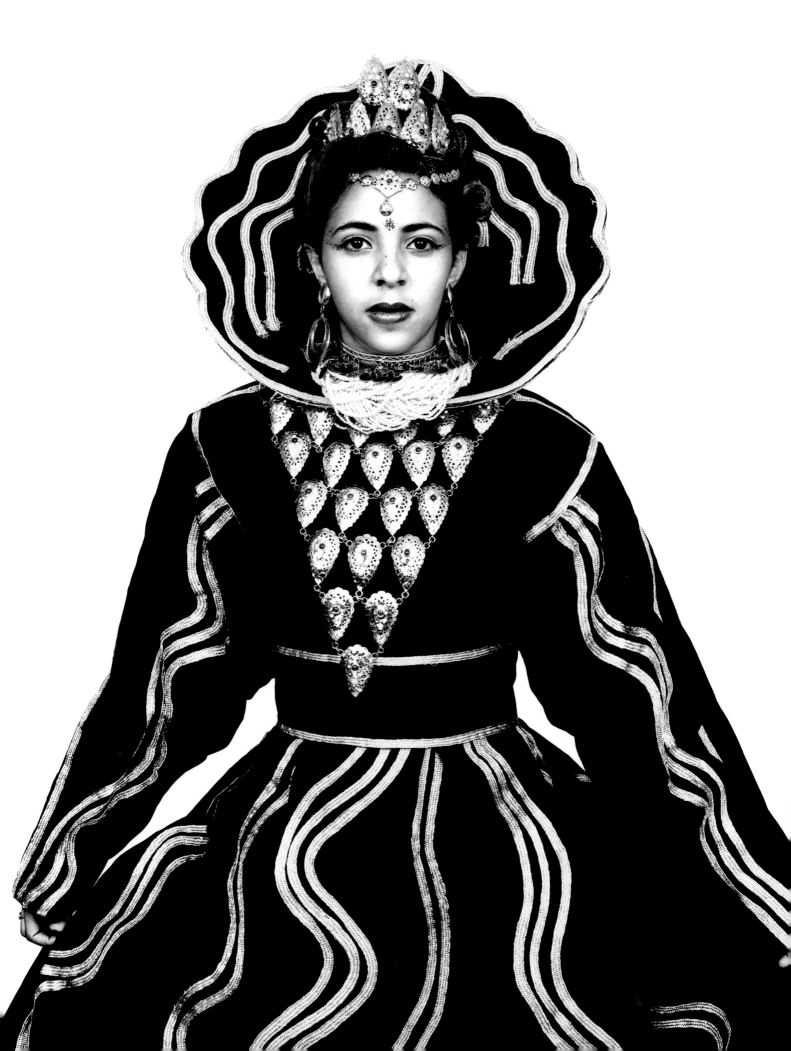

Trans-
sexuals
(Untitled)
2001

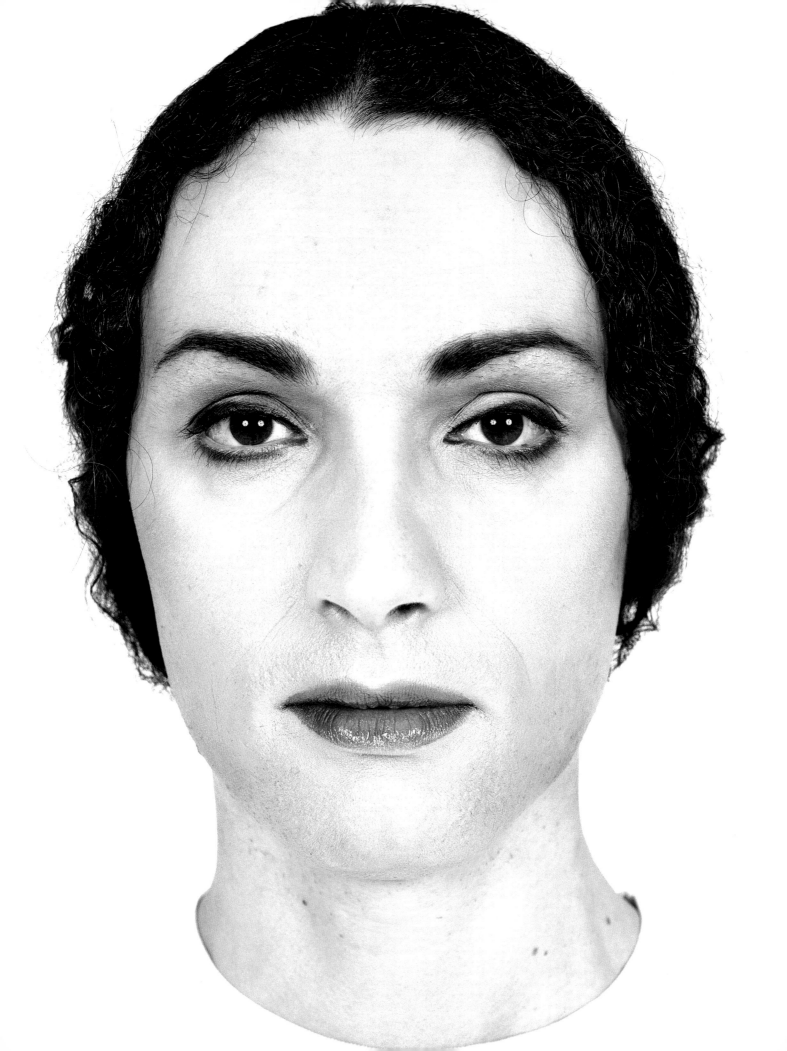

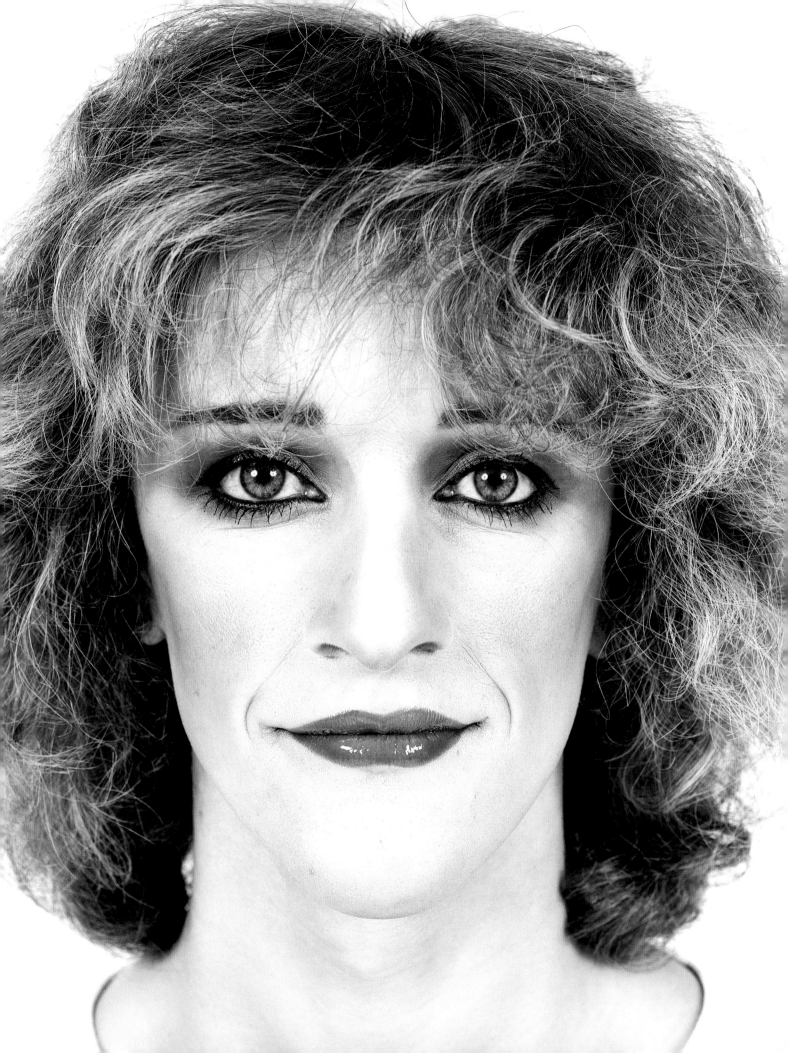

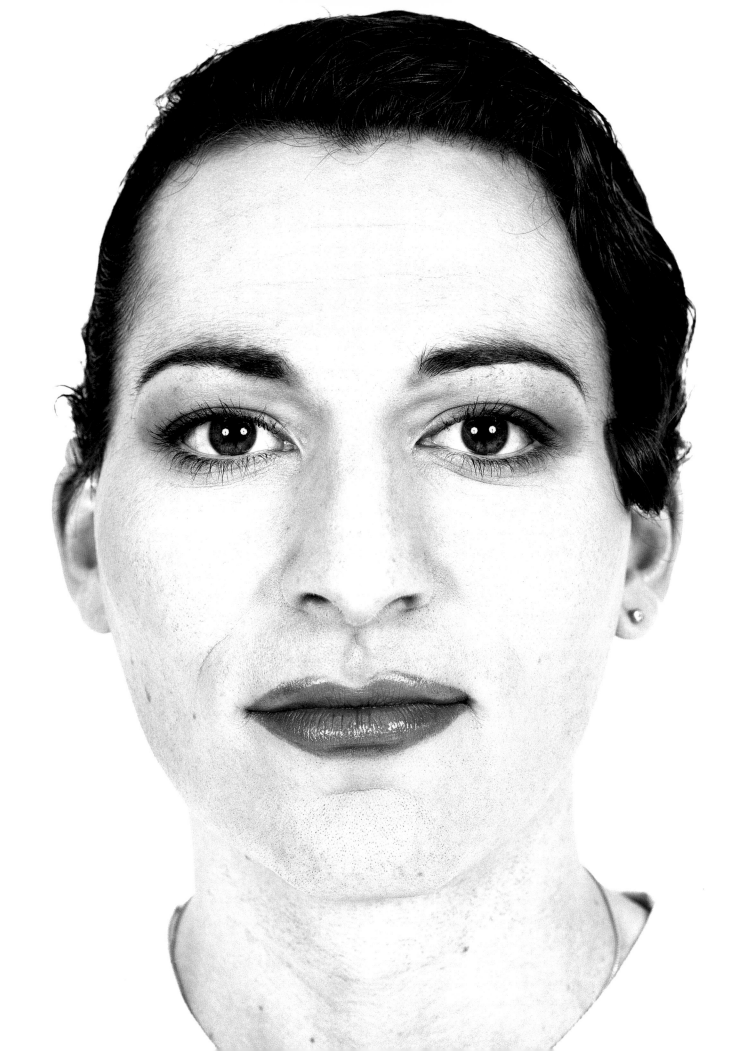

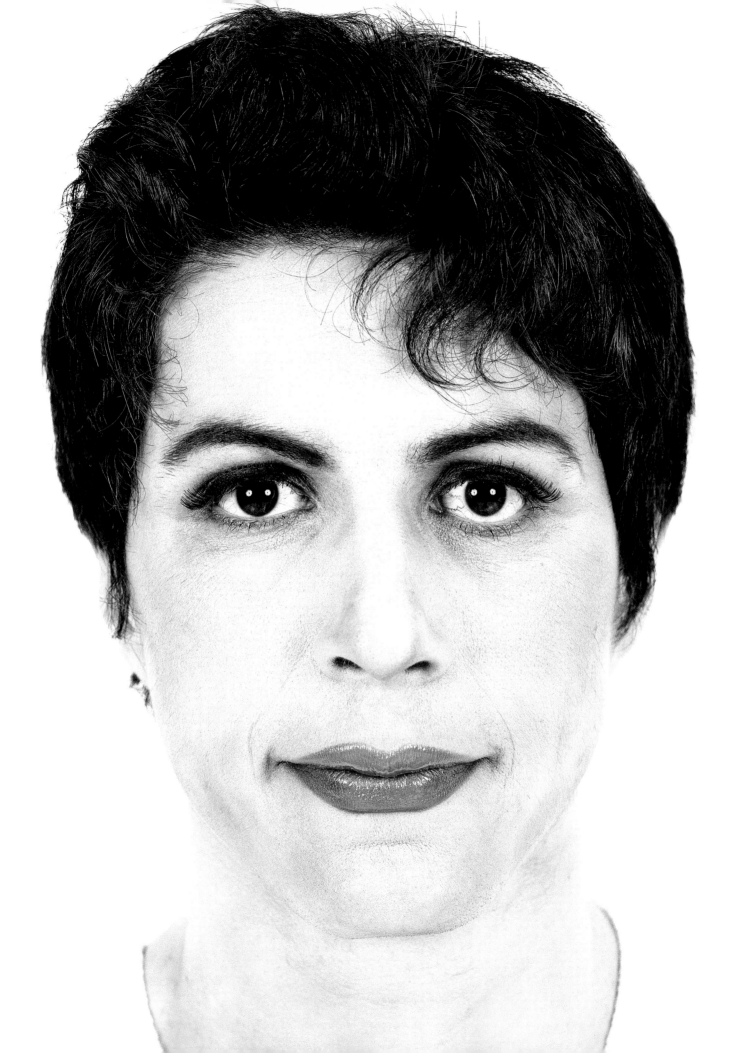

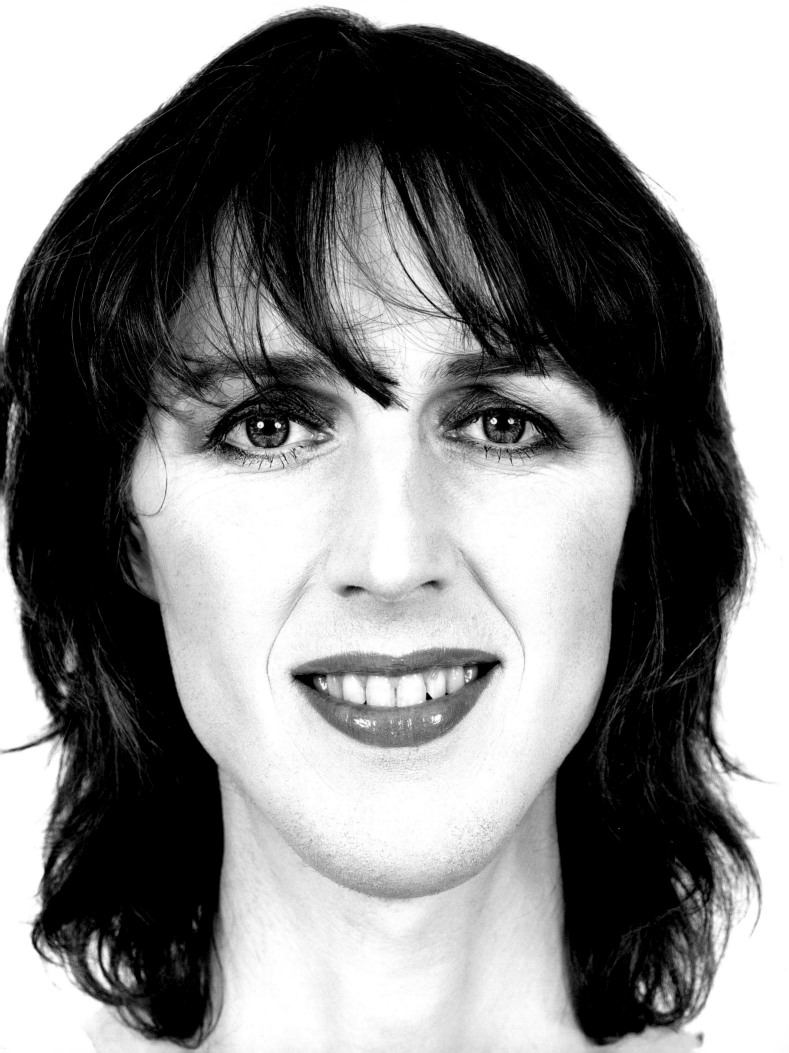

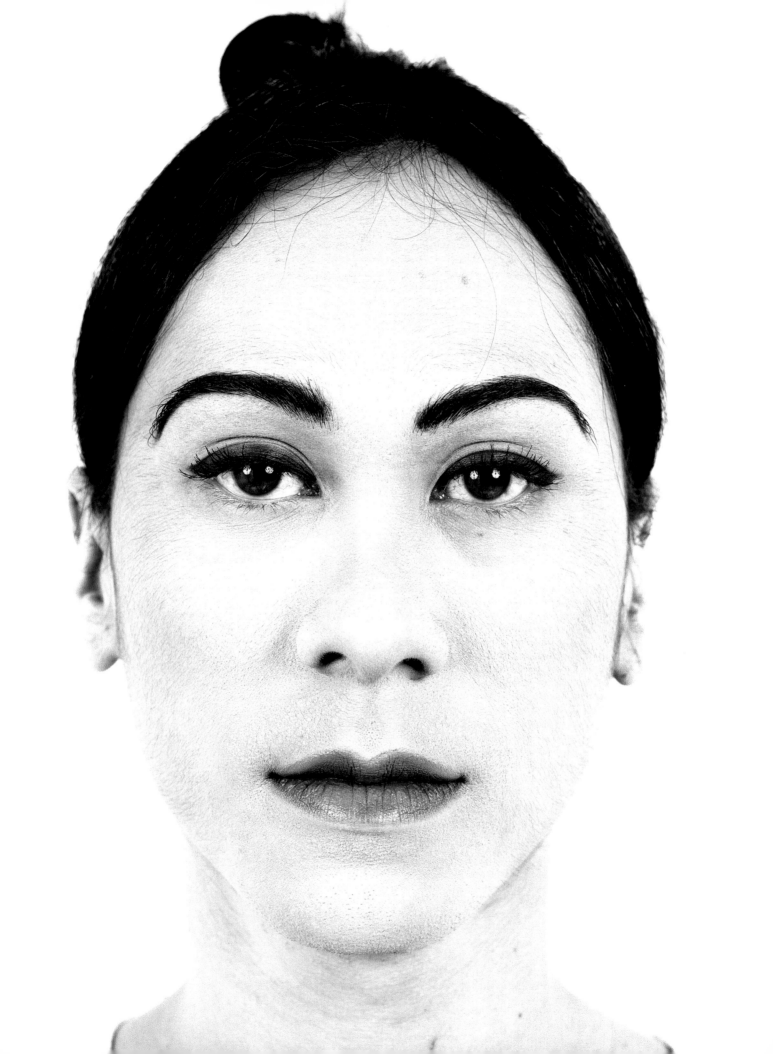

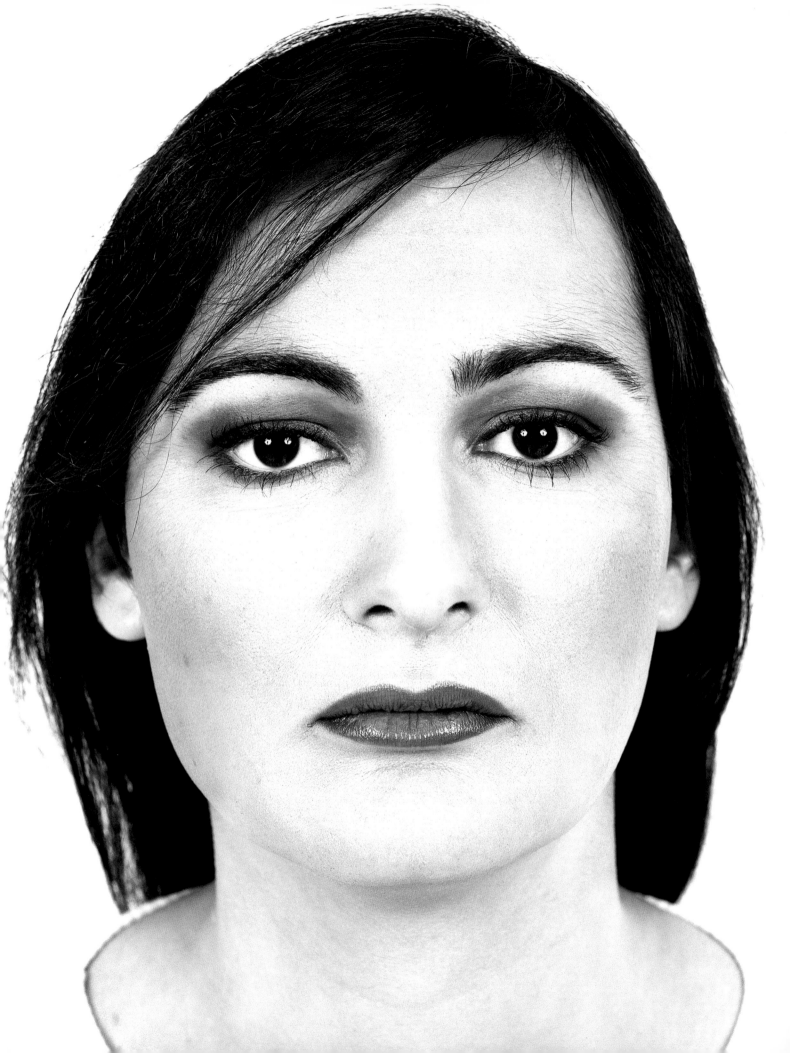

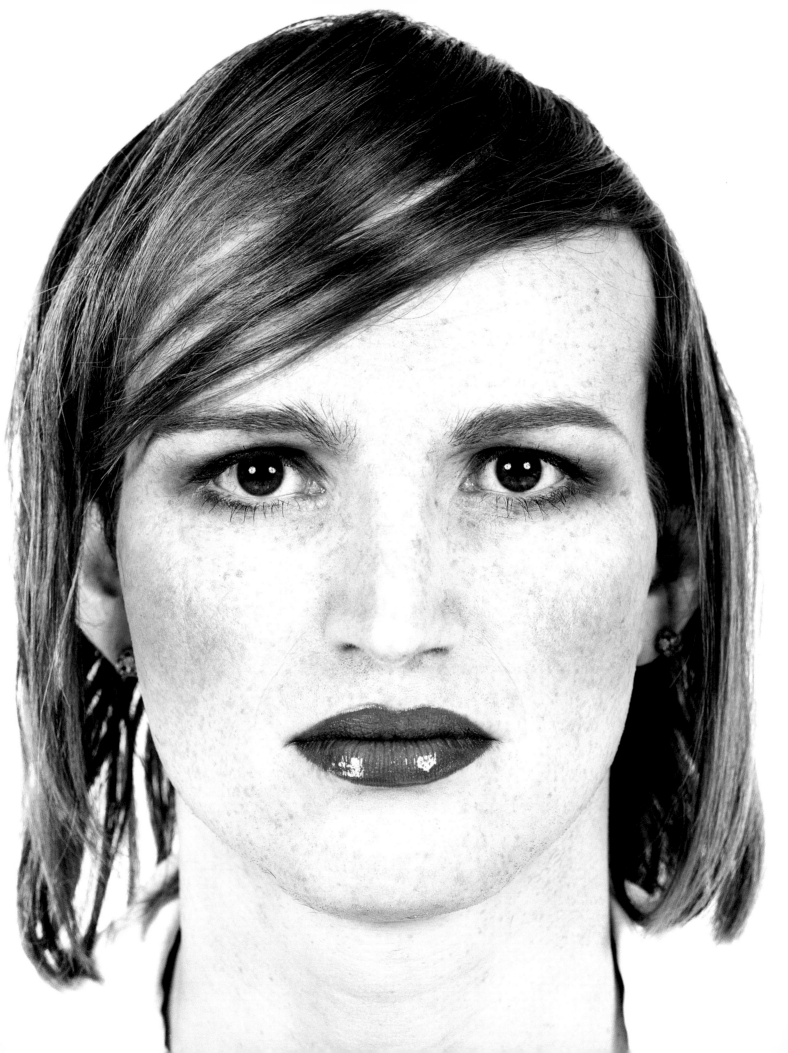

Black
Women I
(Untitled)
2001

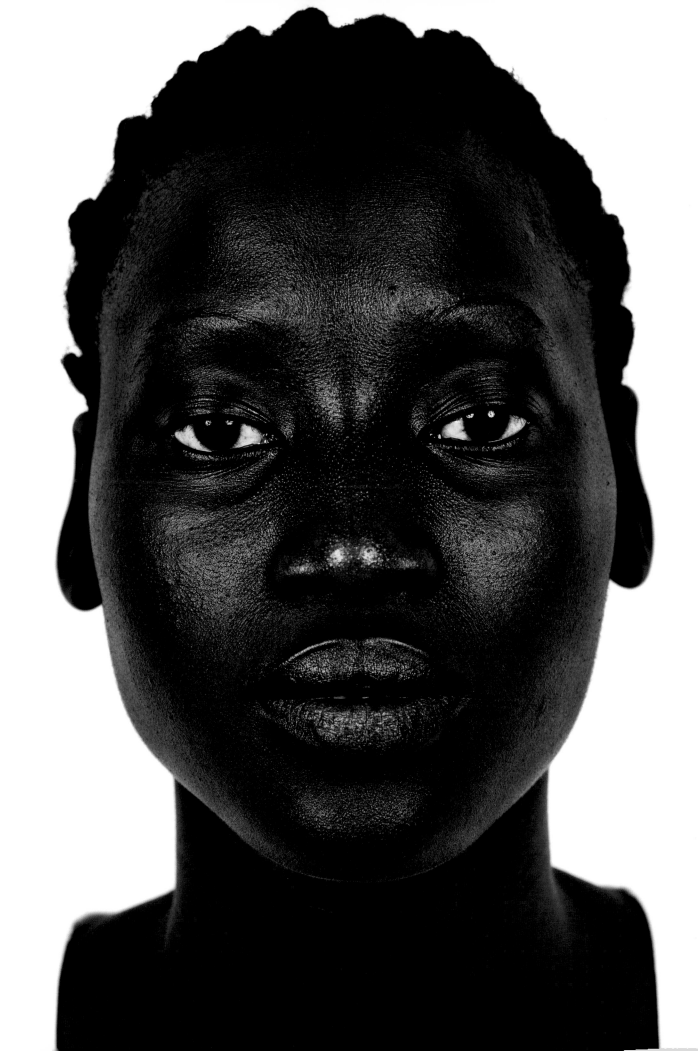

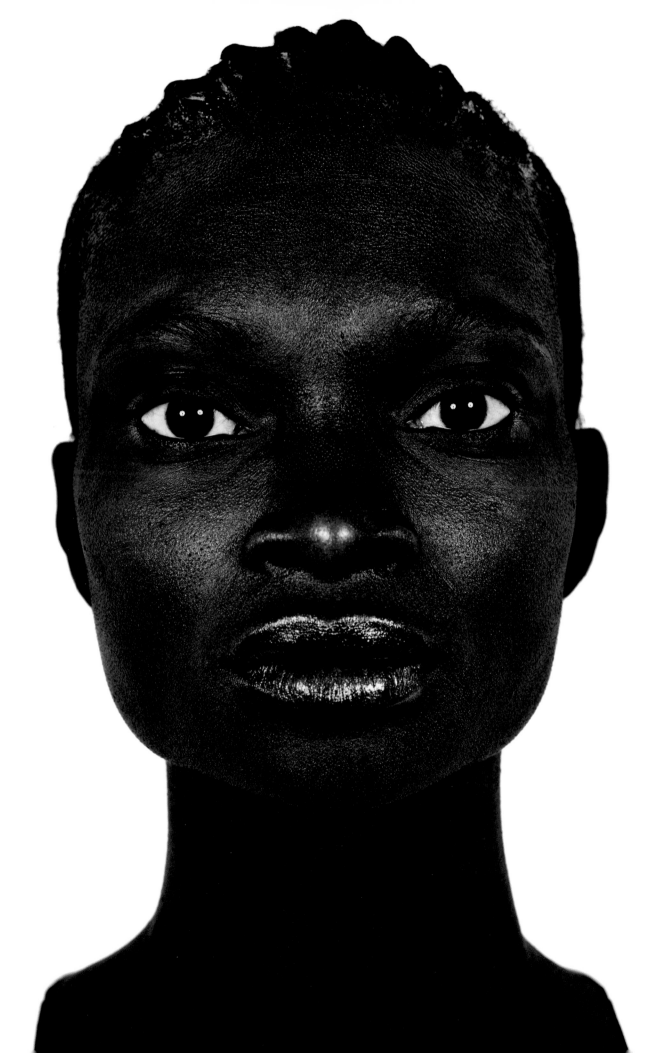

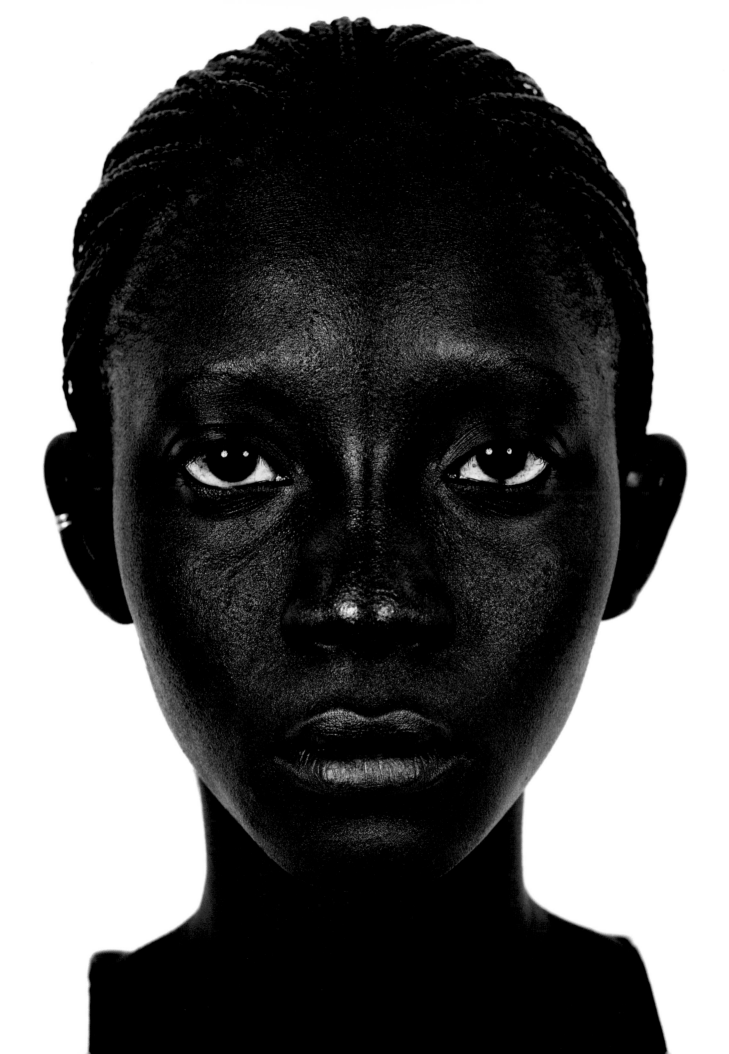

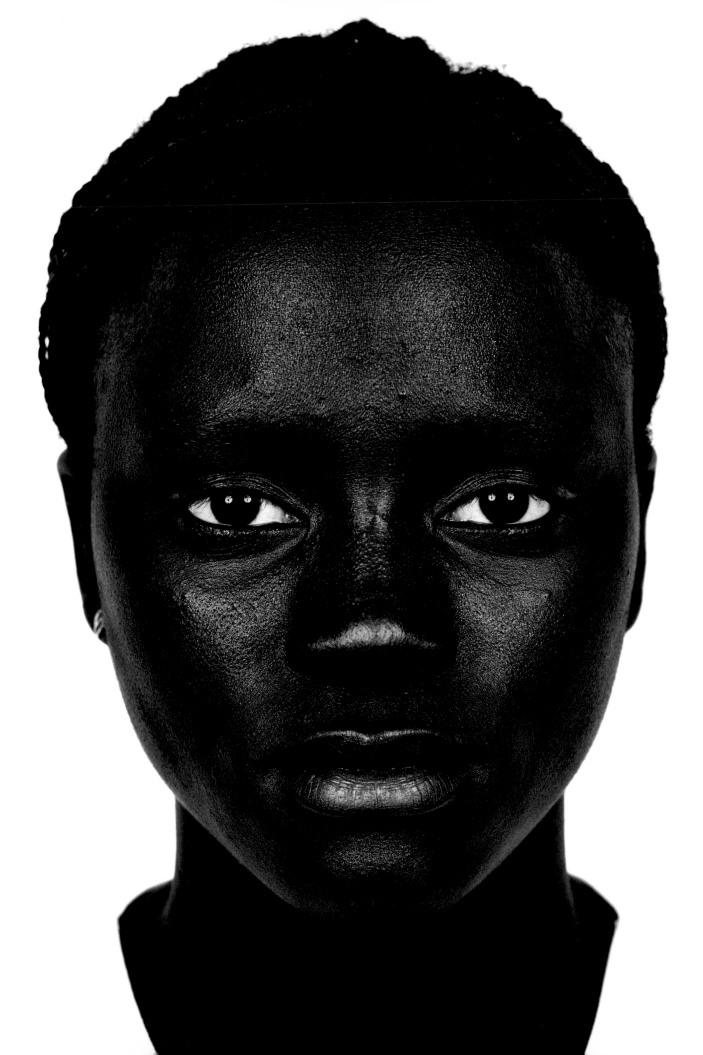

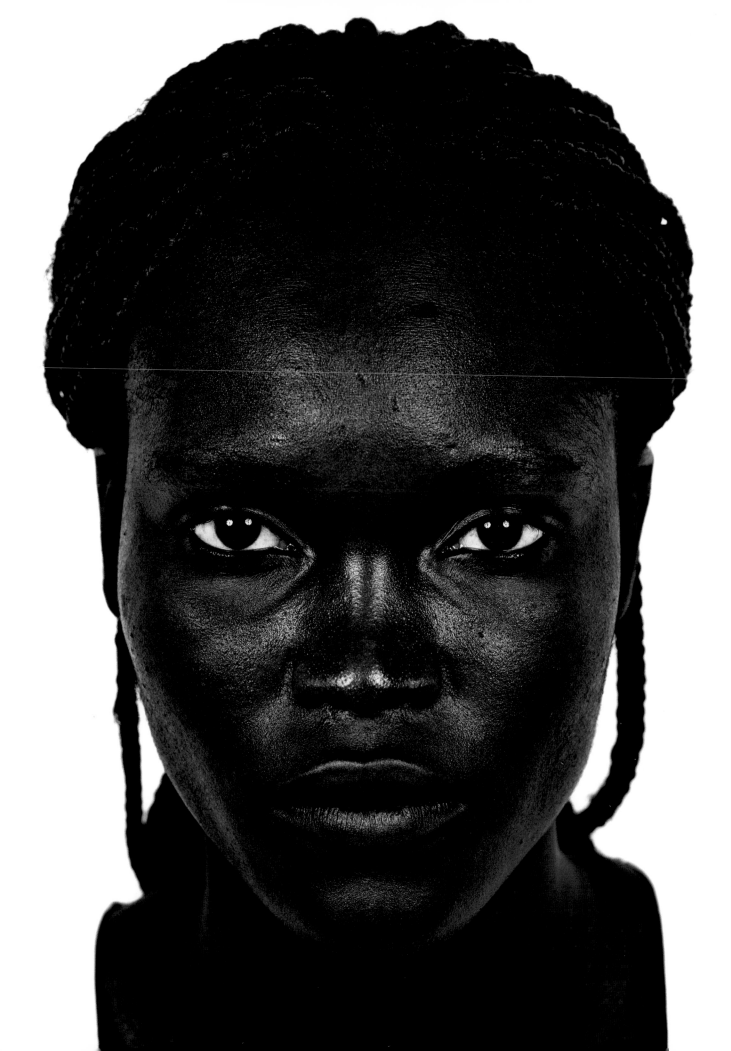

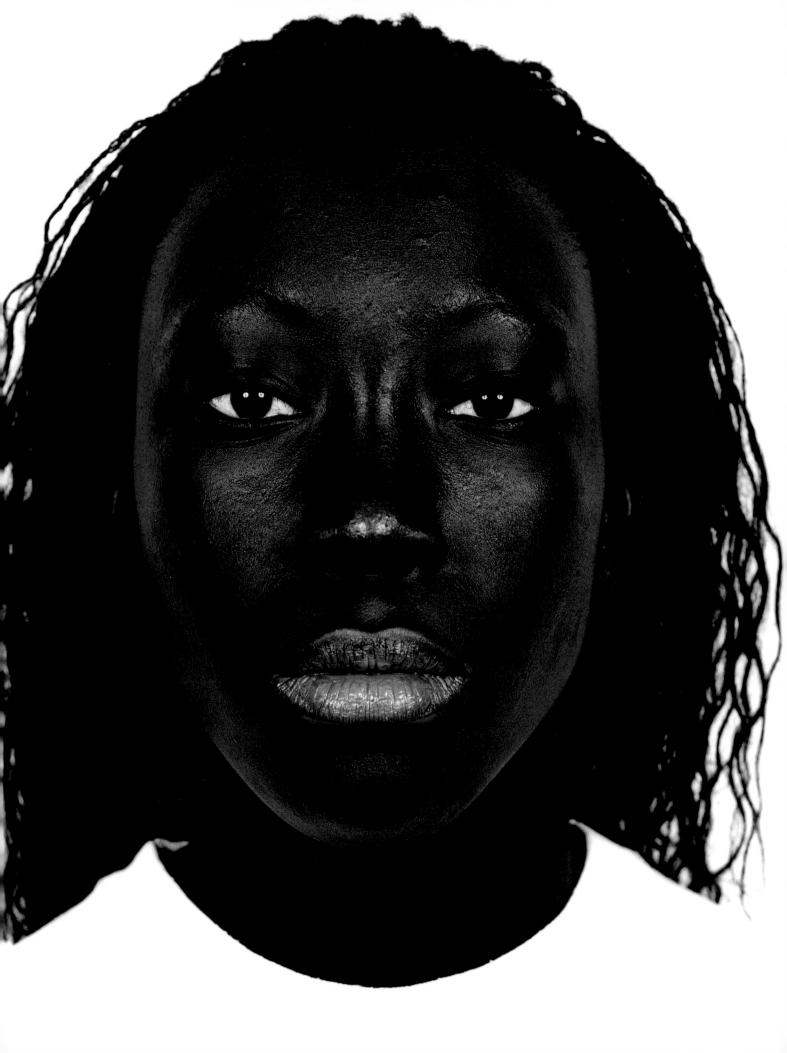

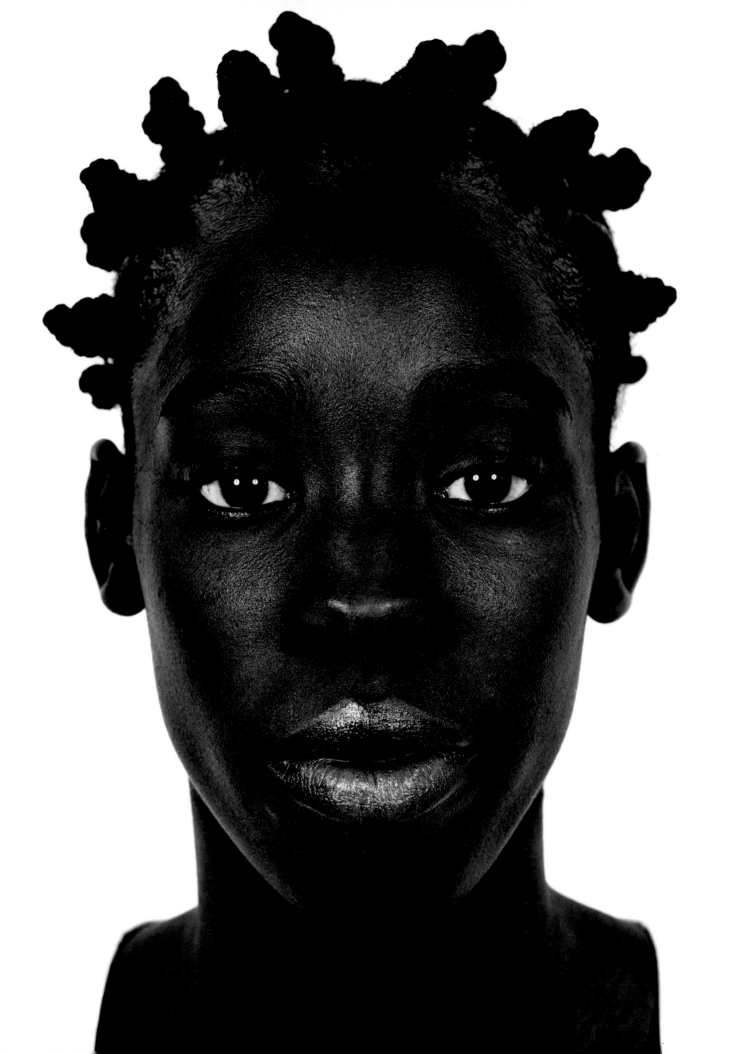

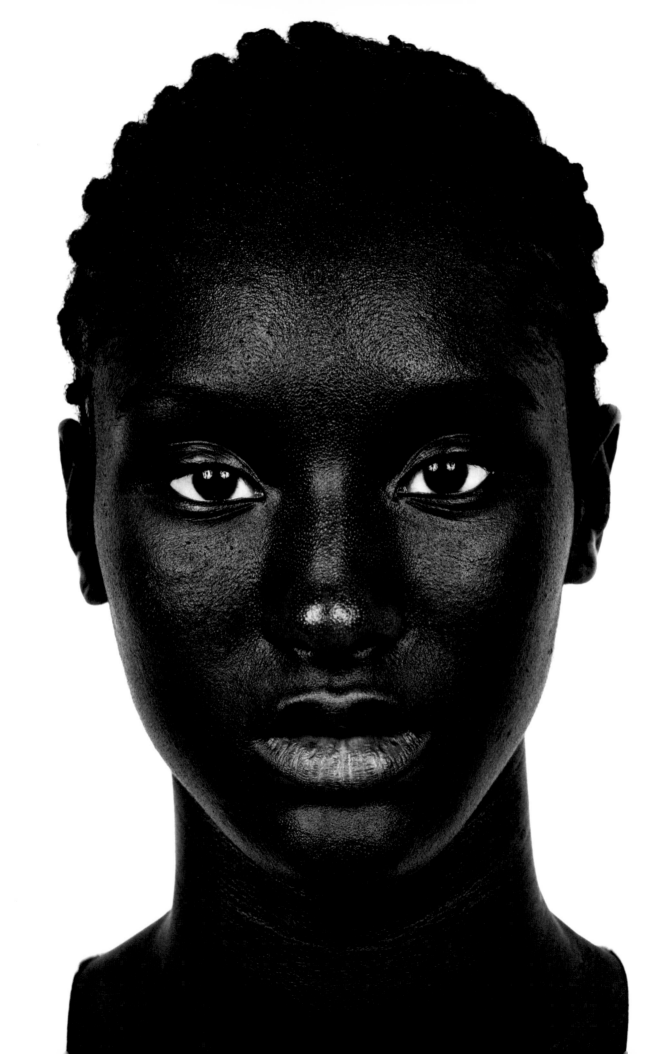

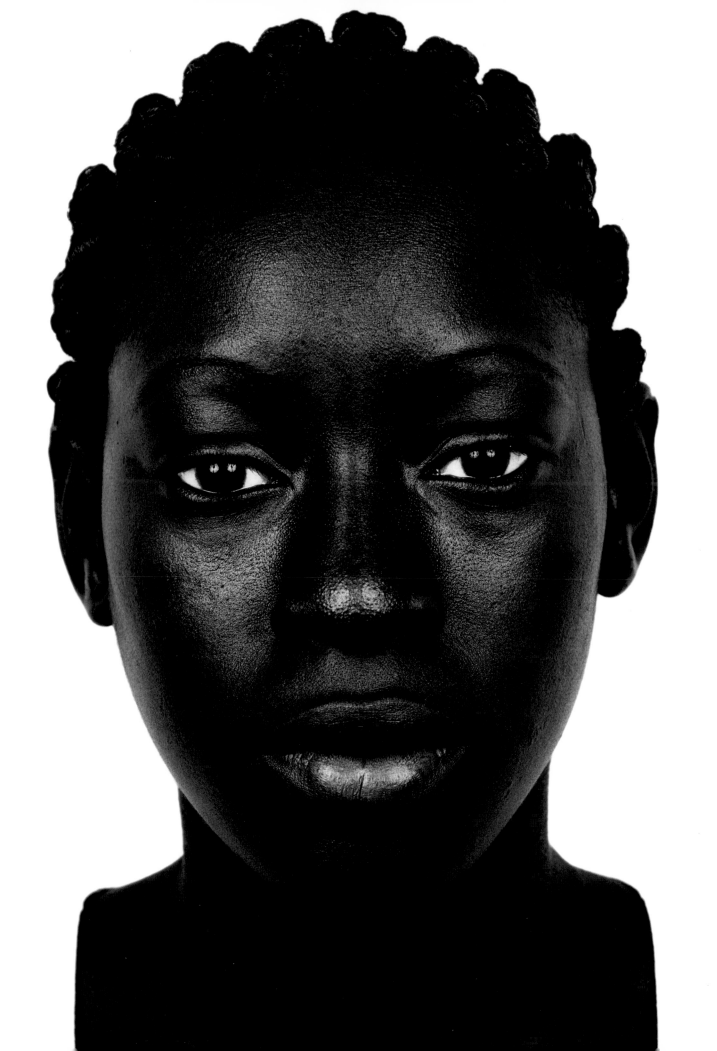

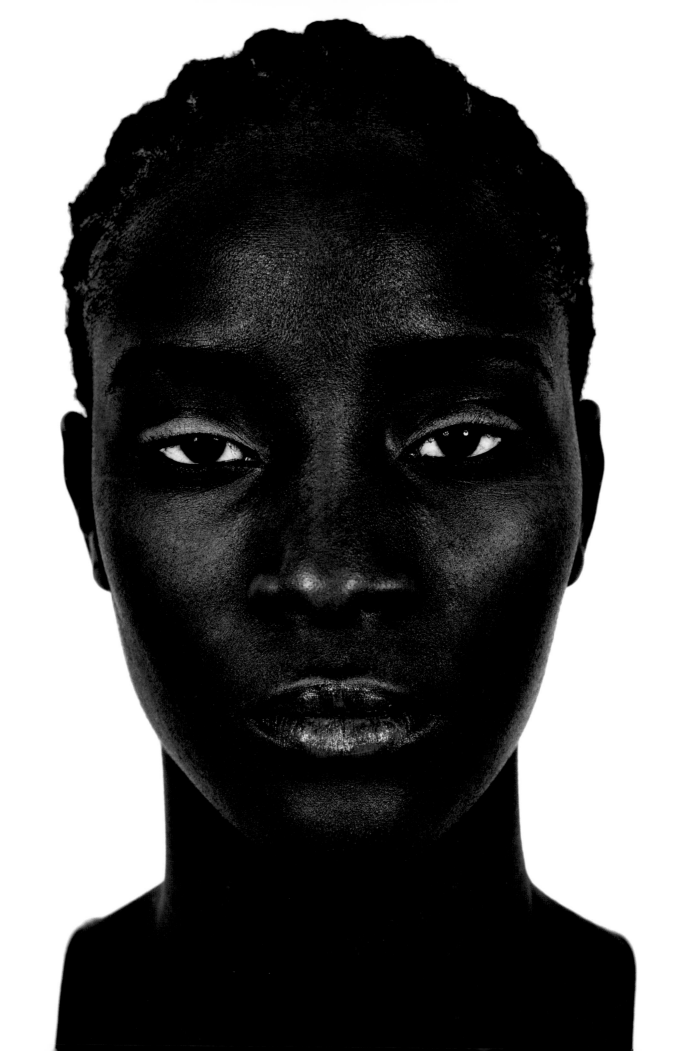

Models I

(Untitled)

2001

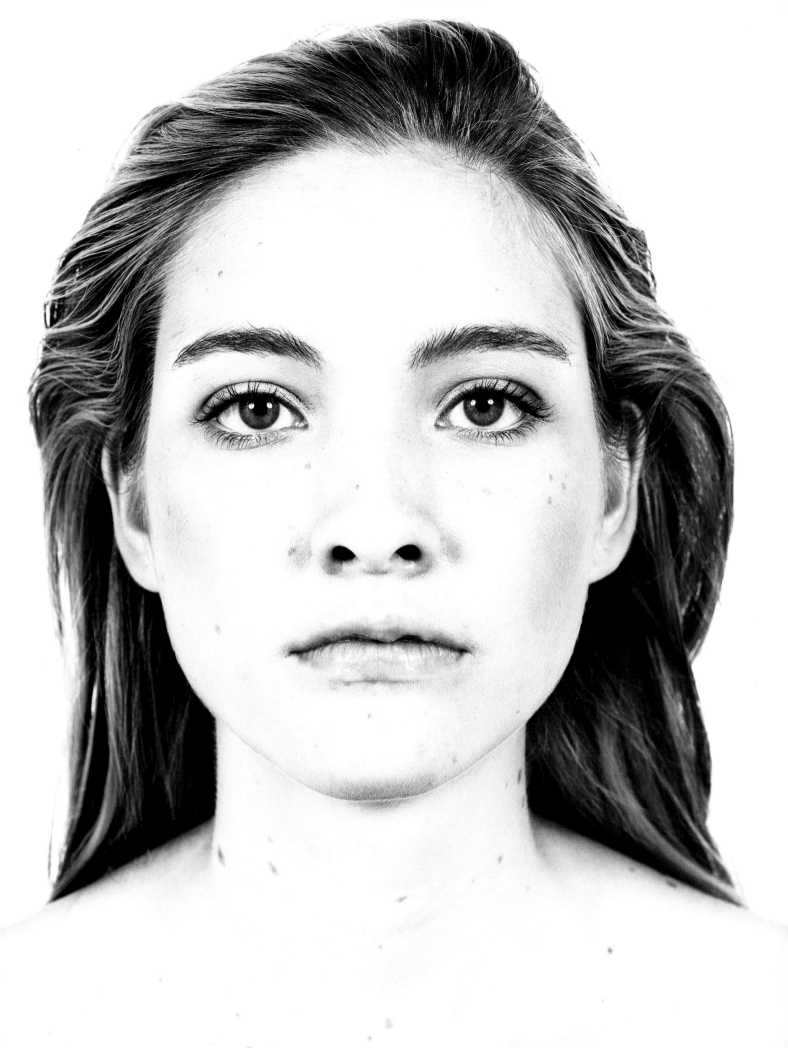

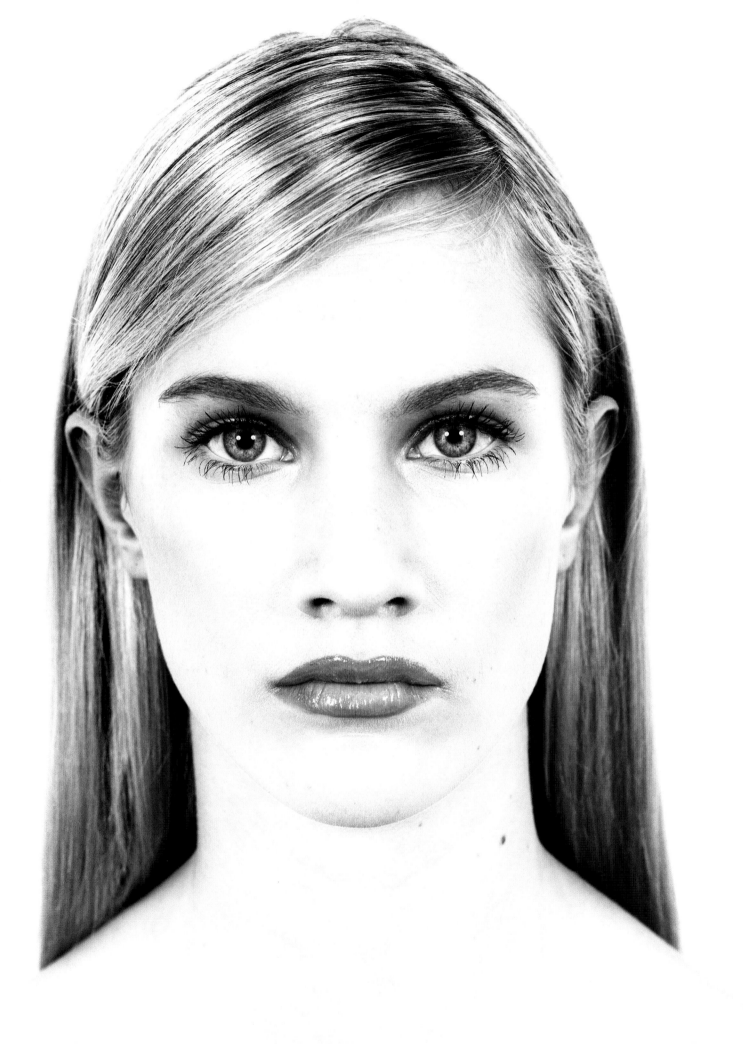

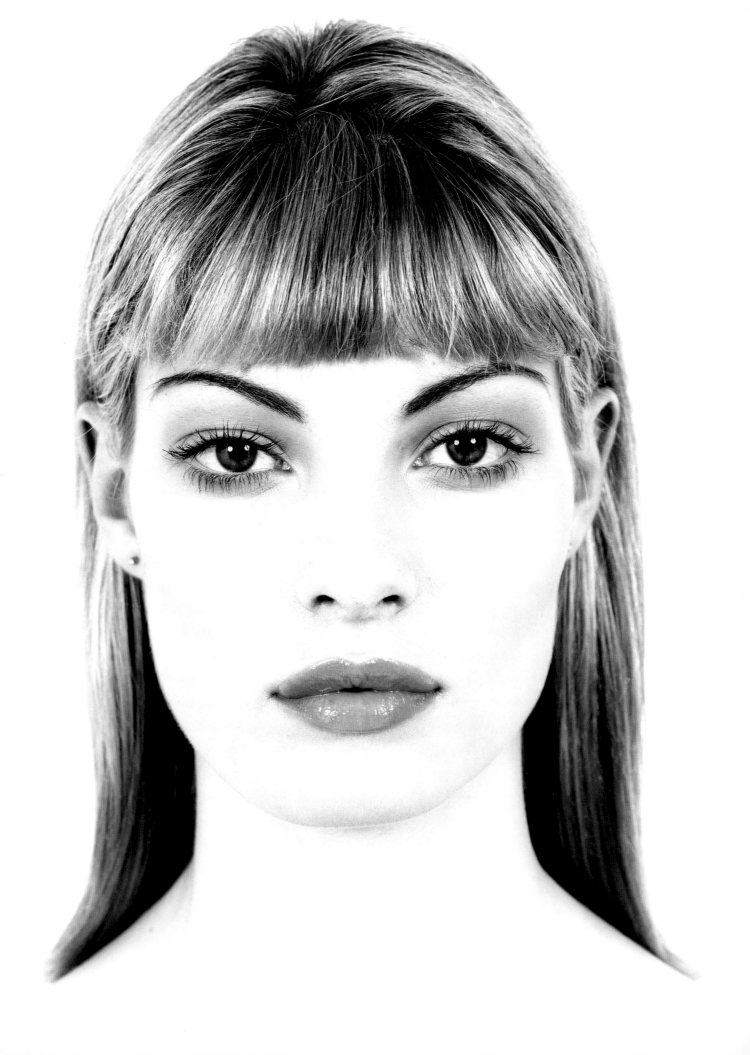

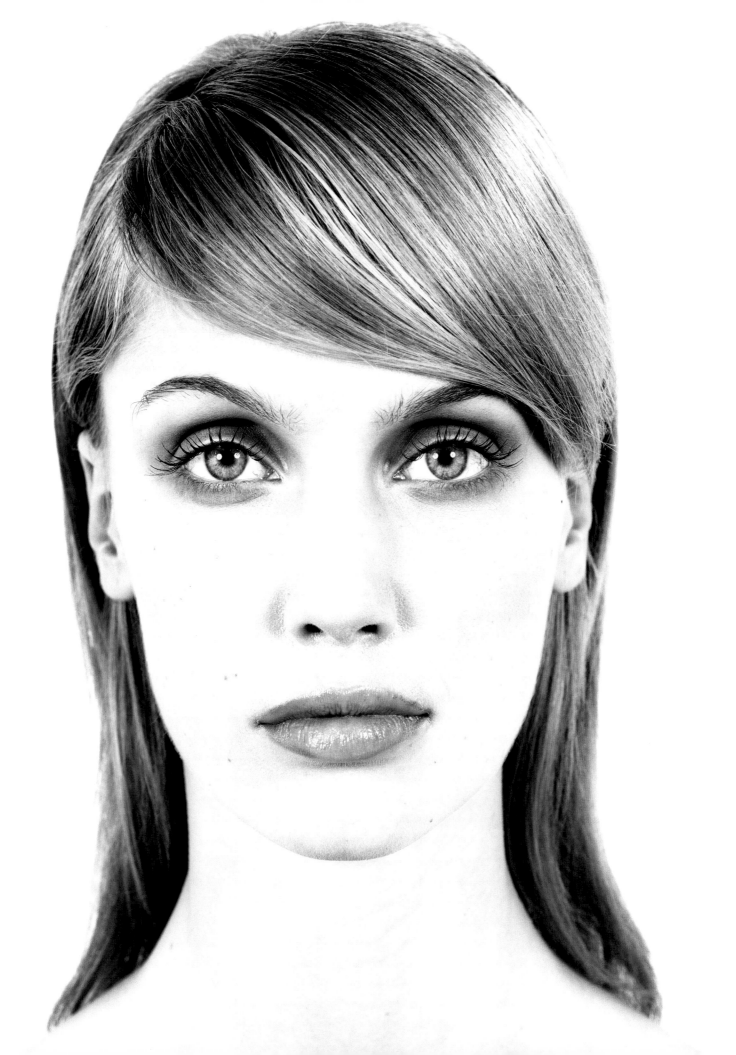

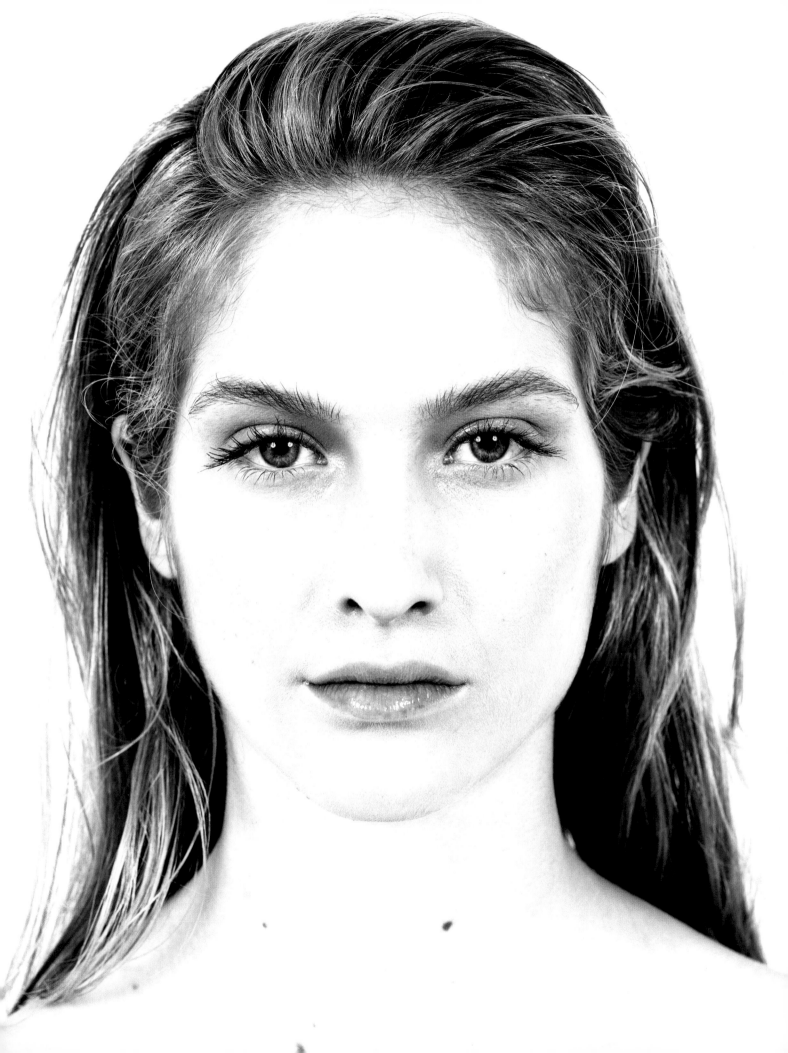

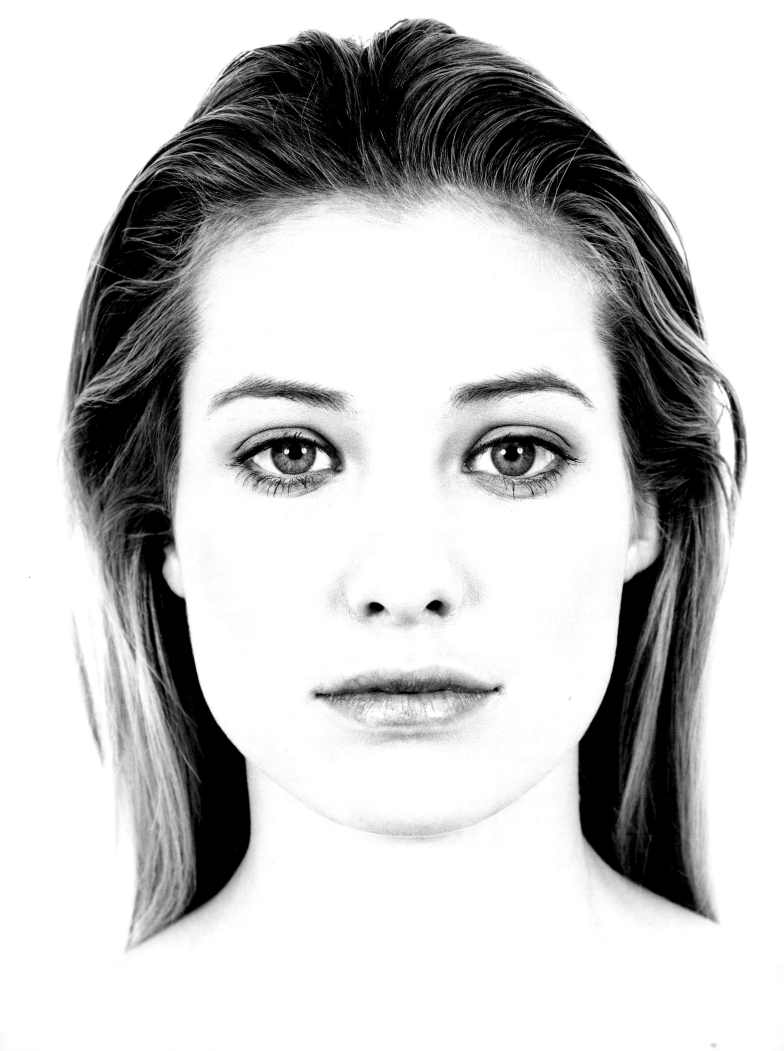

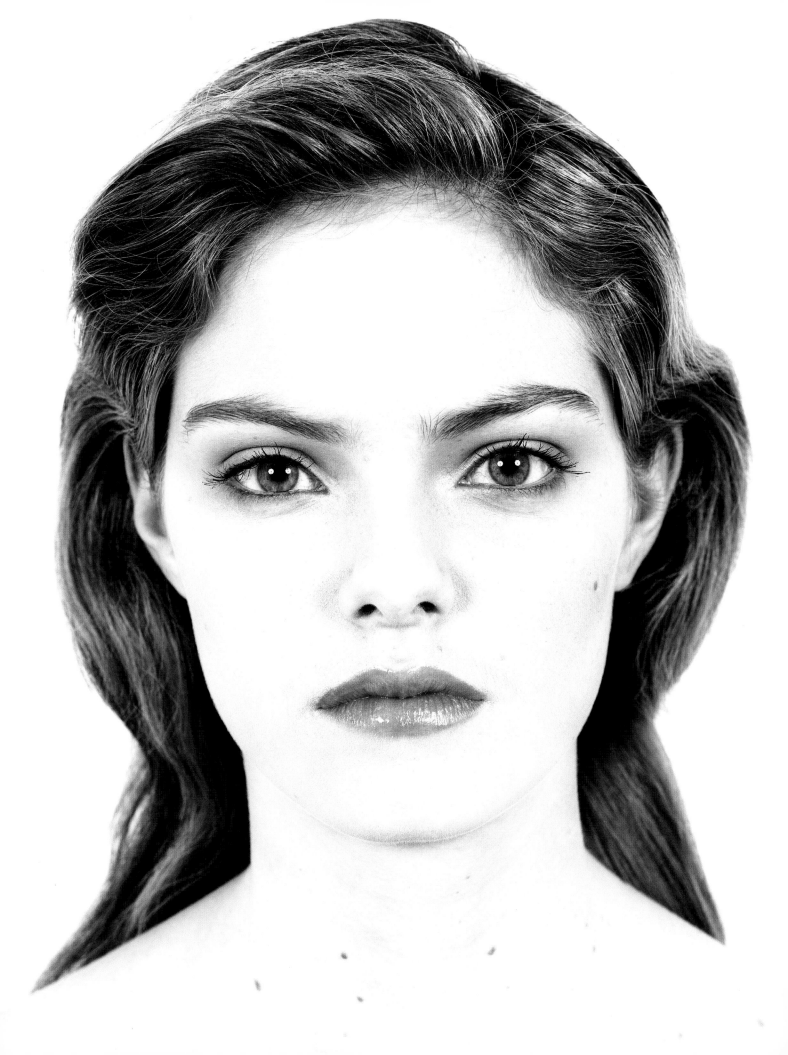

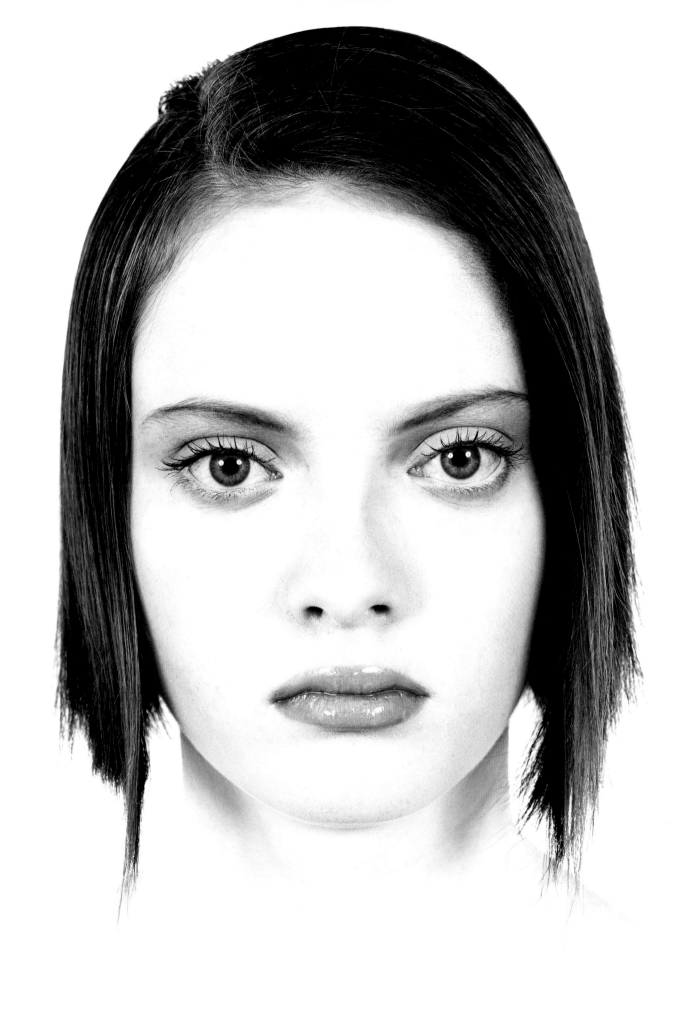

Engines

(Untitled)

2002

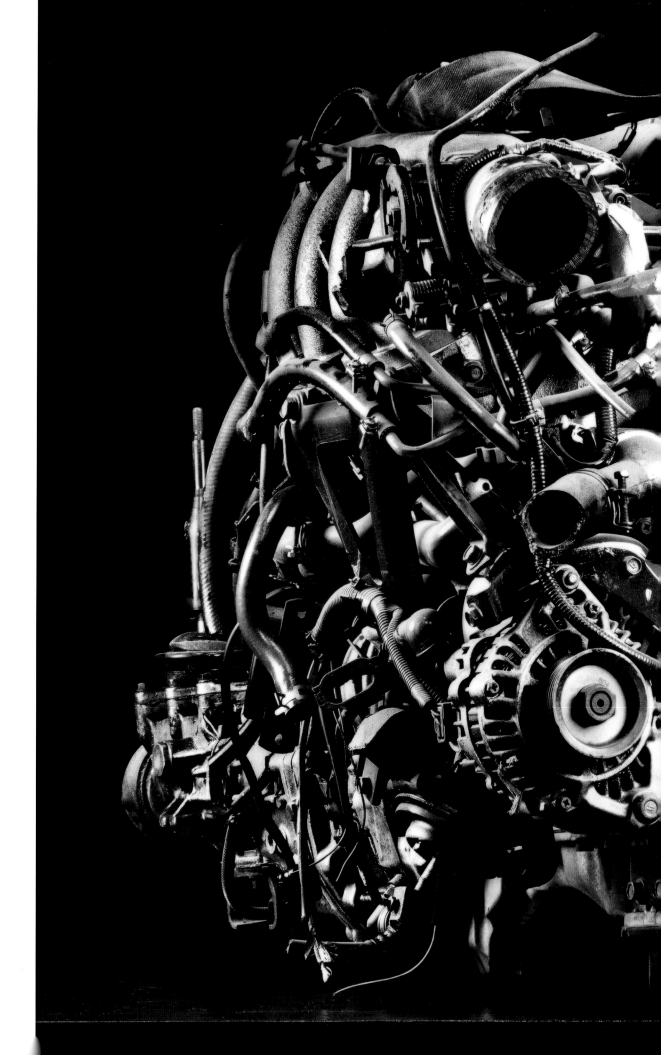

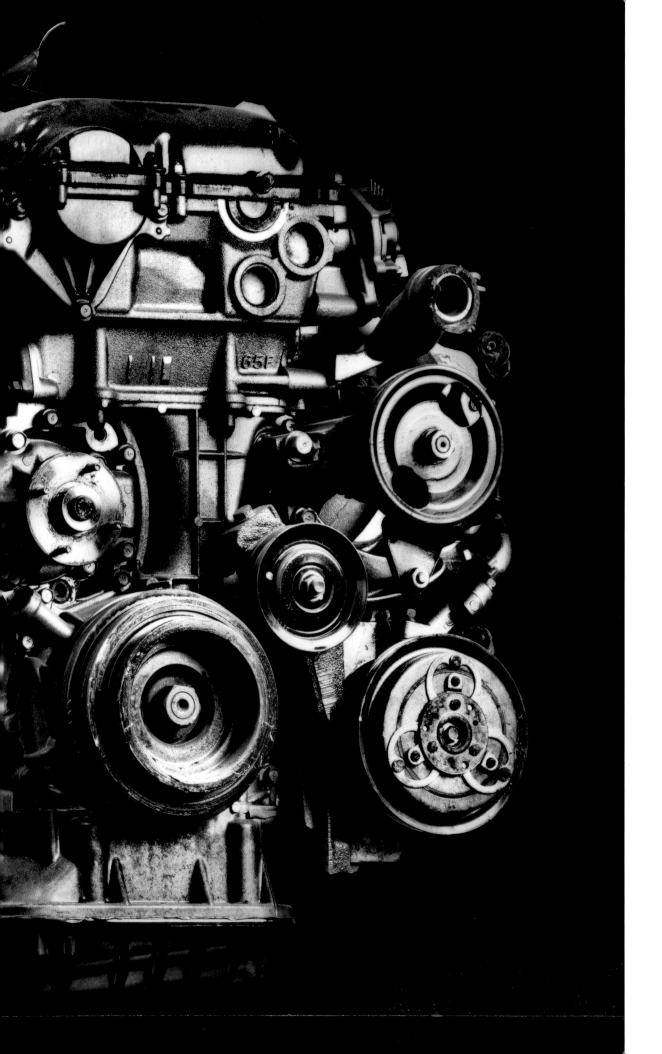

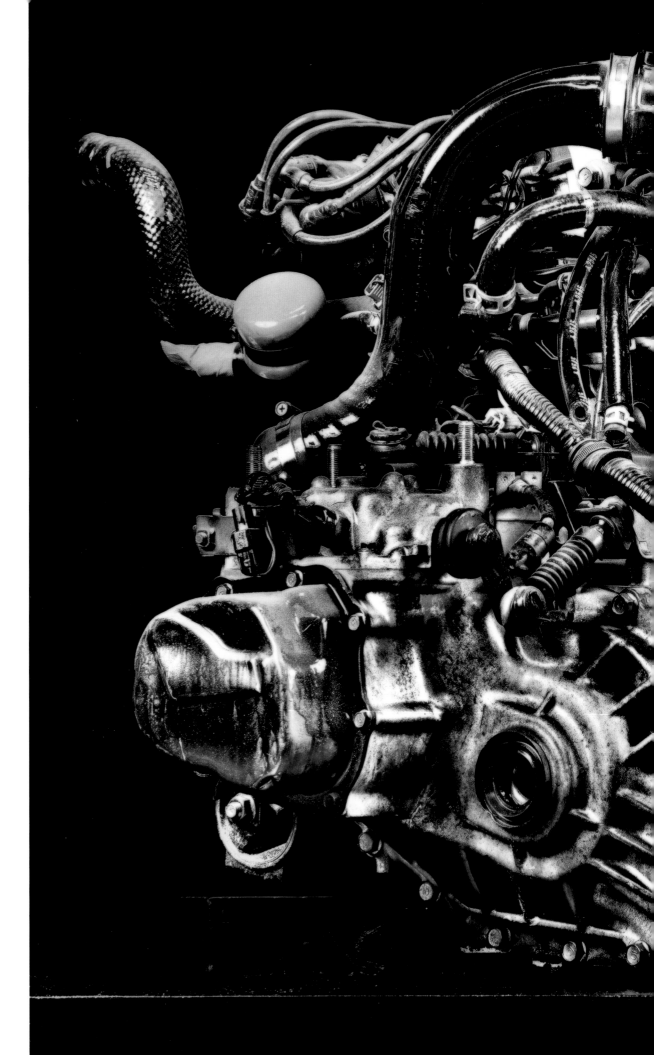

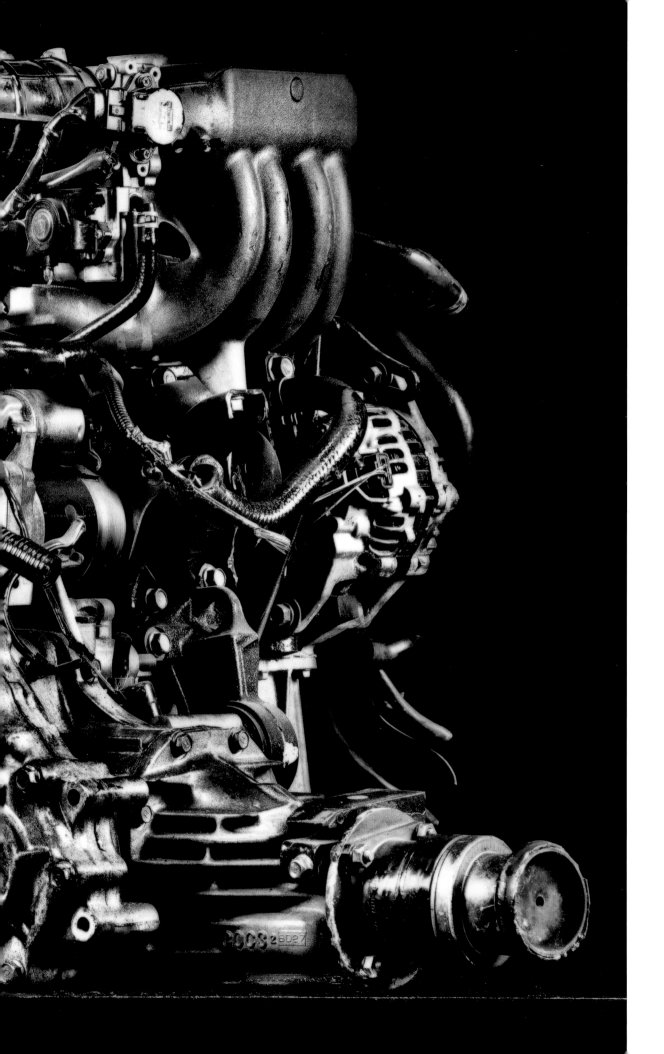

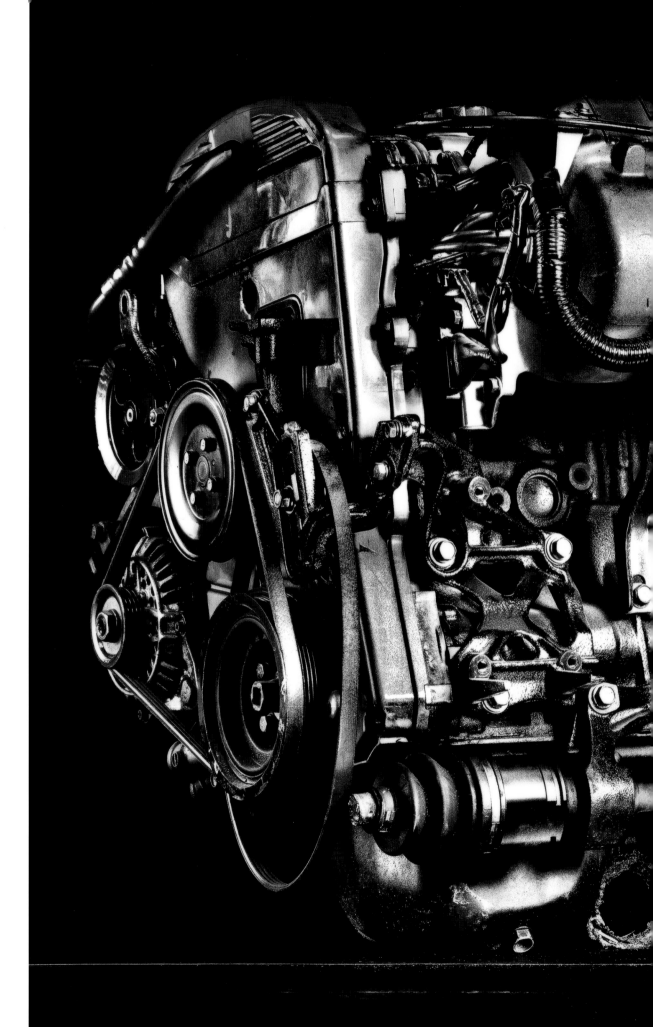

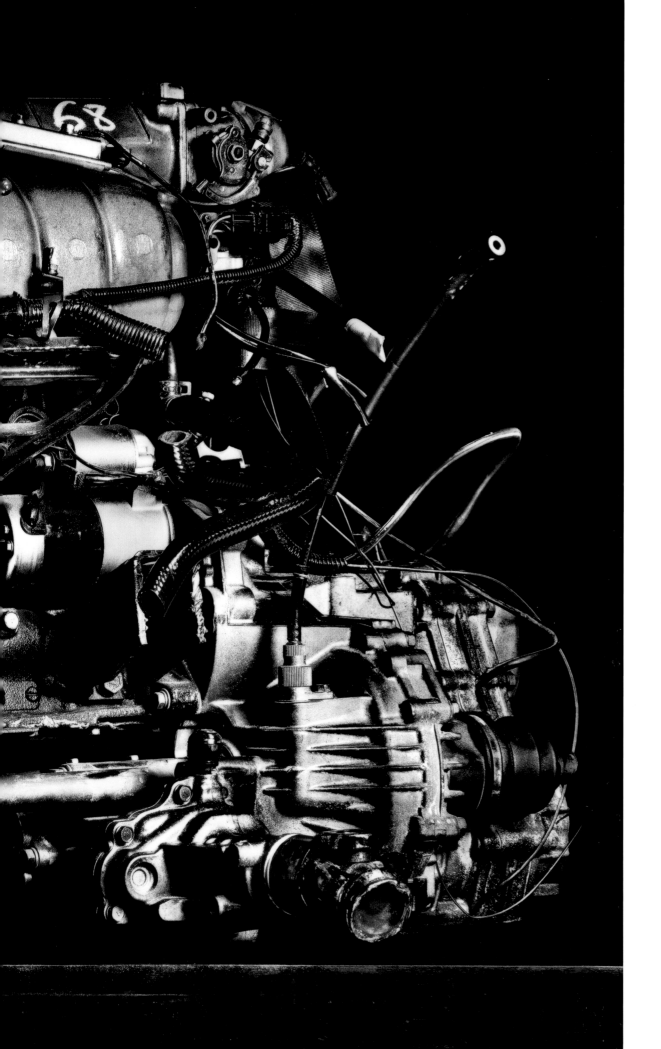

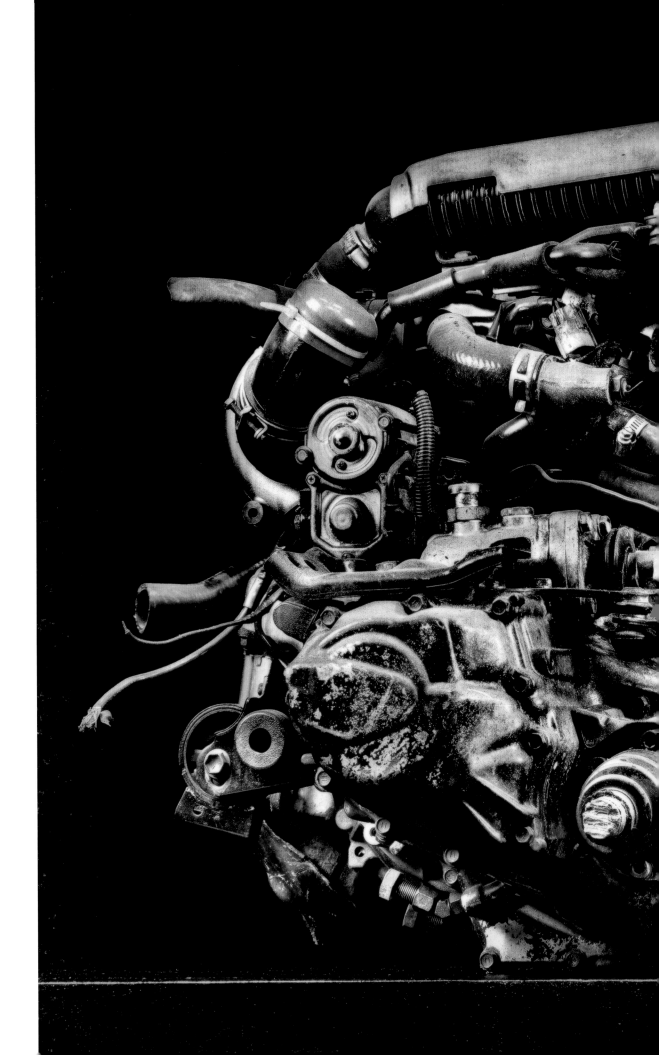

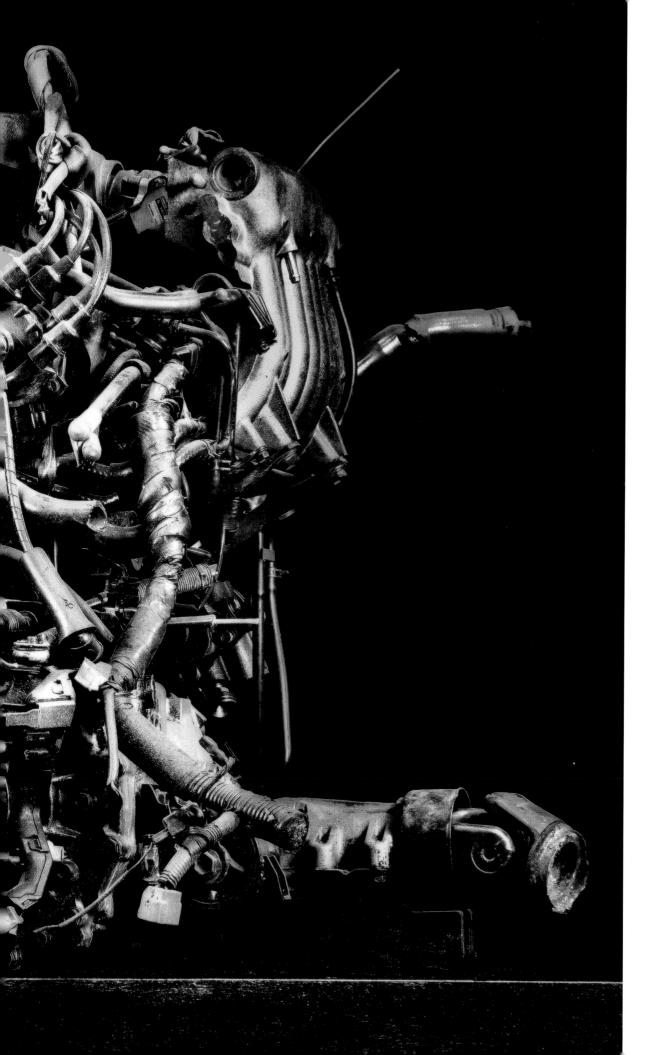

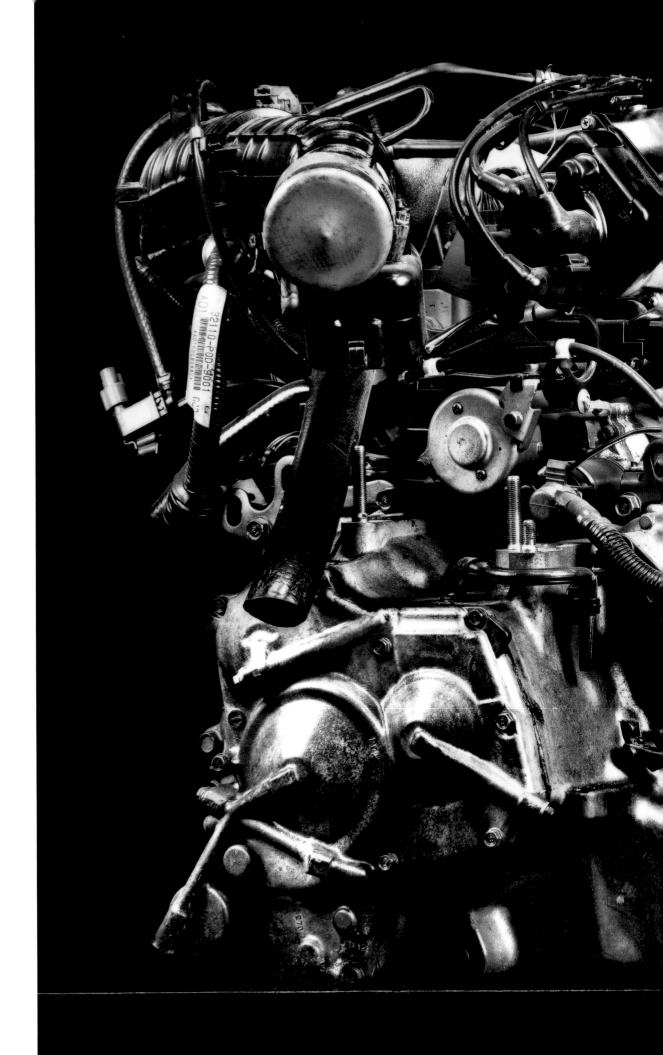

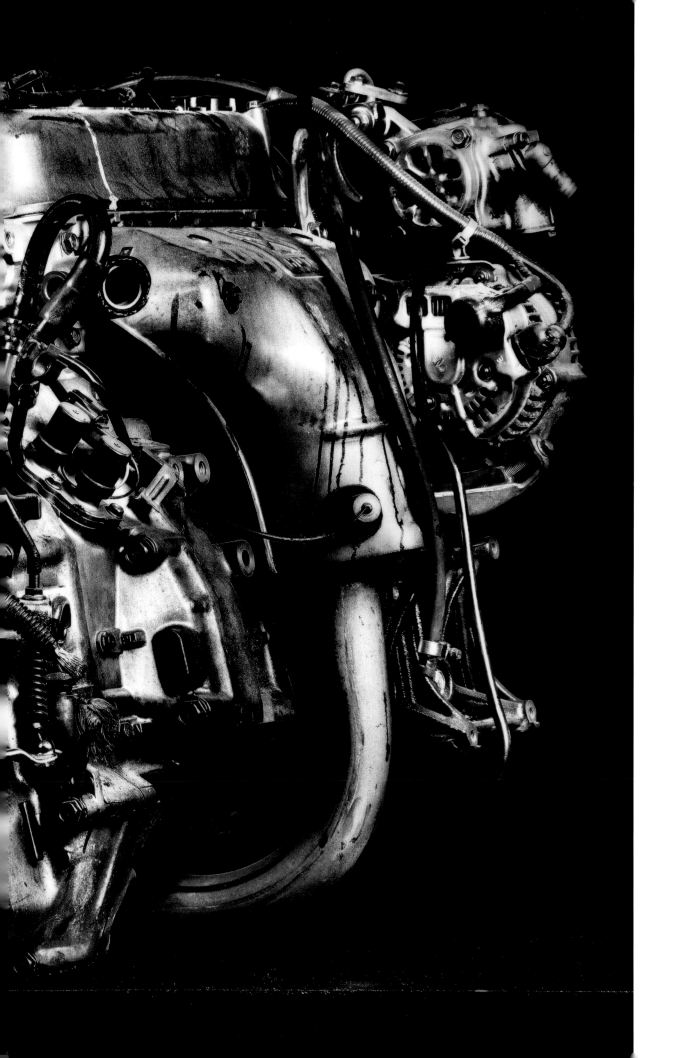

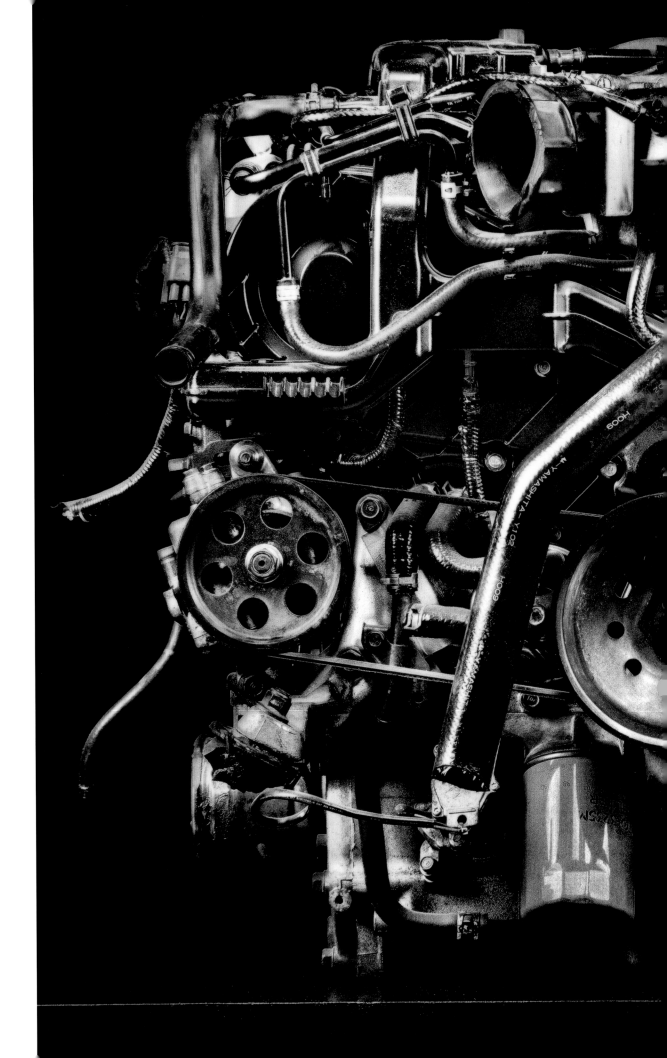

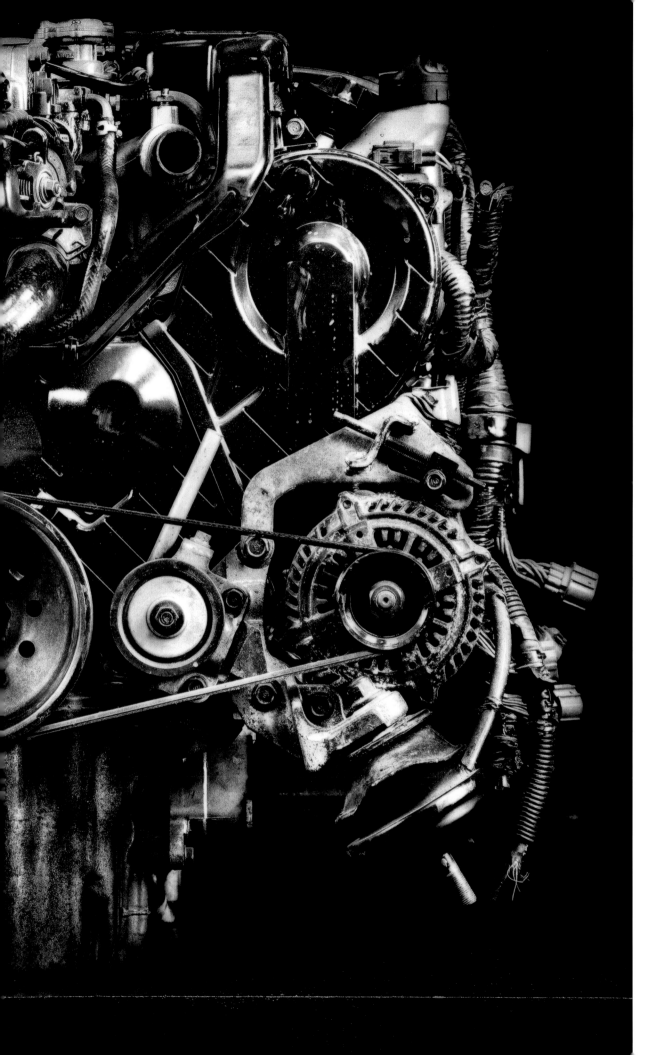

Mannequins

(Untitled)
2003

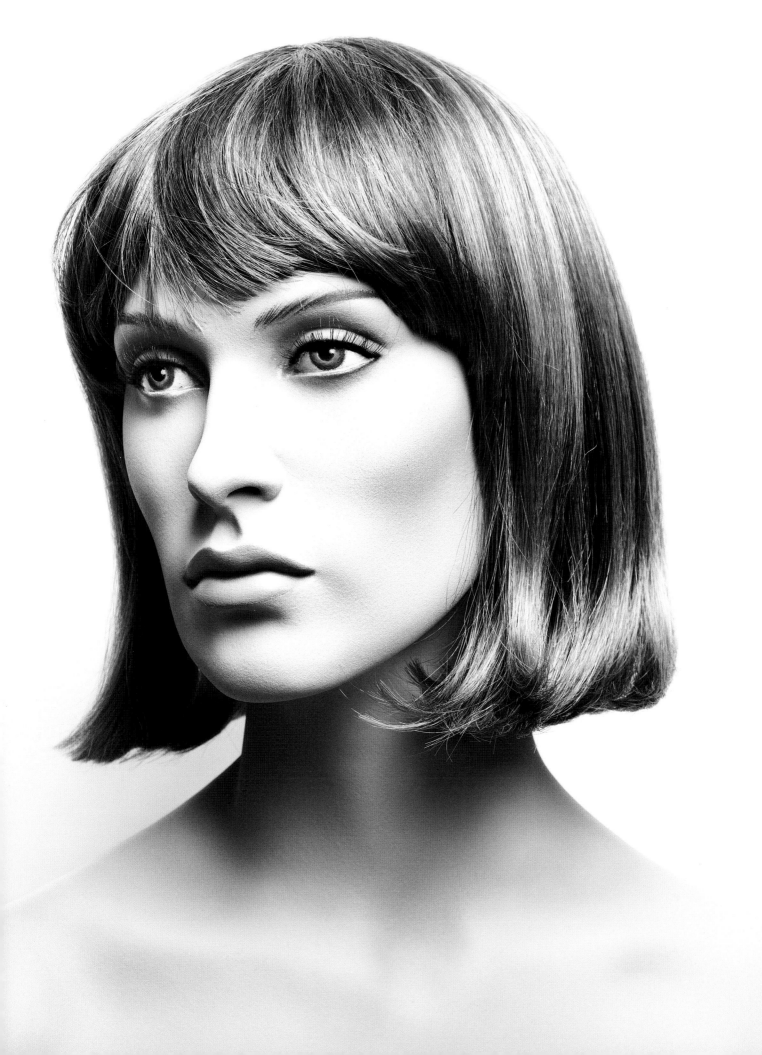

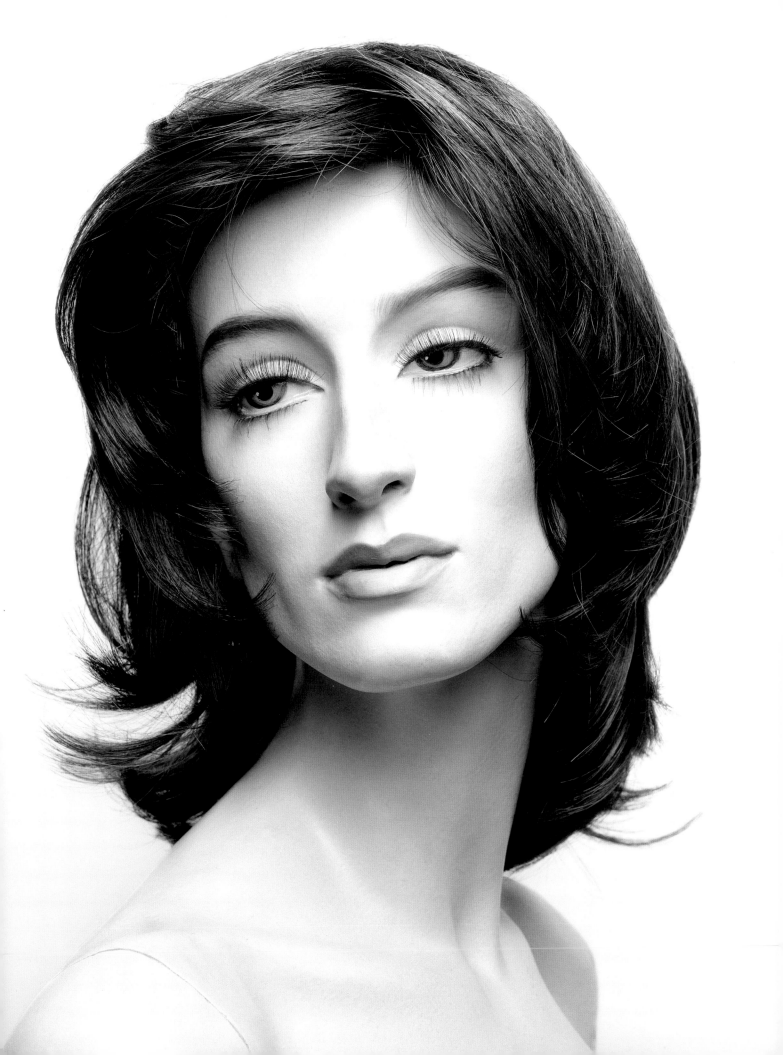

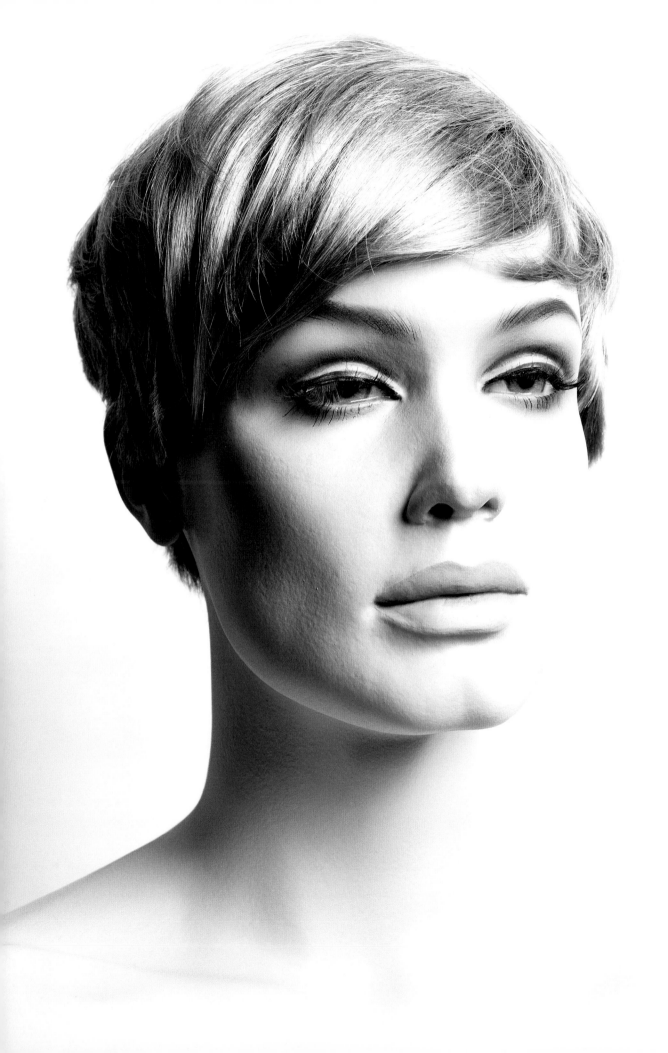

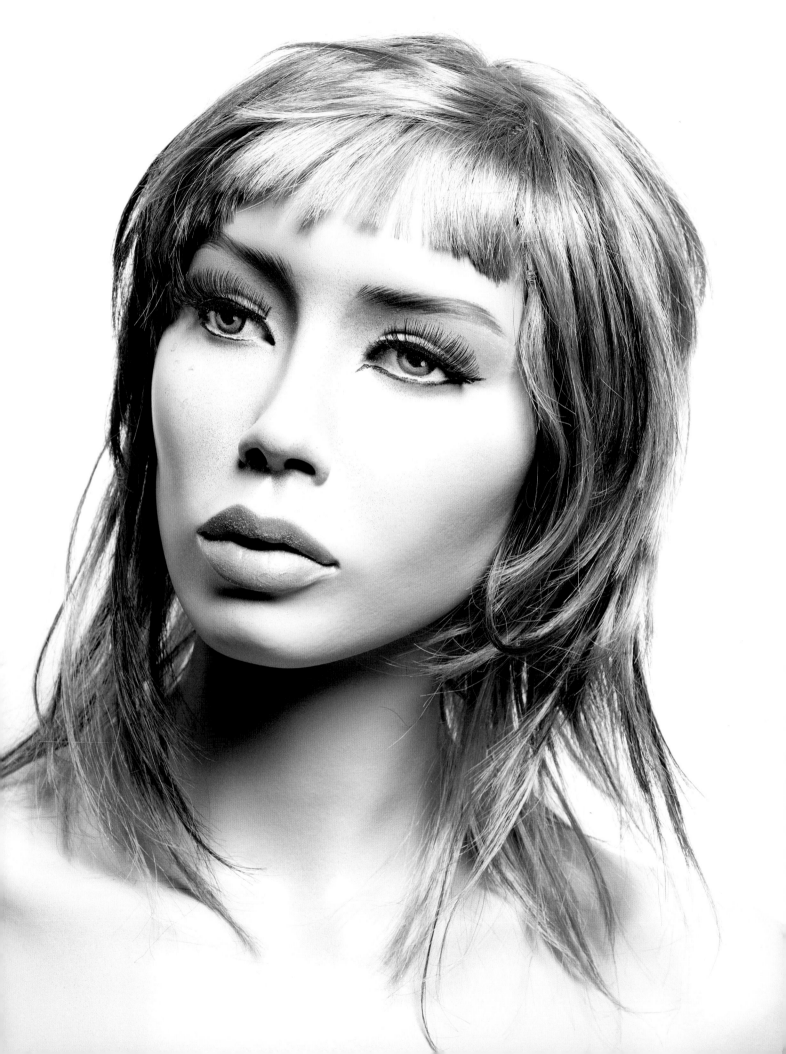

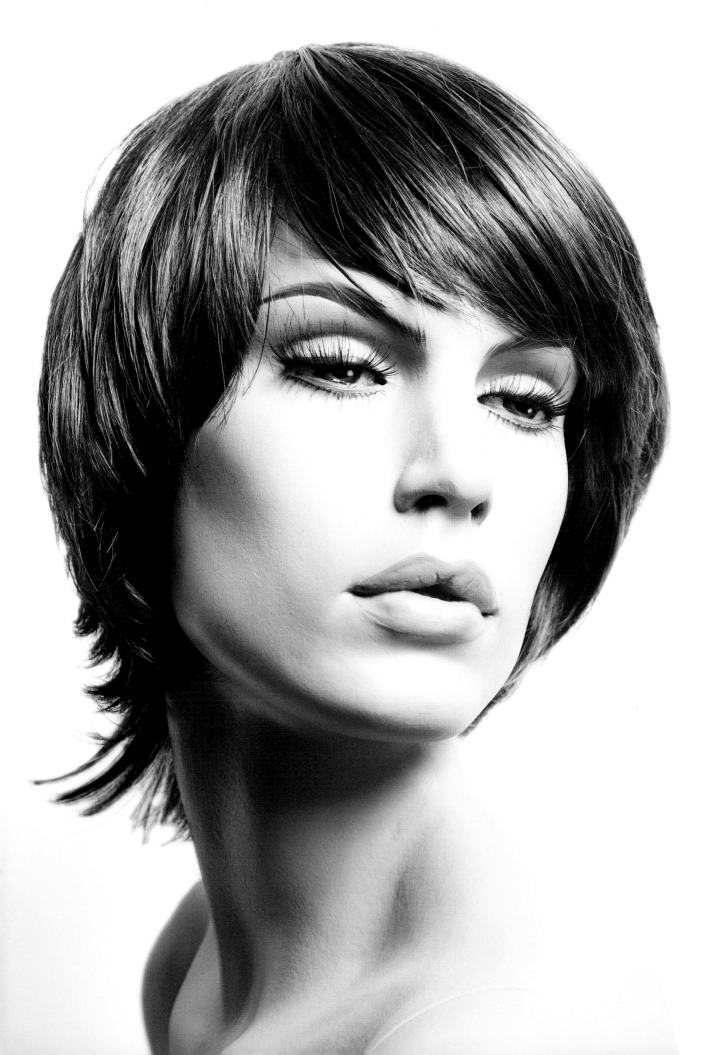

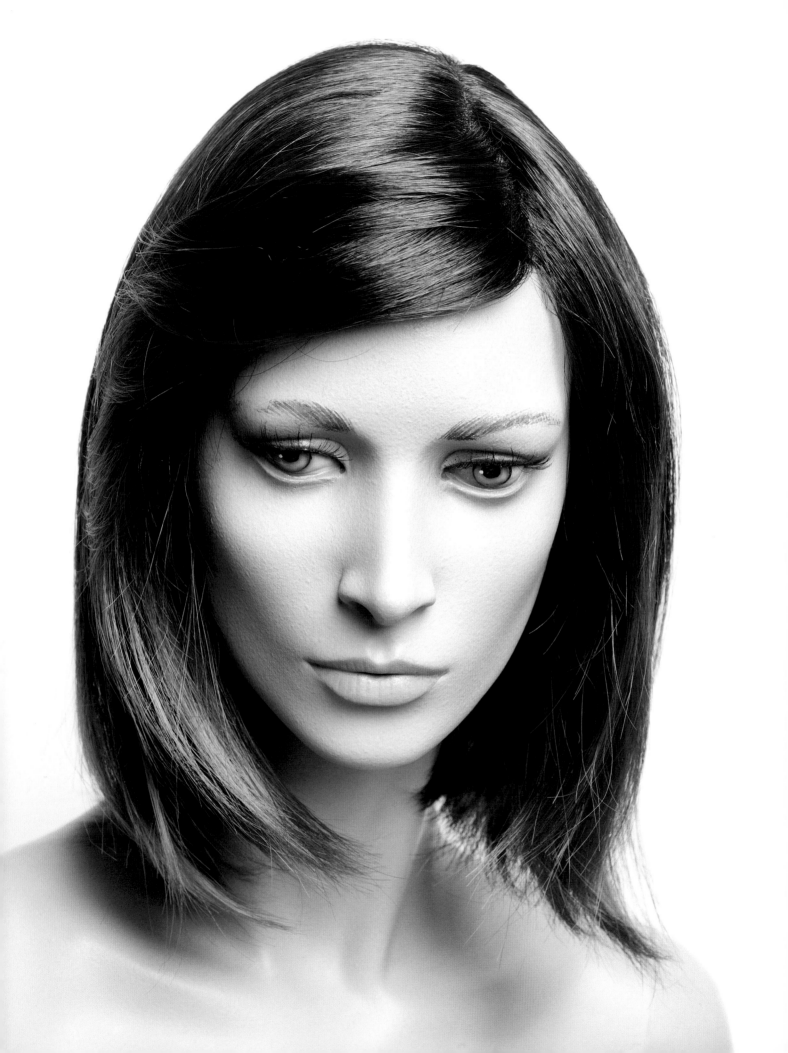

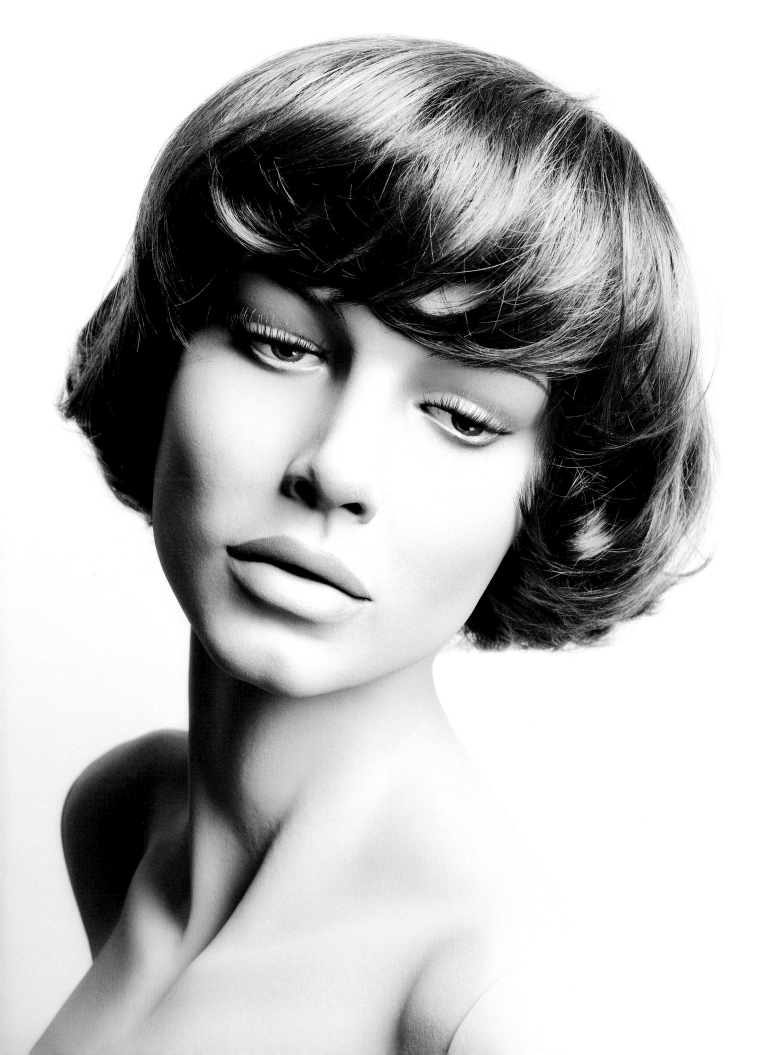

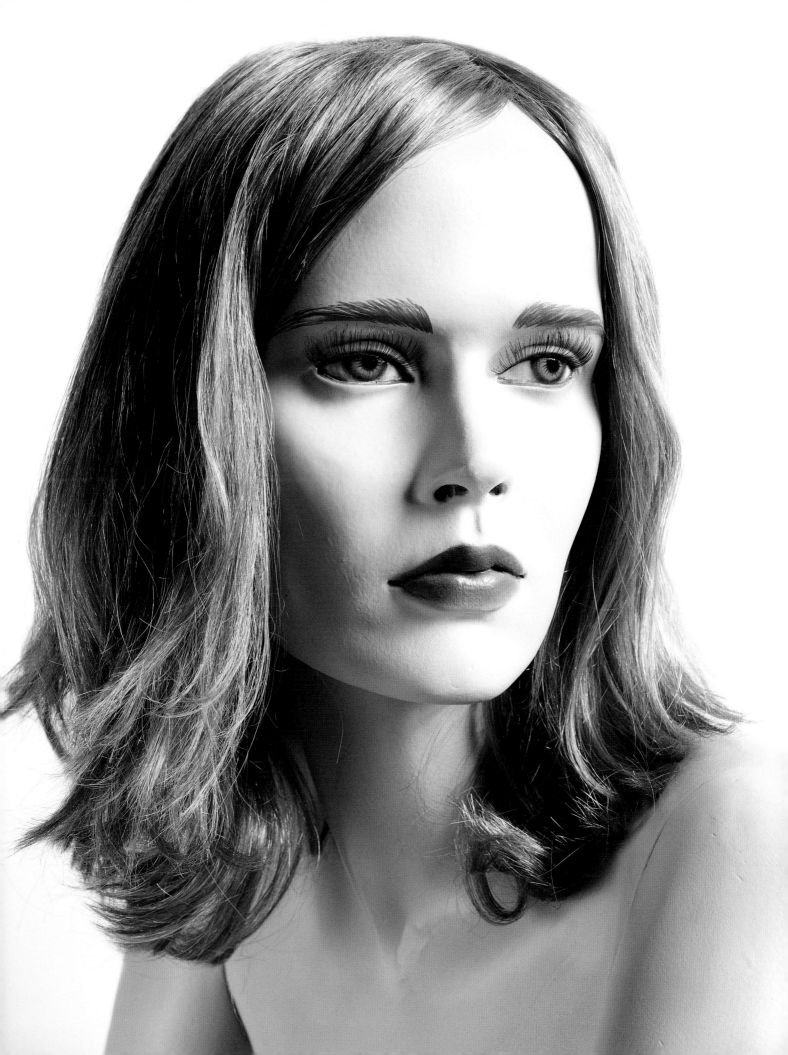

Michael Jackson

2003

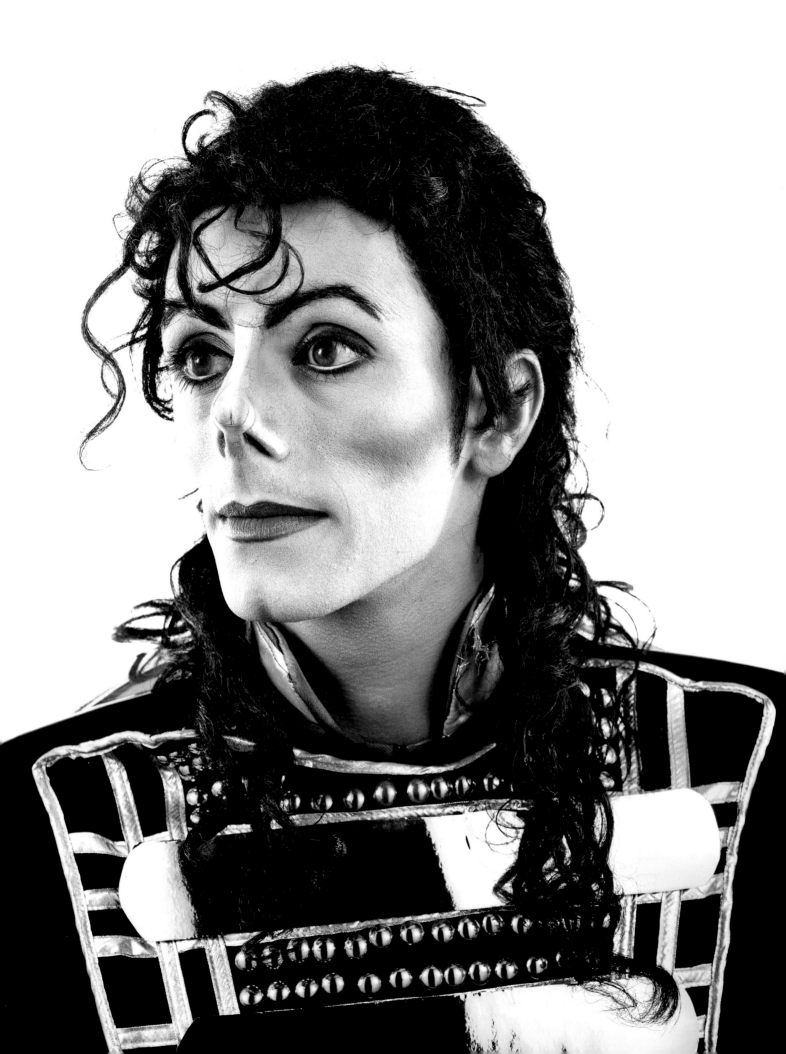

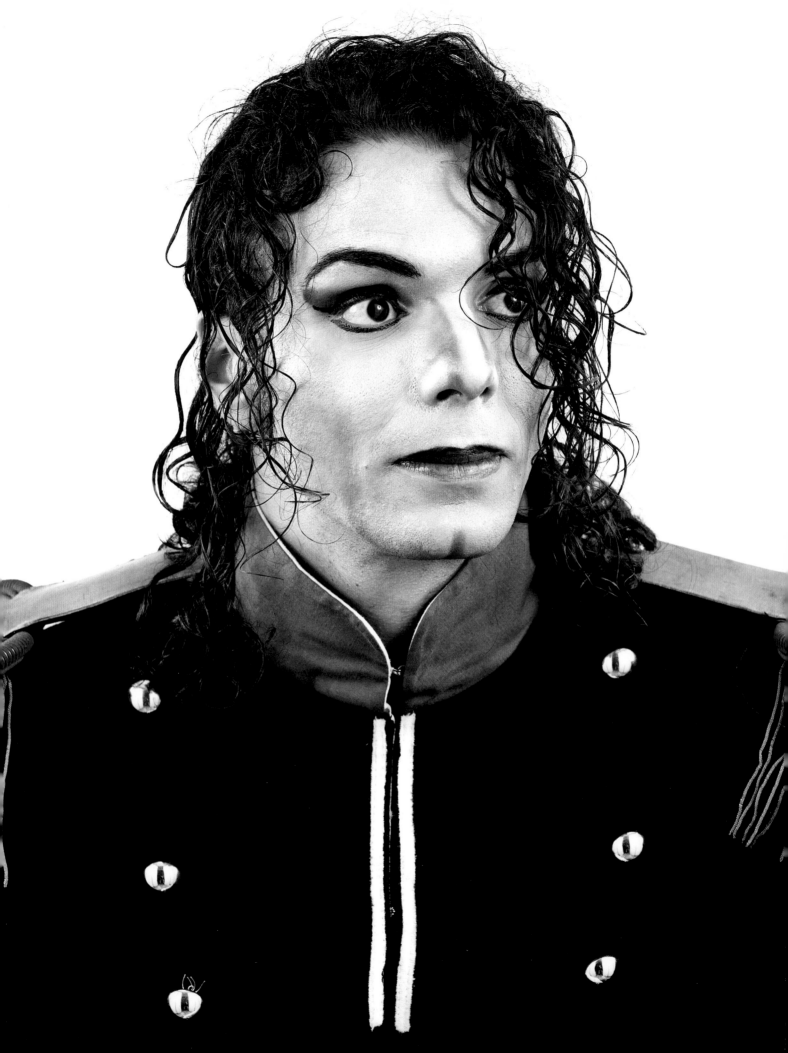

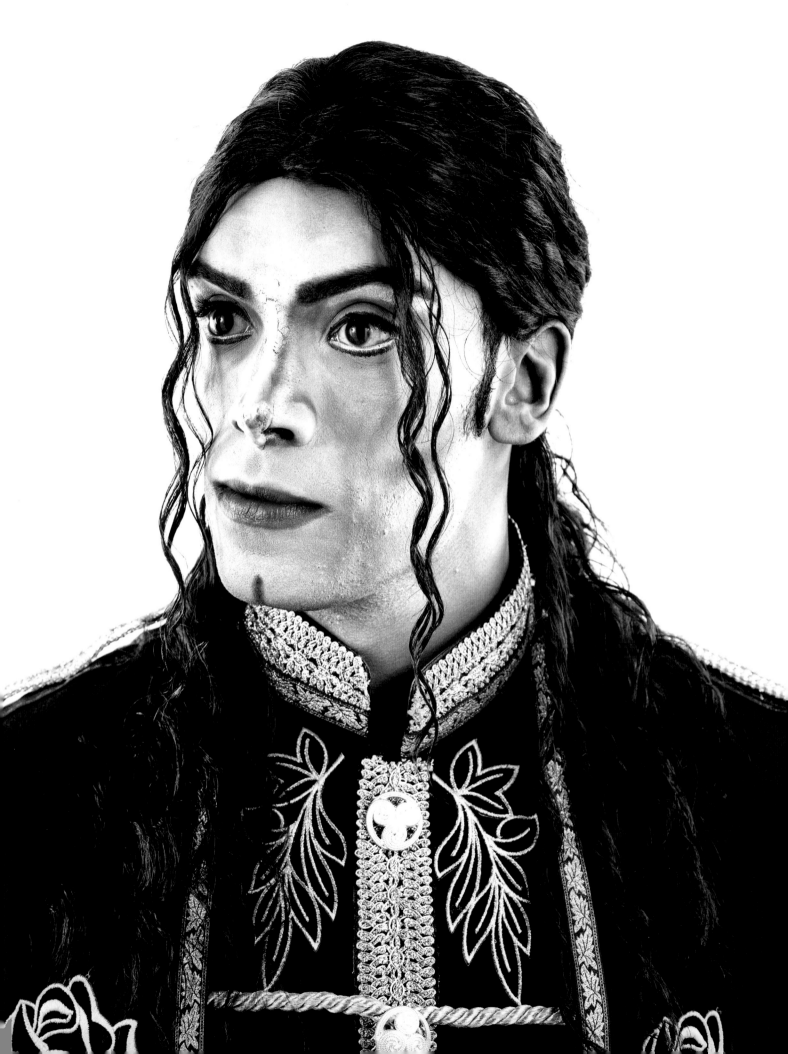

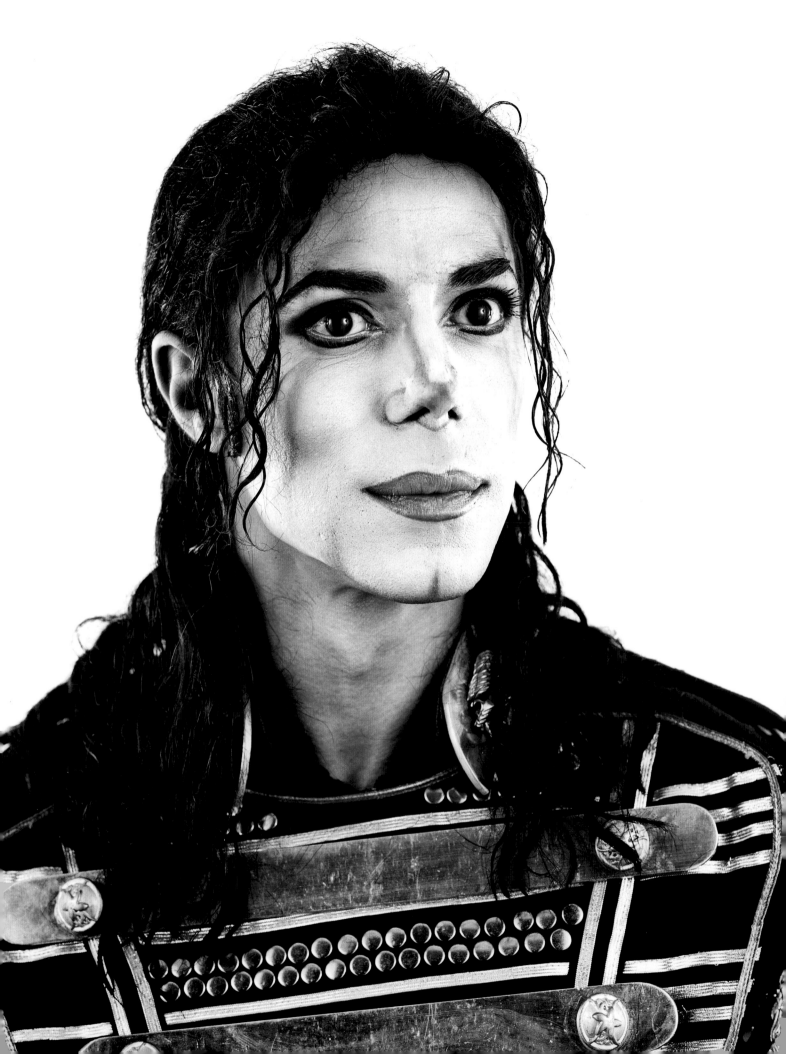

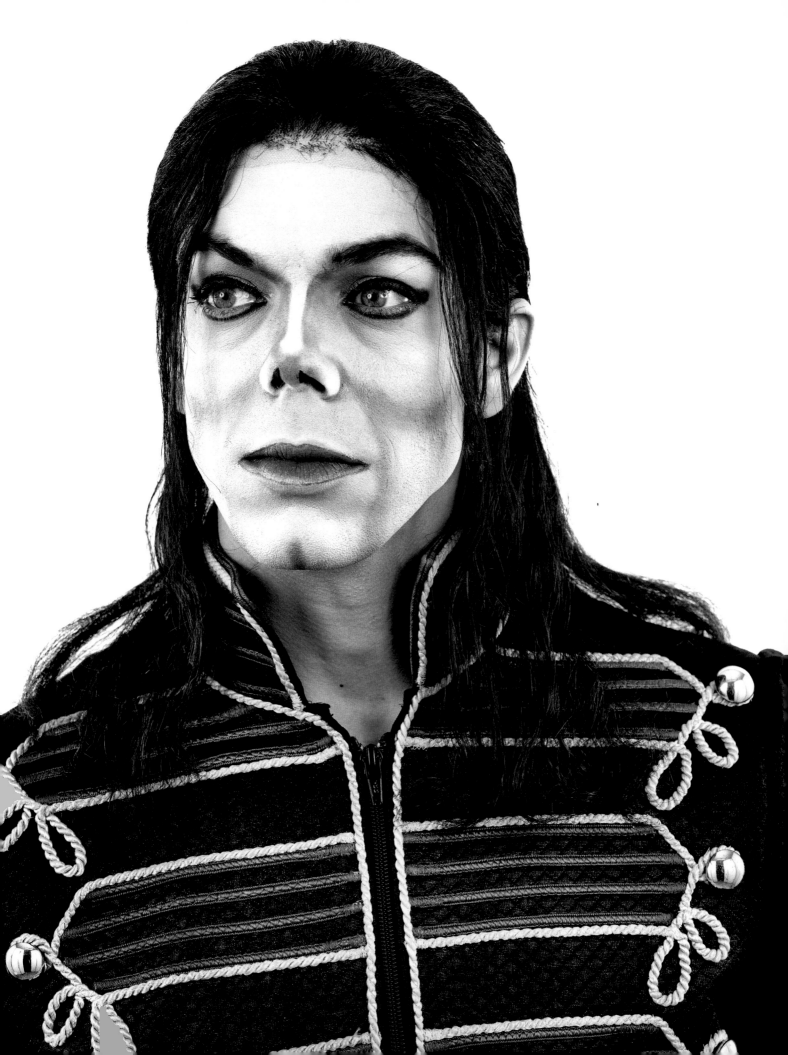

Masks
(Untitled)
2004

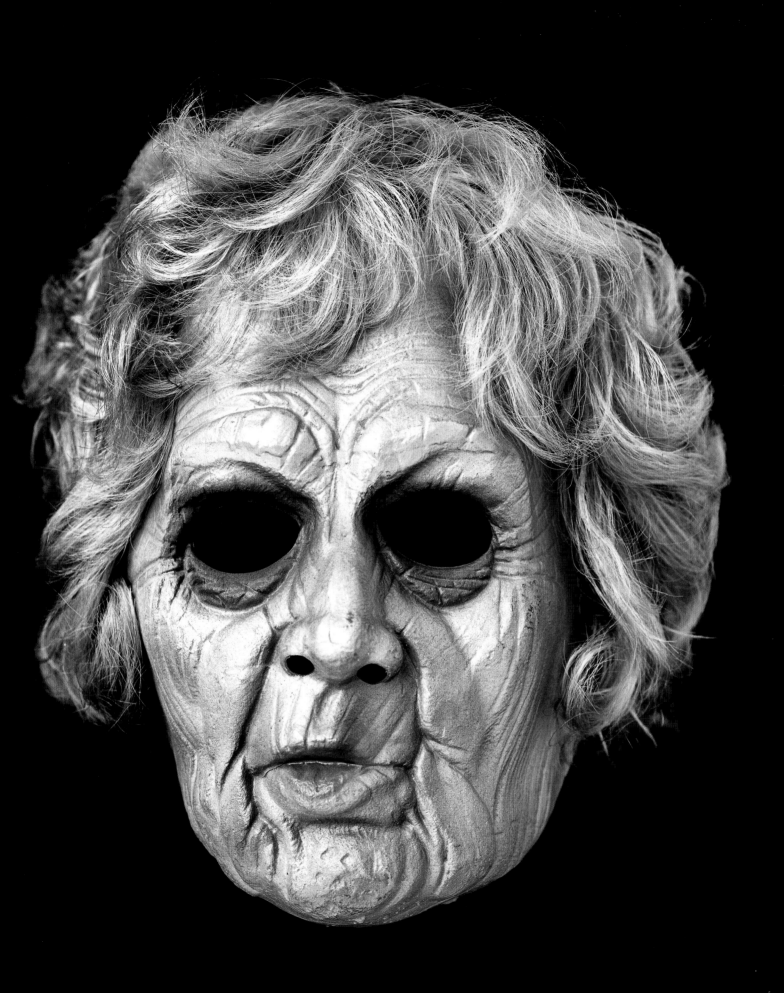

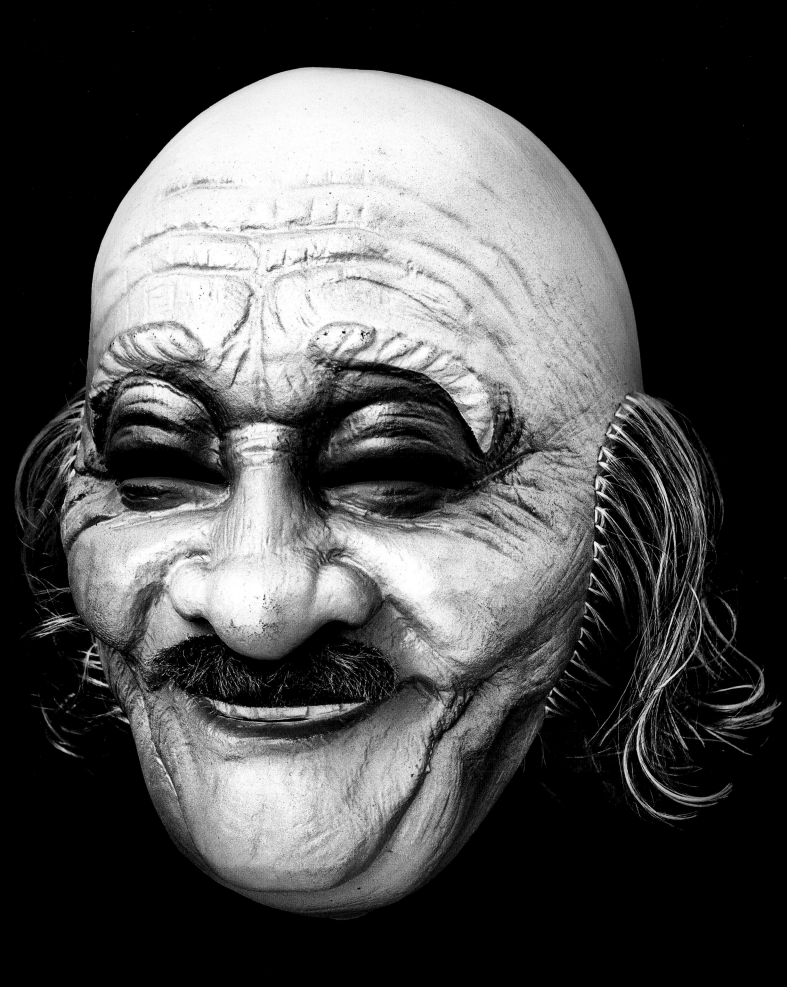

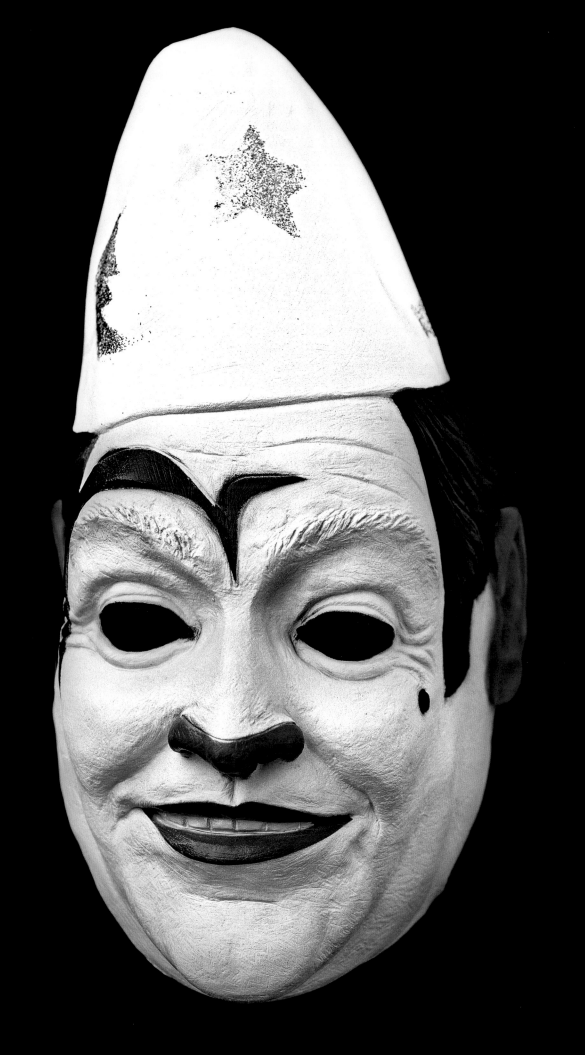

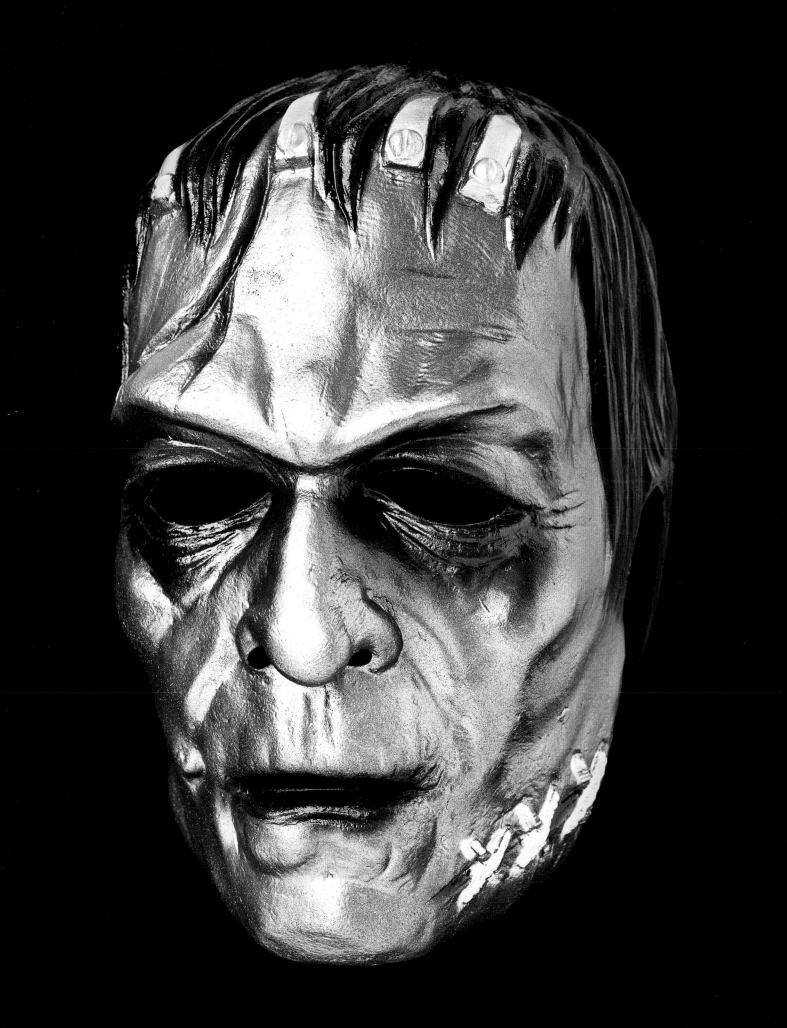

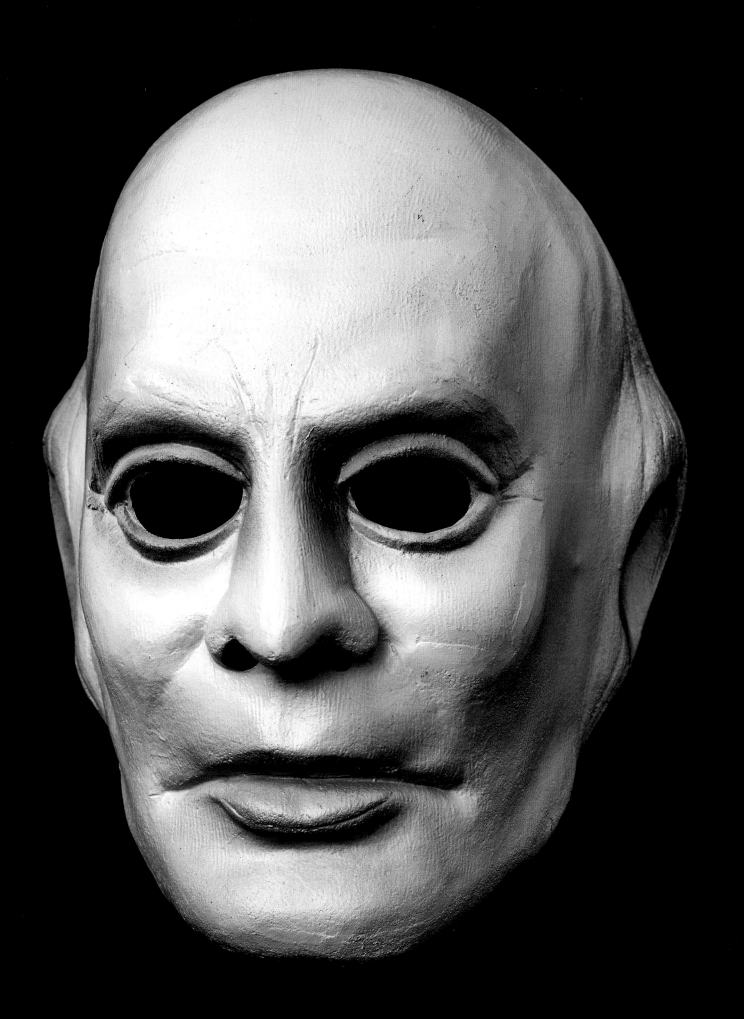

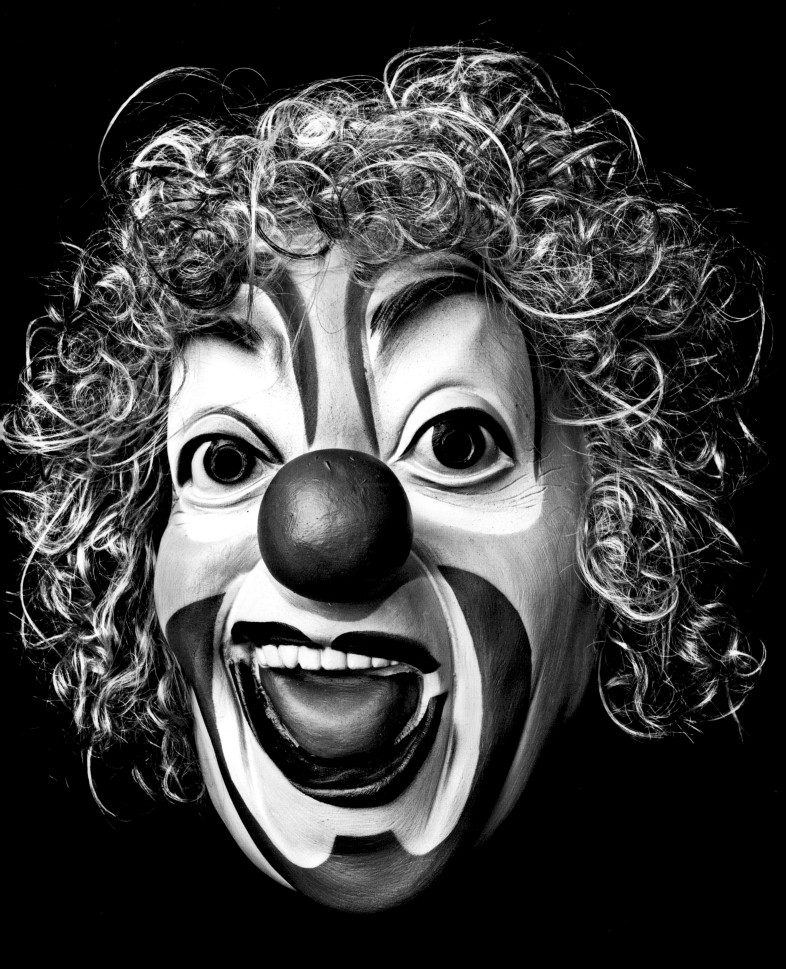

Chips

2004

6 PACK

It's not a Crisp...it's a Frisp ®

FRISPS

2 Ready Salted

2 Cheese & Onion Flavour

2 Salt & Vinegar Flavour

HULA HOOPS®

7

2
**salt &
vinegar**
flavour potato rings

HULA HOOPS®
original
potato rings

3
original
potato rings

2
**barbecue
beef**
flavour potato rings

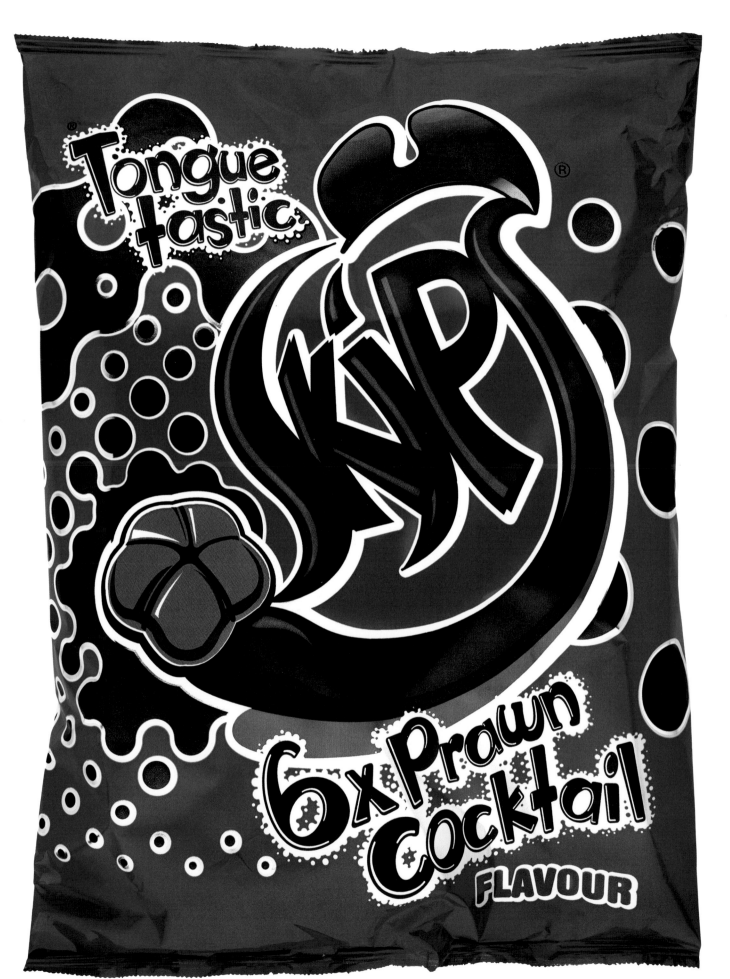

Pallets
(Untitled)
2005

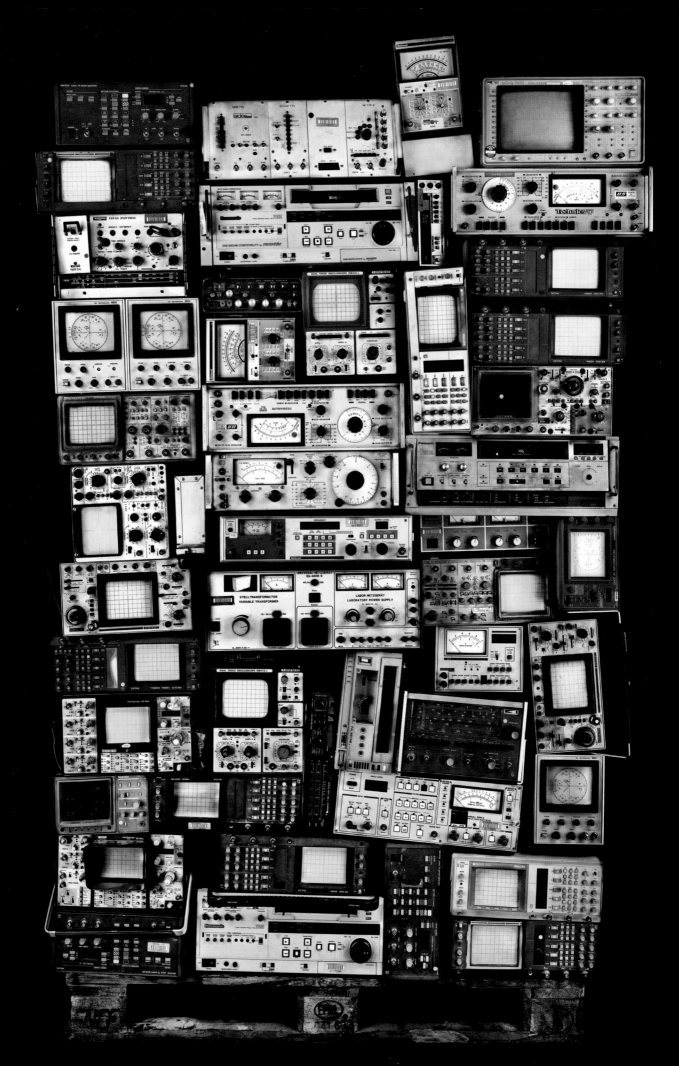

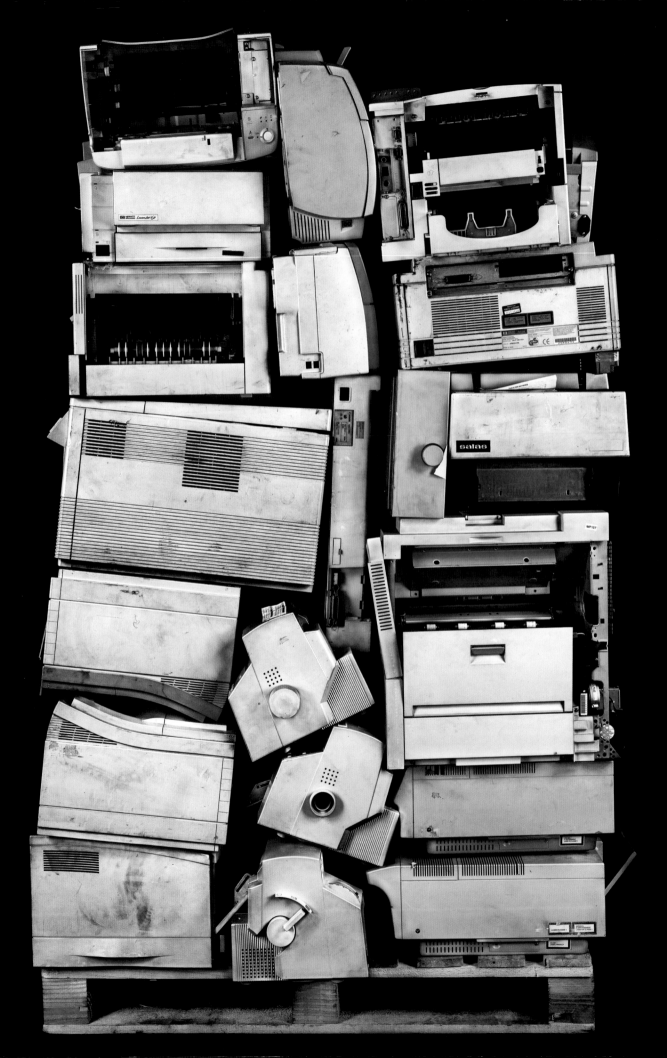

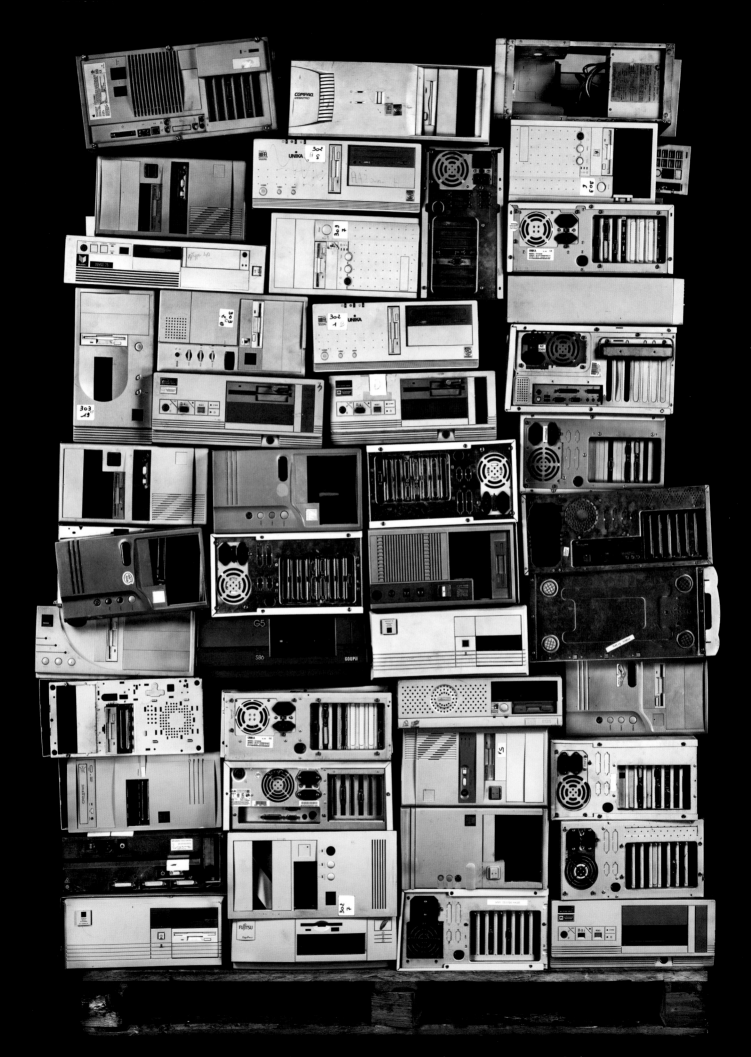

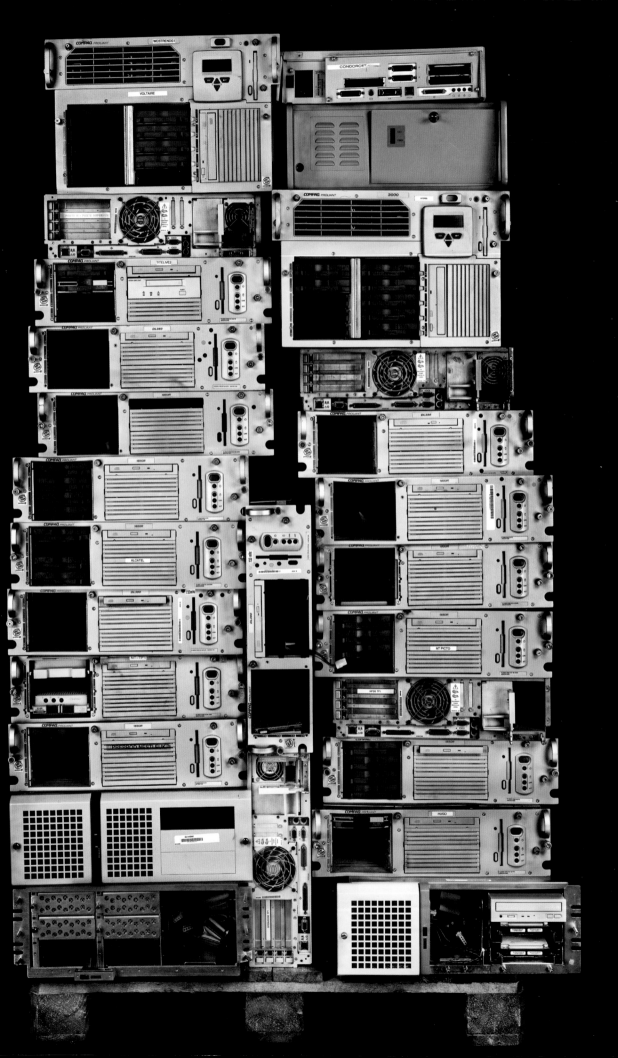

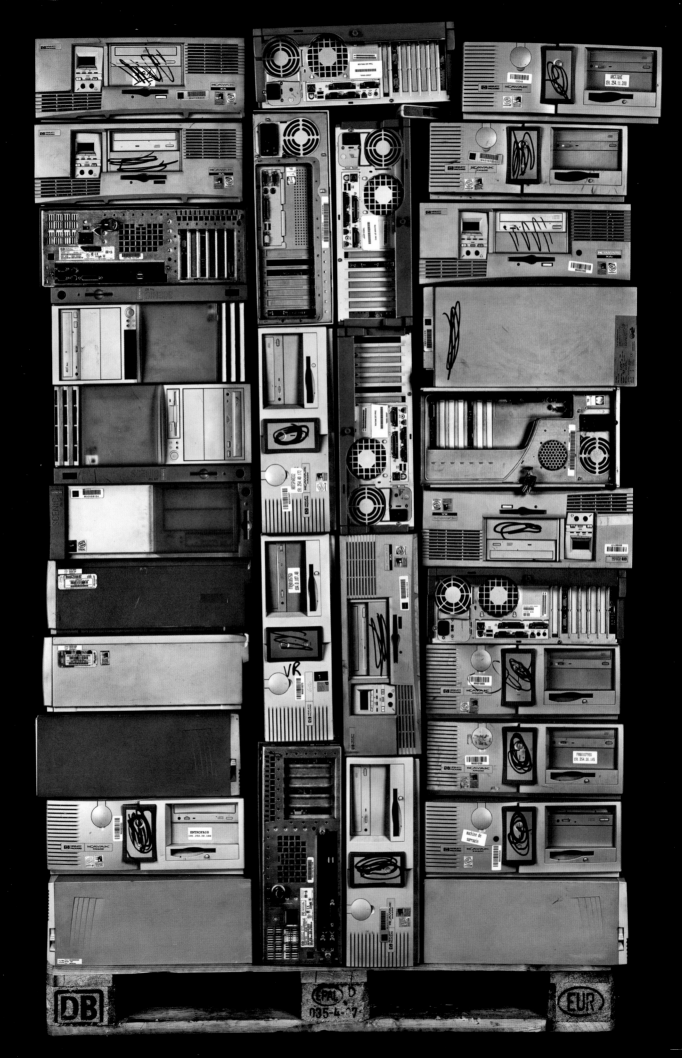

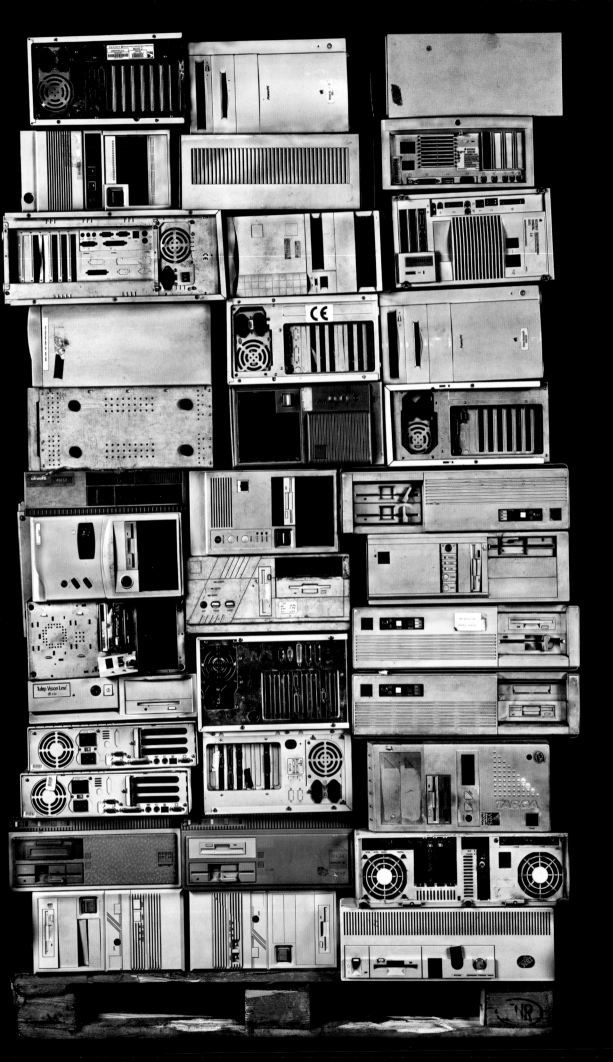

Safes
(Untitled)
2005

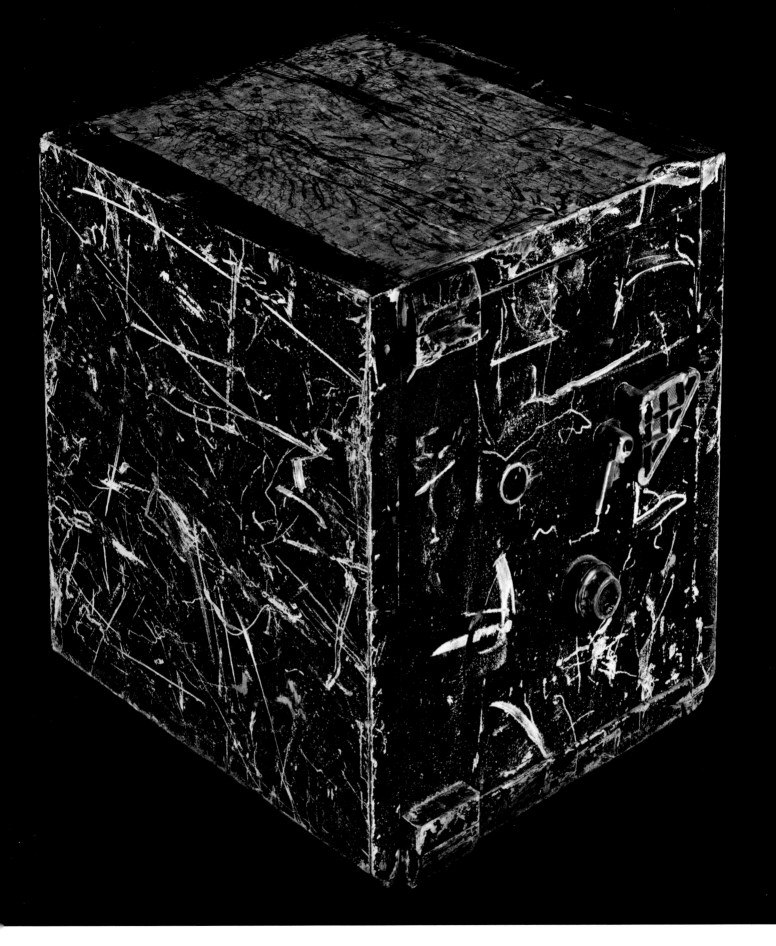

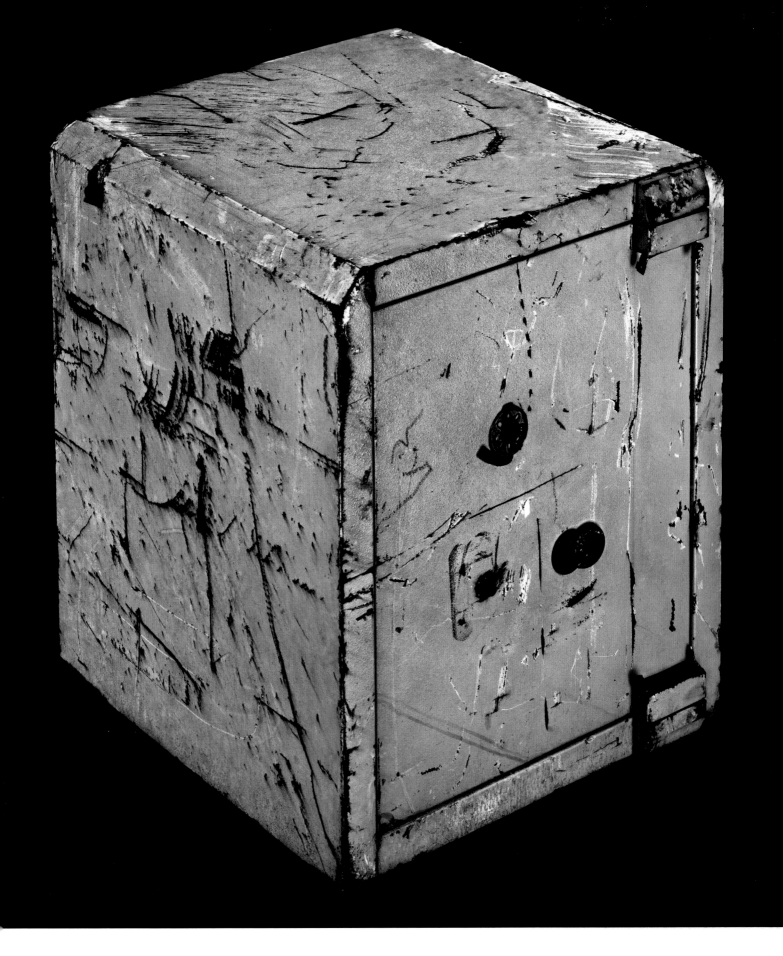

Models II
(Untitled)
2006

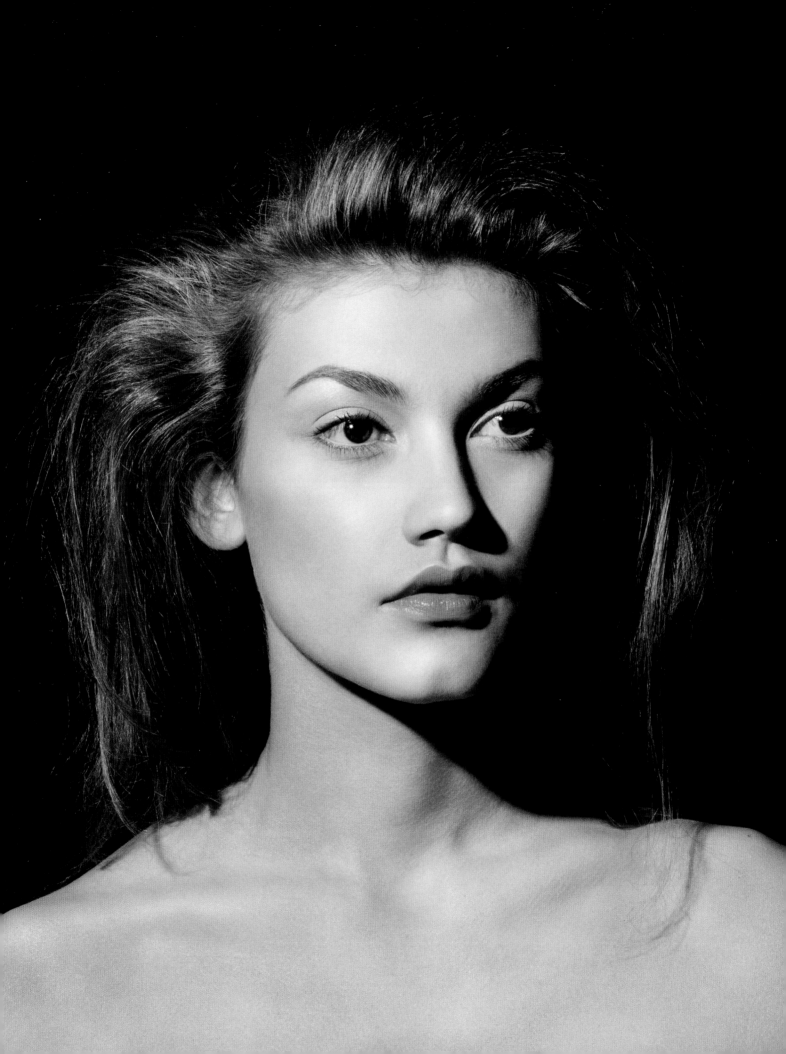

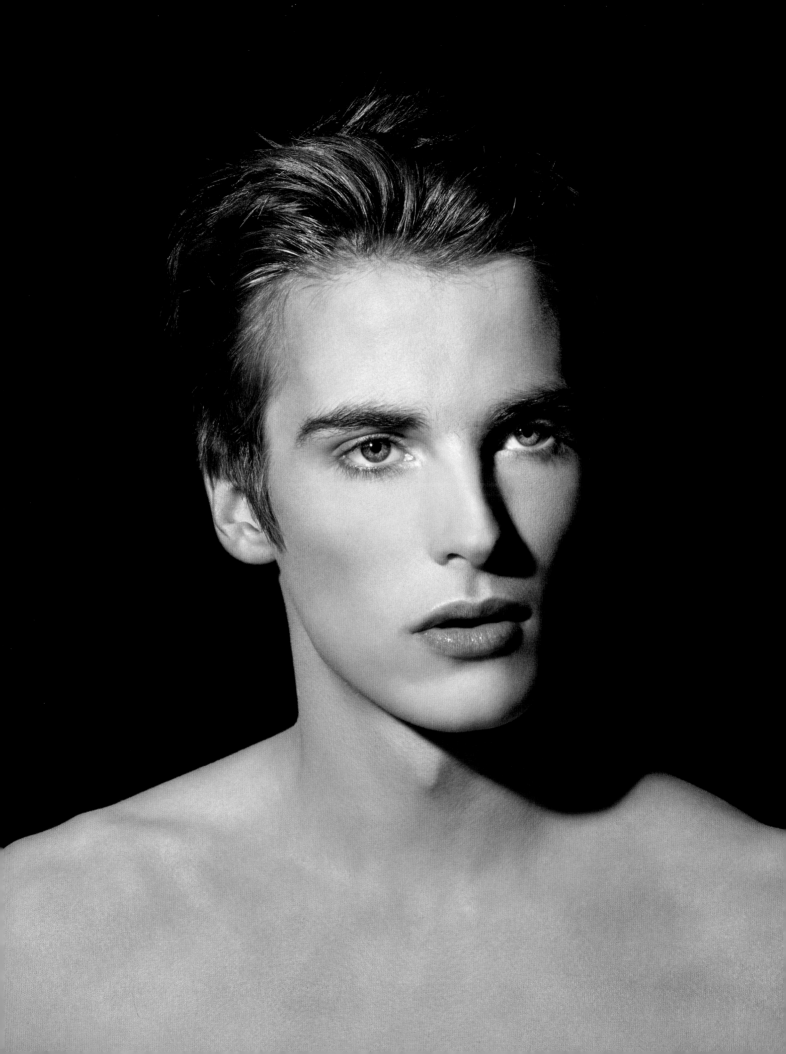

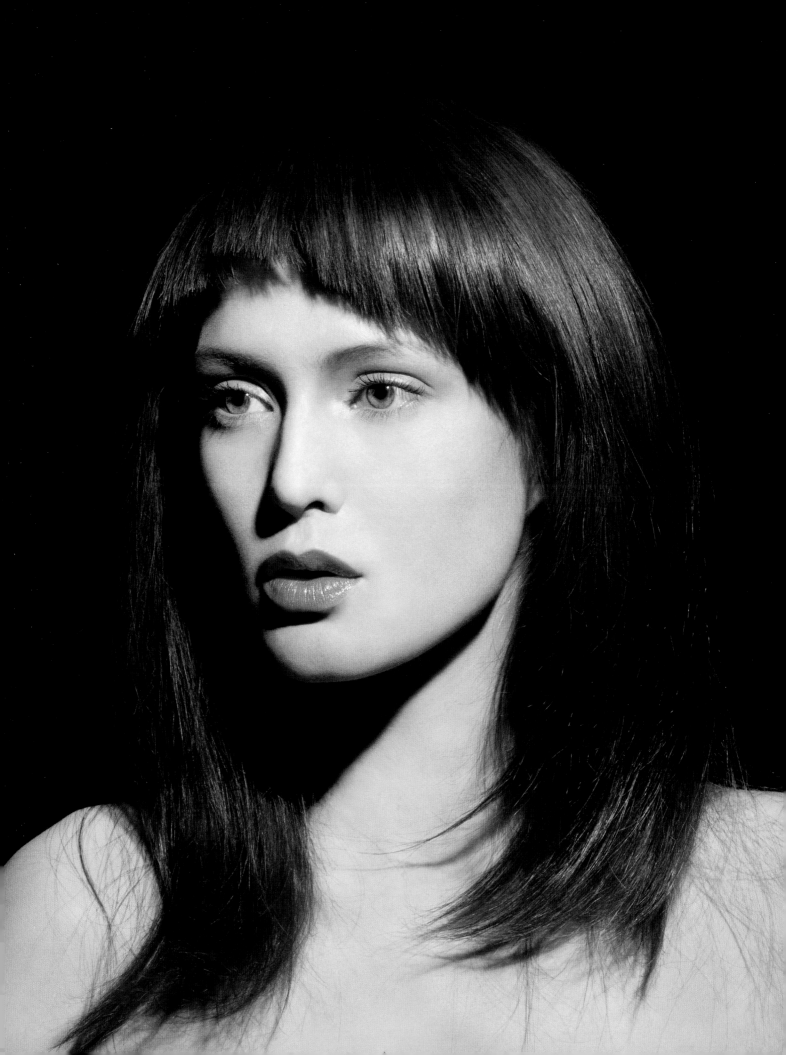

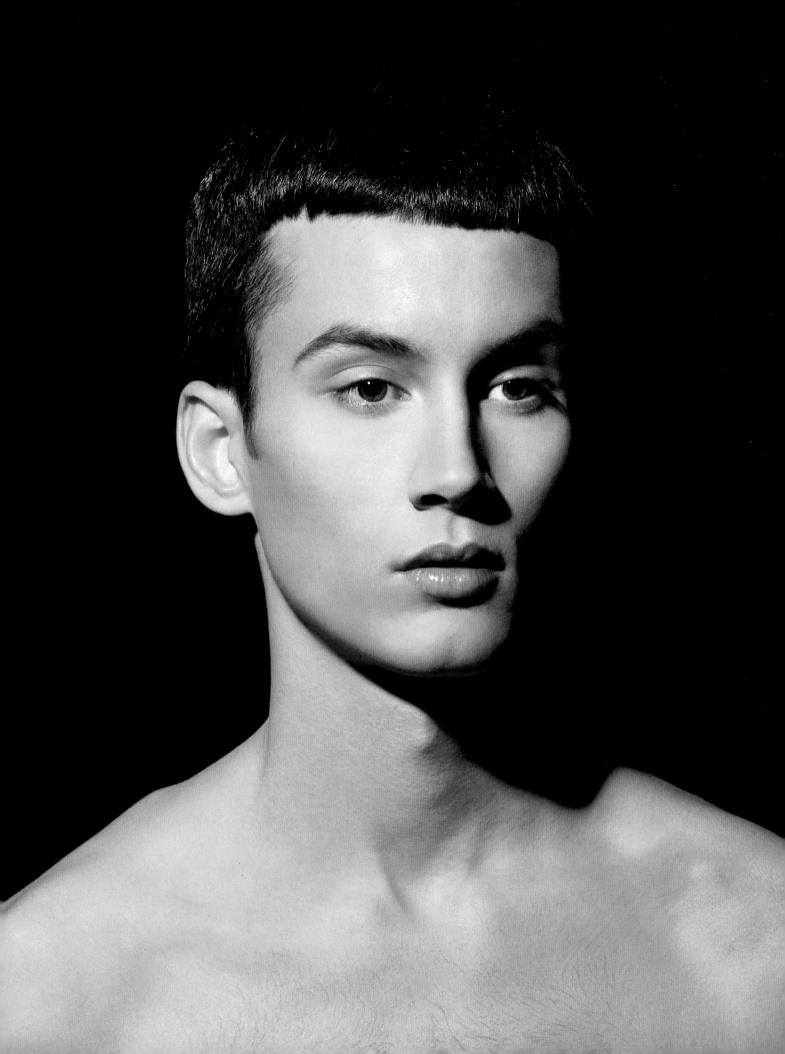

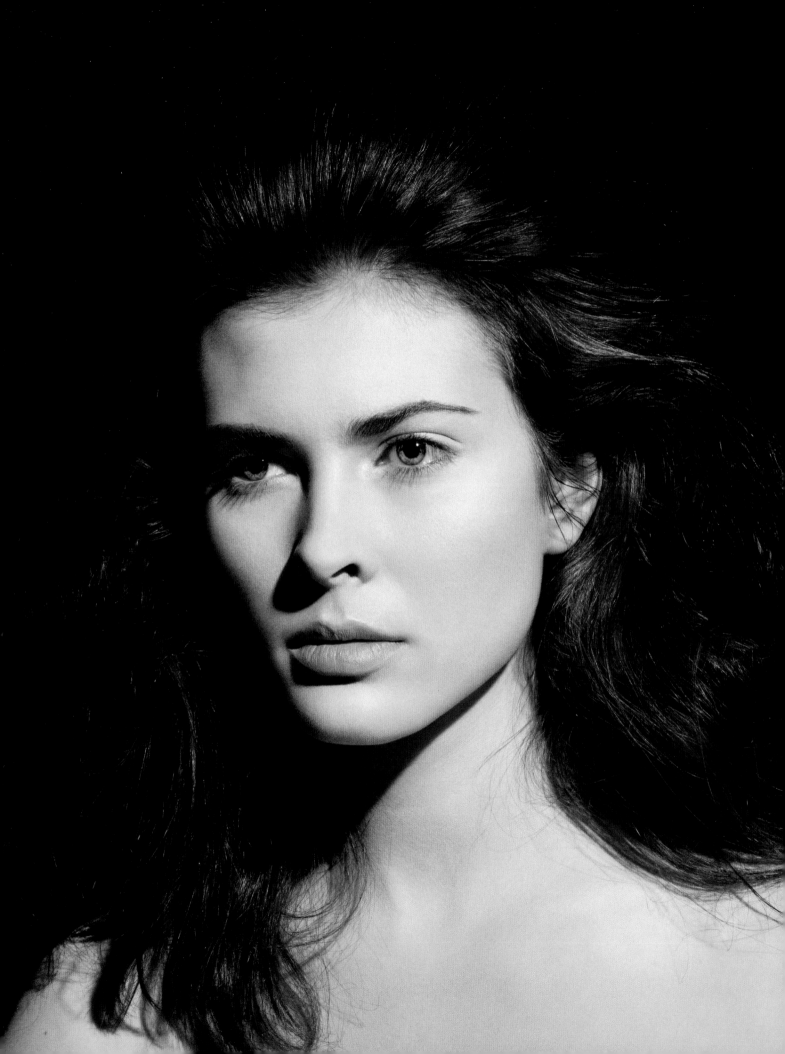

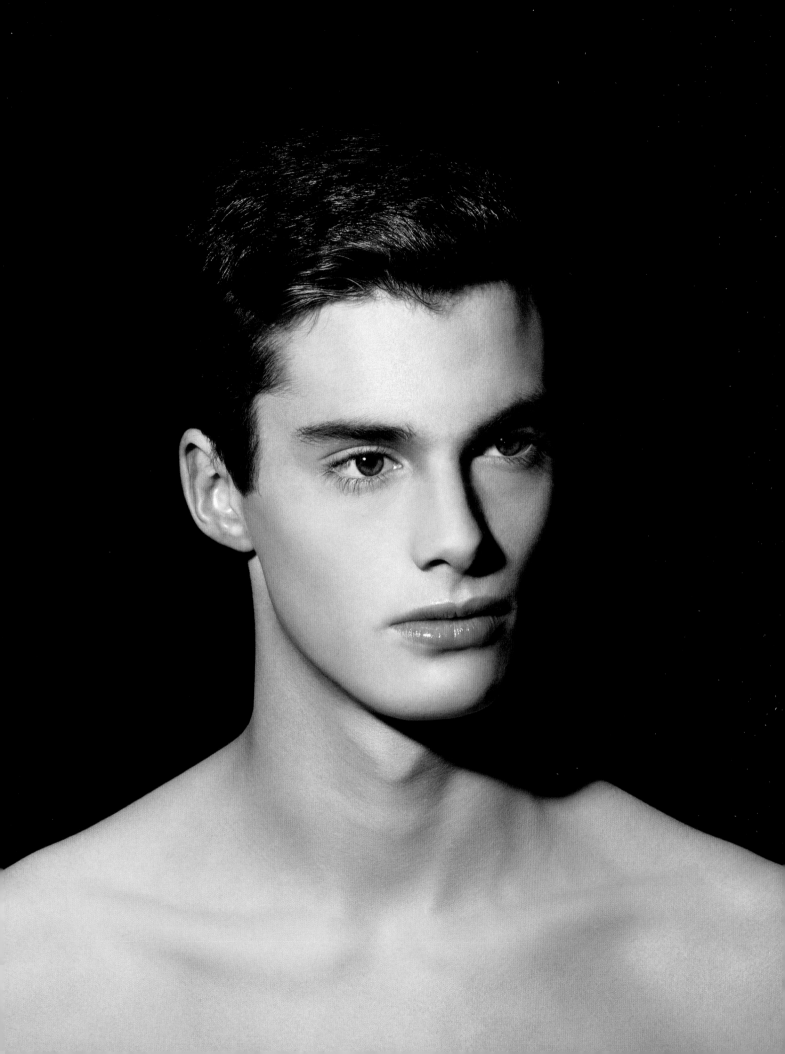

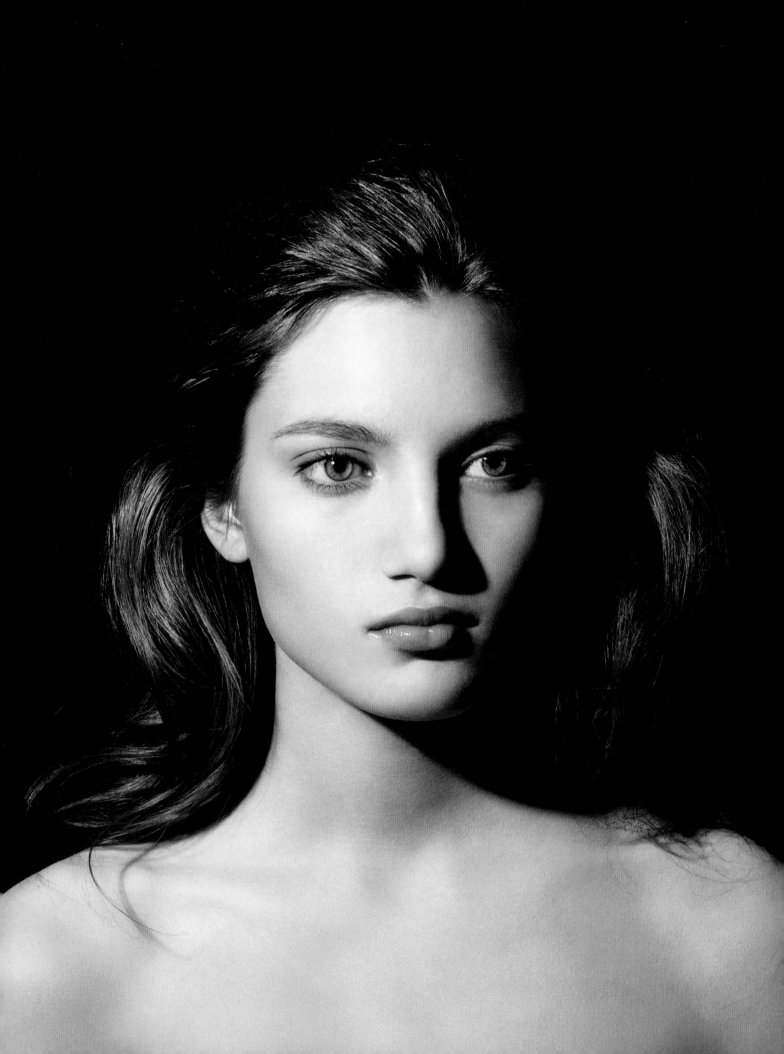

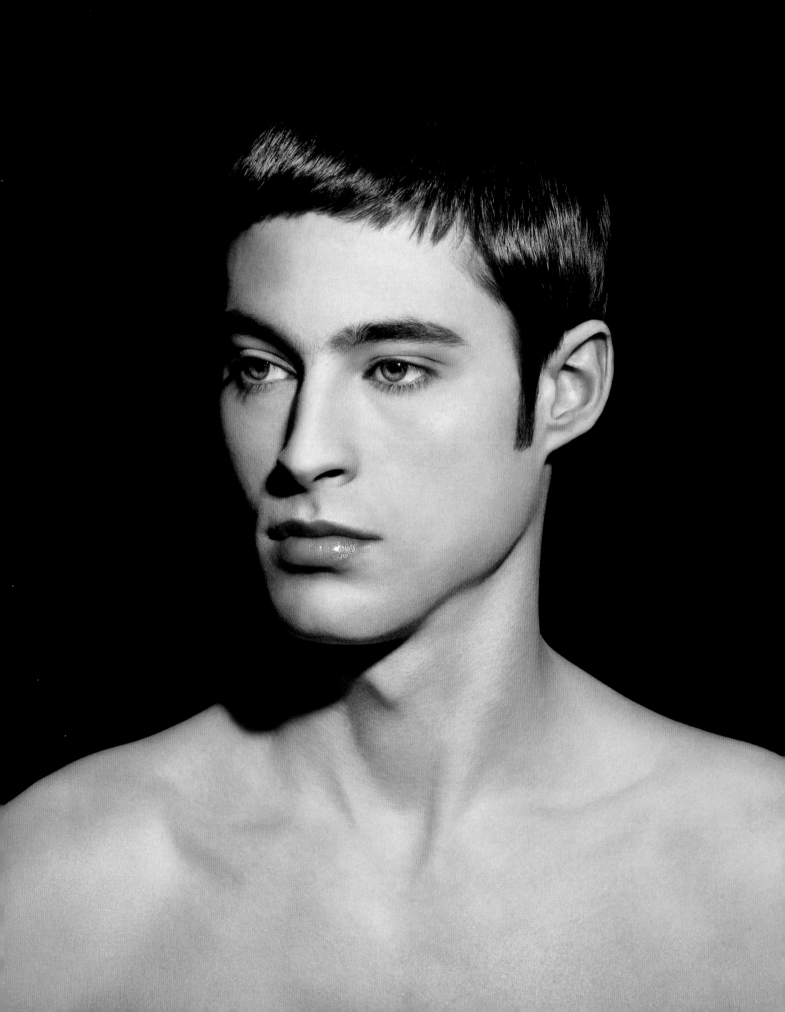

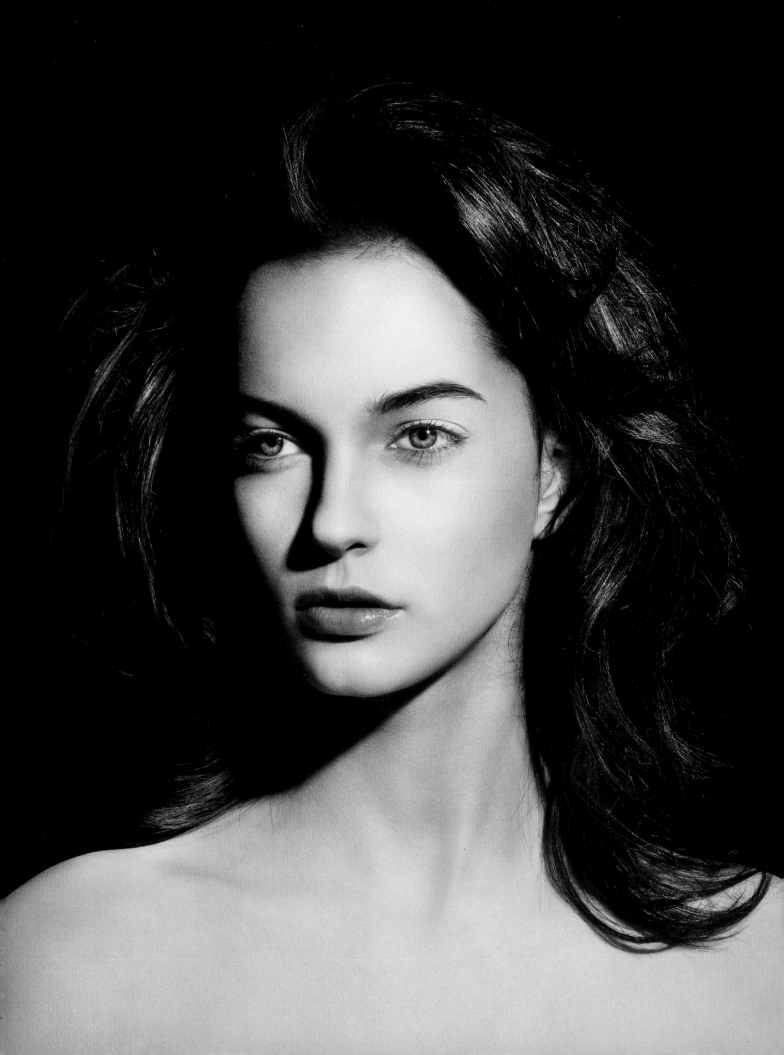

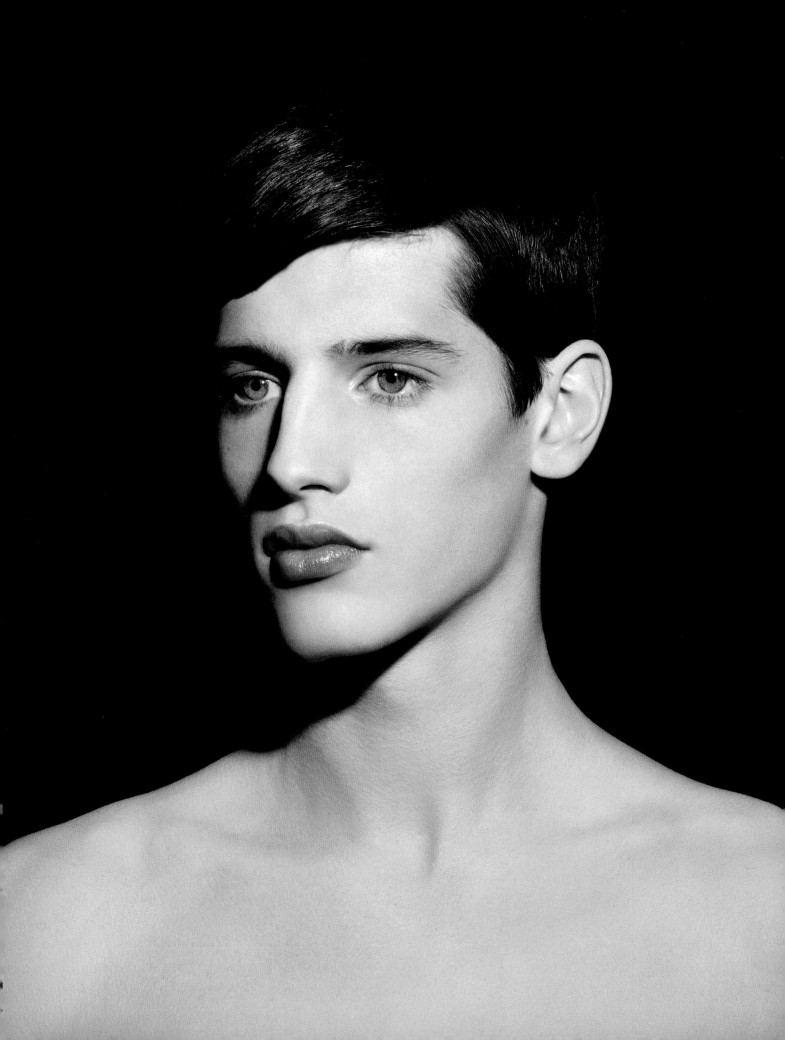

Black Women II
(Untitled)
2006

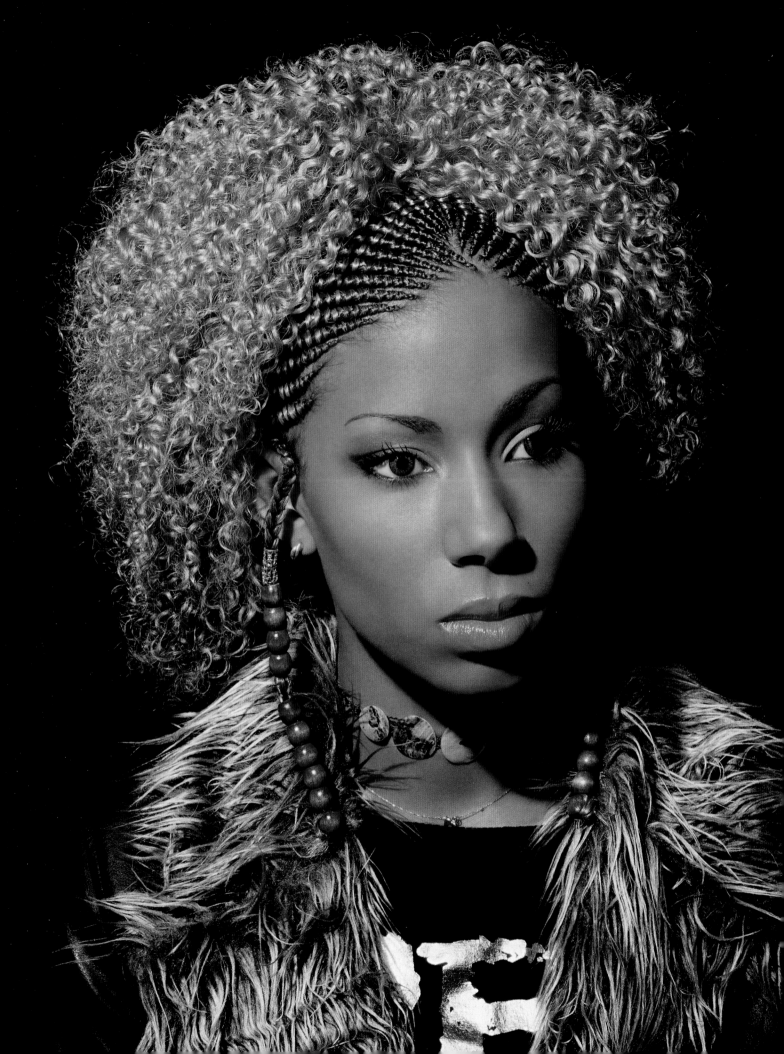

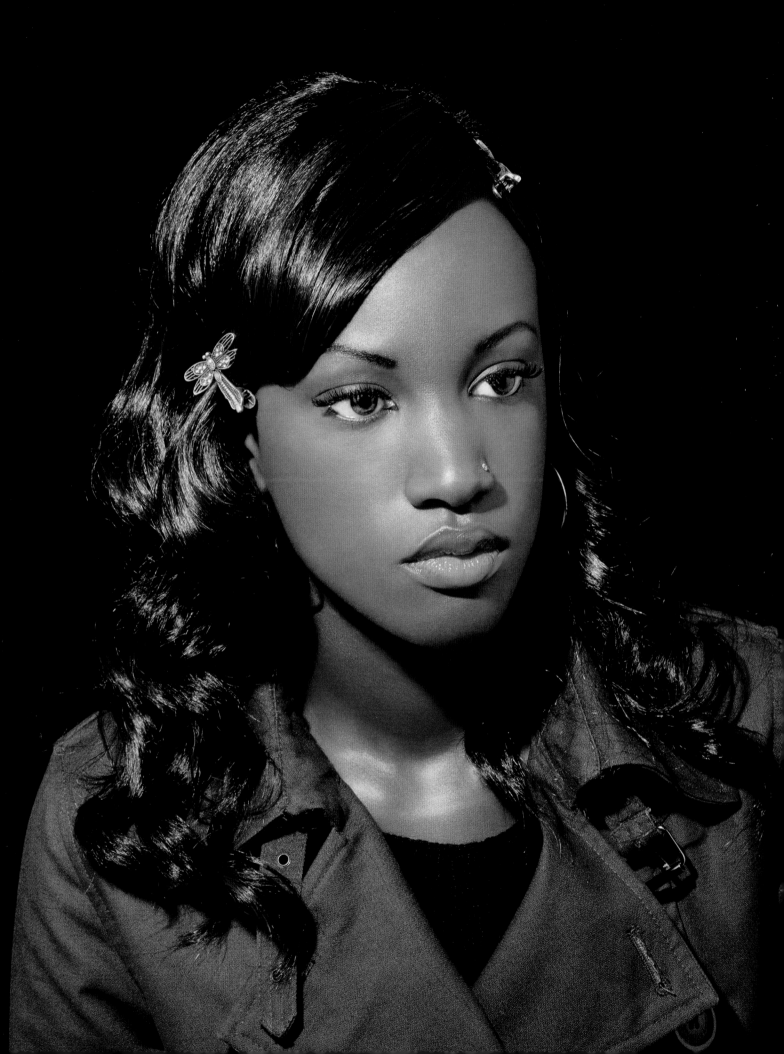

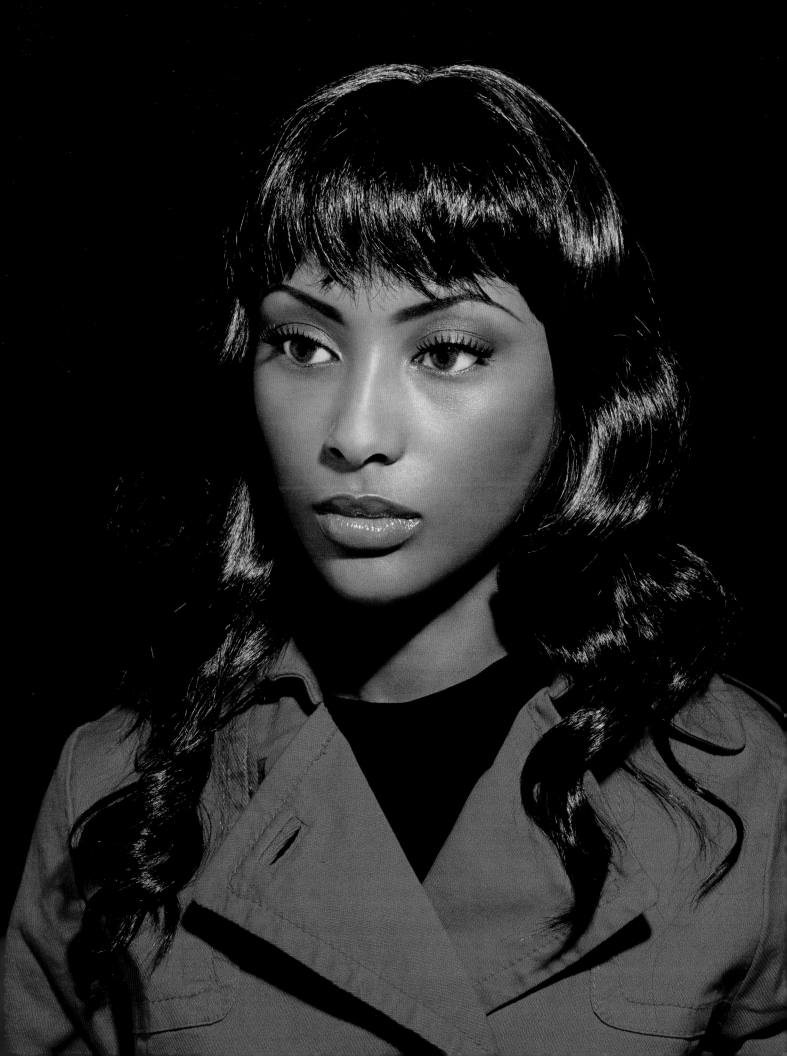

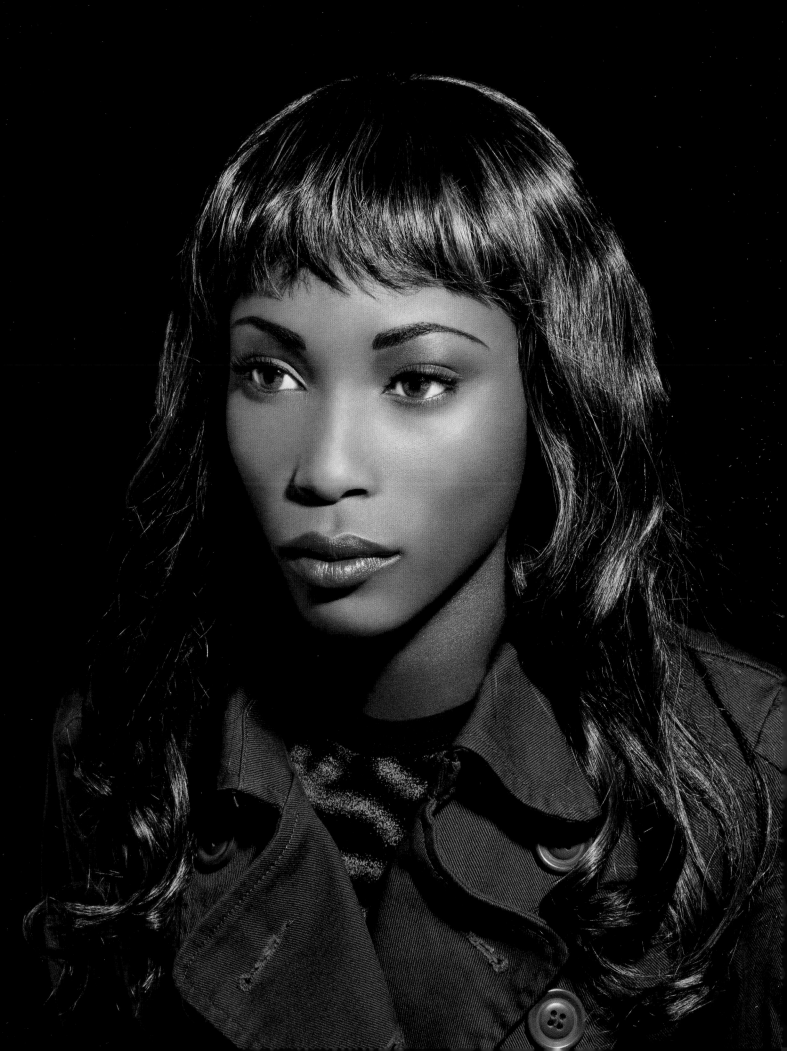

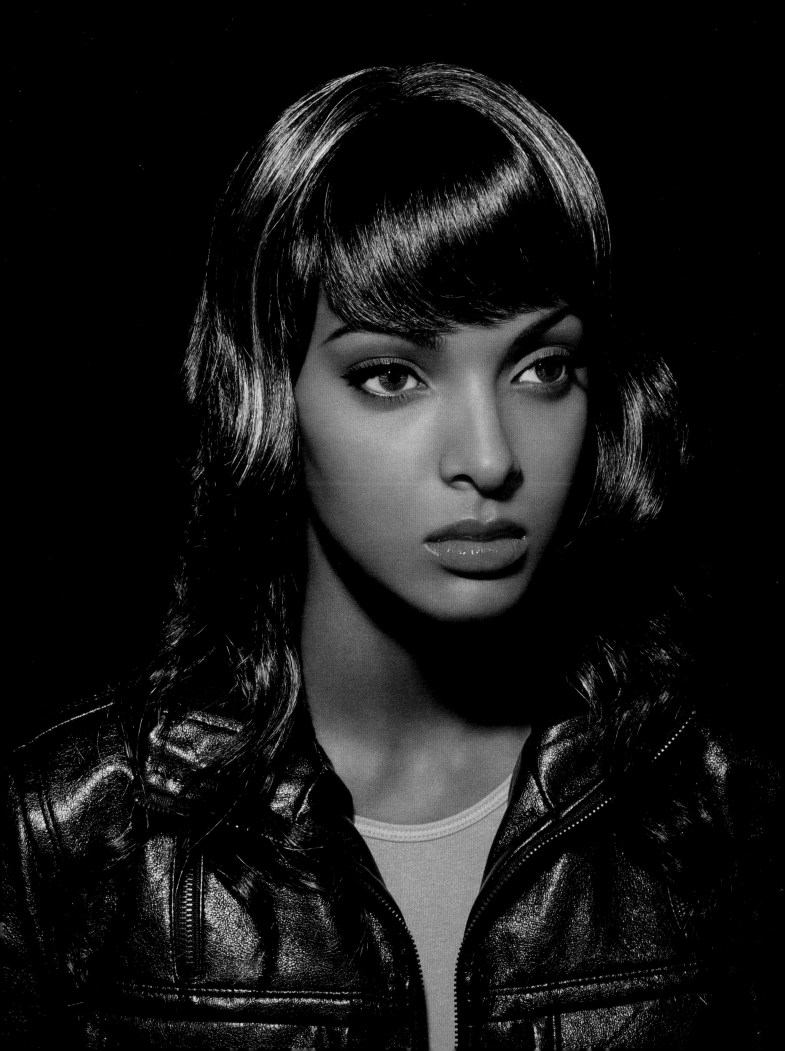

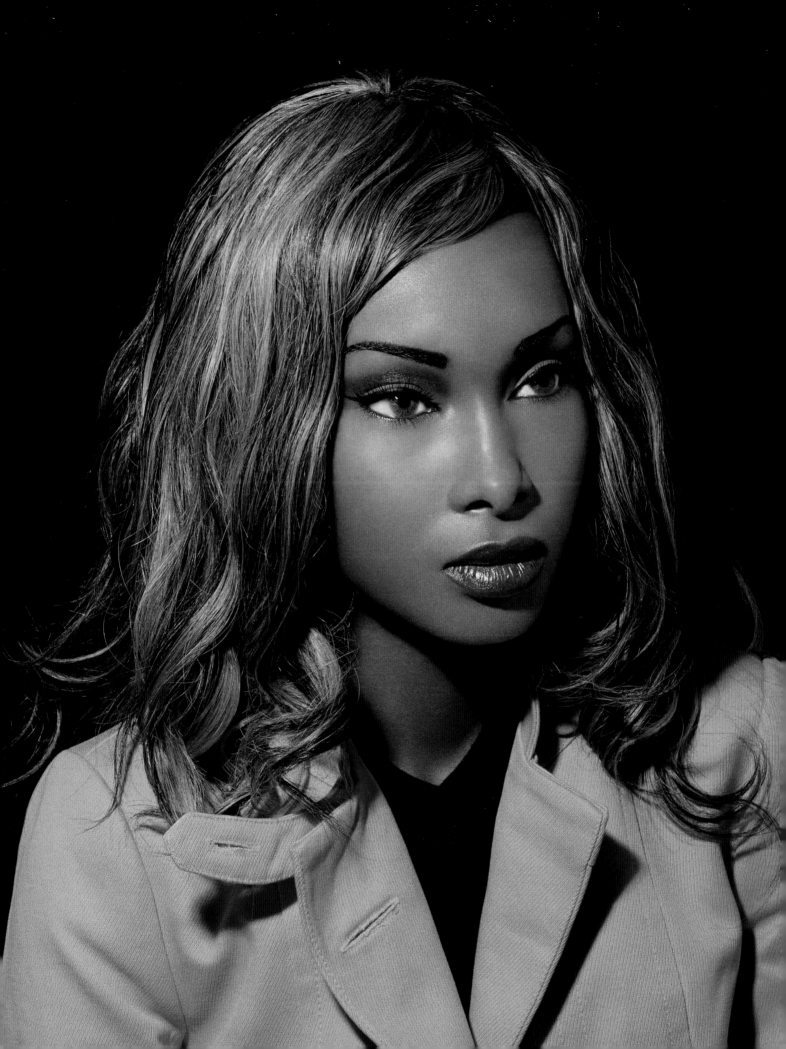

Interview

Nathalie Herschdorfer

What's striking about your overall work is your approach to photography: before considering the object itself, your attention focuses on the way it's depicted, on its image. ◆ My work, in fact, is about something that takes place beyond the object, and it directly engages with the possibilities of the medium. You might say I explore photography 'from the inside', through luminosity, scale, and chemistry – which makes it an imprint of light more than anything else.

Was this interest in the medium present right from your early work? ◆ I became interested in light, radiography, and spectral imagery very early on. Strictly speaking, my first series weren't photographs of objects, but rather photographs of their luminous specter – I wasn't trying to show the object itself, but rather the energy it gave off. Take, for example, the photographs of wrecked cars: it was as though, metaphorically, I was photographing the energy of the moment of the accident. That's why I get very close to an object, which thus appears to 'bulge'. Photography also allows me to bring out the potentialities of a subject. The large format that triggers a certain confrontation with the beholder, the tight framing that eliminates all context, and the use of black and white – all these techniques mean that photography becomes more like a kind of sculpture.

To which we should also add your choice of subjects. Your work always involves objects that possess intrinsic beauty; similarly, the faces that appeal to you always display a certain plasticity. ◆ I don't take a documentary approach, I'm not looking for objectivity. I do indeed chose a subject for its aesthetic qualities – or, more exactly, for its 'photogenic' qualities. The photogenic quality of a face or object is something pretty mysterious, which I discover while working and which largely depends on the choice of lighting. In the series of car wrecks, for example, the metal had to be crumpled and dark in color so that the sunlight emphasized the glitter of shattered fragments. The status of the object was also transformed by enlargement and translation into black and white. For me, photography is the magic of seeing a picture emerge, of attending the transformation performed by the tool.

In each series, the framing of the object is very precise and the lighting is extremely controlled. Can you explain this important stage of the process? ◆ This stage is crucial, it's the moment that everything comes together to shape the picture. For example, all my photographs require depth of field in order to get the greatest sharpness; it's essential for obtaining the effect of flatness and surface that I want. There may have been a lack of overall sharpness in the series of glass objects, but that corresponded to what I was looking for at the time, namely a kind of monochrome abstraction, a pictorial quality. Things then evolved, and I moved toward higher contrast, more defined photography, in which the object was present in all its materiality. But I'm not looking for extremely definition either, which would 'stick' too close to reality. The grain of the image – the kind of 'binder' it creates – is important in revealing the energy that the object gives off, to the detriment of straight-forward depiction or description.

In your series of computers on pallets, the eye does in fact linger over details, but at the same time the overall object dominates the picture, like a sculpture. The anecdotal element and every-thing related to details then disappear, so that the image as such seems to have greater import than the depicted object. ◆ True, but I prefer to use the term photograph rather than image, because we're really dealing with photography in the ontological sense of the term, that is to say an imprint of light reflected by things or people. It's a print, or impression, that can convey an energy to us.

In series after series, the use of black and white seemed to be your trademark. And yet color has triumphed in your more recent series. Why? ◆ For a long time, black and white was the only process that gave me complete control over the image. These days, things have changed, in so far as digital tools offer the same control whether the picture is black and white or color. Take, for example, my two latest series of color portraits – in one of them I wanted to produce pictures that were nearly black and white, almost monochrome; in other on, on the contrary, I emphasized the saturation of colors. For me, the choice of black and white or color is now determined solely by the subject and the results I want to get from it. In my early work, black and white assumed the quality of a blueprint or drawing, which for that matter subsequently produced a certain effect of style. In the same spirit, the portraits that I later did in black and white were schematic in an almost anthropometric

way. Working in color now allows me to attain a new aesthetic dimension, different from the one produced by black and white. My work occupies various borderlines, places of metamorphosis where identity is never straightforward, never unequivocal – the borderlines that separate, for instance, the human from the virtual, and the organic from the sublime.

The series follow one another without ever overlapping. How do you decide on the choice of a particular subject? ◆ My choice of subject-matter is always the fruit of some autobiographical necessity. Moving on from one subject to another in a brief period is another necessity, one related to the way I operate: the choice of subject always occurs progressively, there is a period of reflection and intuition, and then all of a sudden an idea emerges. Then there comes a process of research into the object and its context, which constitutes a large part of the work. To take an example of this itinerary: I started by taking photographs through store windows, which led me to shiny objects – light fixtures, as it happens. From light fixtures I moved on to glass objects. Then I decided that I had to isolate one object from all the others, like in a portrait, without the screen created by the window pane. Next, certain objects appealed to me for their luminous quality or their expressive power. The photographs of glass items – followed by the carcasses of meat – were done in ambient light, 'on location' rather than in a studio. This aspect was very important to me at the time, because I had to immerse myself in the context and atmosphere of these objects in order to get closer to their 'truth'. I wanted to avoid the anecdotal aspect of form, I wanted to get to the heart of things, of matter and light, almost independently of the objects.

Why did you then drop objects in favor of humans? ◆ There's always some link between the subjects I choose. You might say the common denominator is the body and its metamorphoses – its depictions, its poses. A human element was therefore always present in my photographs, before it actually appeared as such. Chronology is important when addressing this question: at first, I chose objects that had the power to evoke absence or emptiness; then I took photographs of Venetian mirrors that don't reflect anyone or anything other than themselves, ad infinitum, so they become 'narcissistic' objects taken to an absurd level; this absence of humanity paradoxically evoked a presence, and this opposition between presence and absence is always very present in my work. It was very strong in my photo-

graphs of wrecked cars, which are like empty cocoons. After the cars came the carcasses of meat, then the bodybuilders. It's almost as though I arrived at the human element by an indirect route, or metaphorically.

Concerning the bodybuilders, you took photographs of them during contests but there's no visible allusion to this context in your pictures. Why are they set against a white background, the same white ground used in later series? ◆ If I'd taken photographs of these bodybuilders among all the others, I wouldn't have obtained the surging, 'bulging' quality of the body. The body had to stand out. The contest was a real public ceremony, there were thousands of people there, but this white background allowed me to yank the body from that context, to turn it into an object, a figure. For a fairly long time after that, I used a white background to detach a subject from its context, to decontextualize it. The body of a bodybuilder is pretty much like an object, for that matter, with its typical sheen. It's also a body that evokes absence, it's a kind of alienation from one's own body.

So was the bodybuilder series an important stage in your work, a kind of culmination that brought a whole period to a close? ◆ Yes, it was important to arrive at the human element. And next there came the photographs of Moroccan brides, whom I felt were a female pendant of the bodybuilders. Even though we were dealing with dresses, rather than muscles, there was the same kind of exaggeration, of display. The face became one element of an overall form, of a surface. There was no longer any depth – the body had vanished, just like it did with the bodybuilders: by exaggerating the volume of their bodies so much, it seemed as though they no longer had one. At the same time, the brides also displayed a few features of the Venetian mirrors – certain floral patterns, strong black-and-white contrasts, and an ornamental, decorative side.

Portraiture is a major genre of photography with a very rich tradition. Which portrait photographers have influenced you? ◆ Walker Evans and August Sander, for their radical approach, their success, and their virtuosity: Sander for the minimal, essential side of his portraits; Evans for his impressive methodology and for the sensitivity of his photographs, both things being related in his case. Later, when I started doing portraits, I became very interested in Richard Avedon, for the nearness of his sitters, the light on

their faces, the monumentality of his portraits, and the way he was afraid of nothing and could appropriate his subject. On the other hand, the expressive side of his sitters is completely foreign to me – my own are absolutely inert, expressionless.

What's your intention? ◆ Right from the early portraits, I sought a type of neutrality of expression, because any kind of expressiveness would have reintroduced some narrative or anecdotal element that was unrelated to my goal. The bodybuilders, for example, had highly expressive faces – often they grinned, which bothered me a lot because it went against the effect of absence and flatness I was seeking. I wanted the face to be expressionless in order to work toward a picture in which, paradoxically, the body would be absent. The relationship to the wrecked cars is obvious – same bumpy bodies, the same light. In later series there was this same withdrawal from expressiveness. Everything here is paradoxical, because the Michael Jackson impersonators, the bodybuilders, and the masks are potentially expressionist subjects. But the photographs cool it all down, hold the subject aloof, freeze or eliminate expressiveness.

Doesn't the question of identity arise with the bodybuilders and Moroccan brides? ◆ The notion of identity arose the instant I started dealing with human subjects. Bodybuilders transform their bodies in order to become somebody else – their activity reflects a desire to become an 'other'. For the brides, the ornamental garments symbolize the passage from one status to another, from girl to woman. In both cases, they're in a kind of a divide. With the Moroccan brides, I became interested in the face as a site of uniqueness and identity. In order to explore that idea of metamorphosis, that blurring of identity, I needed to find very special faces. Hence my interest in transsexuals in the early phases of their transformation, when the masculine and feminine elements are still blurred, still appear on the surface of the face like some not-yet-finished morphing effect. Transsexuals, like bodybuilders, are trying to change their identity, which for them means changing gender.

In your work, the face is not presented as a mark of individuality. Unlike traditional portraiture, which claims to reveal the sitter's inner life or character, here were remain on the surface, we have difficulty getting beneath the shell. ◆ For me, phenomena happen on the surface of

things, skin-deep. A fashion model, for instance, has a slick, neutral physique that allows everyone to project their fantasies onto him or her, which isn't possible with someone whose face bears the marks of a personal history. I'm interested in presenting an open work onto which everyone can project their own histories and allusions. Within the space of a single year I did portraits of transsexuals, black women, and fashion models. The identity of black women is unconsciously perceived through a cultural filter: they're perceived as sculptural, and photography allowed me to stress this 'object' quality. The young models exist in a divide, a little like Barbie dolls that are either overly human or not-quite-convincing. For me, the culmination of this project is the series of really weird and disturbing window dummies.

These window dummies seem to be some kind of modern fetish… ◆ I wanted to suggest hybrid beings, between virtual creations and archaic objects. So I looked for showroom dummies that had a highly realistic quality. And I wound up discovering a London manufacturer whose dummies are cast from real women and then recomposed to create an ideal being – the arms of one woman, the neck of another, etc. Since they were cast from real women, these objects are already three-dimensional photographs, in a way. By photographing them I exaggerated this aspect, their illusionist nature. The photographic medium plays its full role here: photographic grain is almost completely identical with the grain of the skin, the compositional angle and lighting are studied to give a maximum degree of modeling. From a distance, it's possible to get the illusion of a live person; from close up, though, you see the artifacts, the false eyelashes, the brush strokes.

Your explorations constantly return to the idea of the uniqueness of a face. But these days there's nothing permanent about a face – thanks to make-up and surgery you can change your face to fit the canons of beauty of any given moment. Transsexuals and models reshape their faces, as do Michael Jackson impersonators. ◆ The idea of the impersonators logically followed from my work on window dummies. In both cases they are manufactured beings. I began by taking photographs of various impersonators – of Madonna, Britney Spears, etc. But it didn't work, you couldn't really see who they resembled. So I radicalized my approach by choosing one individual, Michael Jackson, who has undergone so many transformations that he's already a kind of impersonator of himself. Then I took

photographs of five different Jackson impersonators, and although they don't resemble one another, they all resemble the same mold via a kind of alchemy of transformation. After this exploration of resemblance, I began photographing masks, the kind of mask you'd use as a disguise, bought from a joke and novelty store, all of high quality and ultimately very 'life-like'. These masks are like real faces, but empty, in contrast to the faces of impersonators, which make you think of masks.

The photographs of safes demonstrate your ongoing attachment to objects. They're also very singular. What do these two objects, presented as a diptych, mean? ◆ This series carries on from the pallets of computers because it, too, deals with scrap – although of another kind, here – which I found at a scrap yard when I was out scouting: a white safe and a black safe, which echo one another like a photographic negative and positive. These objects are not presented frontally as in earlier series, but from the perspective of an axonometric projection that nevertheless flattens their volumes, as though we're dealing with a drawing. I wanted to show the impenetrable – and, here, indestructible – nature of this object, whose shape has remained intact despite the aggressiveness of the bulldozer, as witnessed by the scratches on the surface. It's also a tribute to minimal sculpture. Minimal art had a fundamental influence on me. I was strongly marked by Robert Morris's formal reductivism and above all by Tony Smith's biomorphism and his blend of formal restraint with metaphorical power. I feel that my own work stems from a similar dialectic, the strong expressive charge of my subjects being frozen by the formalism of the photographic image.

Your work suggests monumentality, reinforced by the size of the prints, yet at the same time we detect a certain fragility in the subjects. What can you say about these two opposing forces? ◆ Take the example of the pallets of computers: the object is solidly imposing, but the balance is precarious – we can imagine the moment when everything comes crashing down. Once we raise this notion of a fleeting moment, we're dealing with something very photographic. These opposing forces recur again, on a formal level, in the early series of glass objects: there is a rigorous, very systematic composition on one hand and a baroque profusion of objects on the other hand, counterbalancing that rigor. Finally, my still lifes could be perceived in two ways, either as virtuoso compositions in which the formal aspect

dominates, or else as votive pictures evoking, for instance, in the case of the pallets of computers, a certain consumerist frenzy where almost-new items are already at the end of their lives.

Getting back to your choice of subjects, whether dealing with the car engines, the pallets, or the various series of faces, the beholder is first attracted and fascinated by the object on view, but then this feeling changes. Often, the viewer becomes appalled. ◆ I photograph things that are simultaneously appealing and repulsive. That's probably true of many artists – this kind of ambivalence between seduction and freakishness. A work is never unequivocal, it's always ambivalent; otherwise, it would just be an illustration. There are antagonisms in my work between austerity and proliferation, between organic and inert or metallic. Sometimes the subject is very carnal yet at the same time disembodied: the body is there, but its life-likeness has been totally neutralized by the image. In the portraits there's always some doubt about what's alive and what's inanimate.

Why do you restrict yourself to a limited number of photographs for each series? ◆ I take the number of photographs needed to make the intention clear and the demonstration obvious. In general, a series will contain eight or nine pictures; doing more would produce repetitions of inferior quality. It's a question of rigor, of the standards I set myself. What matters is establishing equivalences between objects and people, and between different types of people – a little like variations on the same theme.

There's an exemplary coherence to your series, notably through a unity of viewpoint. What drives you, series after series? What are you pursuing? ◆ Ultimately, I photograph the surface manifestations of things and people, like symptoms that are related to the body and the way it's exhibited, to the forces of destruction and metamorphosis it's subjected to. All of this, including the objects, refers back to humanity, either through metaphor or absence. It's an obsessive task – the subjects vary but they all express more or less the same thing. The early glass objects, for example, could be metaphorically compared to a body through which things pass, a transparent body.

In your latest series of portraits, artificiality dominates. It's hard to believe these people actually exist. Why are they so perfect, their hair so shiny, their skin so smooth? ◆ The people I photographed were professional models. They have a special beauty, somewhat strange and exaggerated. This series is obviously closely linked to the showroom dummies. I asked the models to place their shoulders square to the camera, give a slight three-quarter turn to the head, and then stare straight ahead without looking at anything in particular. I wanted them to be similar to a three-dimensional drawing, unreal, like the avatars you choose to represent you in a virtual world. With this series I'm moving away from a social discourse that assigns a person to a class or genre – bodybuilder, impersonator, transsexual, model. Here, they exist solely on the level of the image. To obtain this effect I needed greater freedom in my choice of tools as well as in my choice of individuals. Colors, for instance, are desaturated, and the flesh-tones are diaphanous; there's a kind of disembodiment, a detachment of the subject, neither human nor artificial. The black background and the lighting that shows only one side of the models help to propel them into another universe. But there's always something unfathomable about a work, something you can't totally understand, because an artwork doesn't function solely on a rational level, it also – and mainly – functions on the level of impressions. I'd say that, compared to earlier portraits, these operate on a different register. Before, the subject was very powerful, it was primordial. Now the subject primarily serves the photograph – I transform it as I like, it appears through my eyes.

Biog-
raphy

Born 1964 in Boulogne-Billancourt, France.
Lives and works in Paris.

1999

Union centrale des arts décoratifs, Paris.

Musée de Picardie, Amiens, France.

Centre d'art contemporain de Vassivière en Limousin, Beaumont-du-Lac, France.

1998

Galerie Xippas, Paris.

Galerie Prinz, Kyoto, Japan.

1996

Galerie municipale Édouard-Manet, Gennevilliers, France.

Des séances, Crédac, Ivry-sur-Seine, France.

1994

Galerie Alain Gutharc, Paris.

École nationale d'arts, Cergy-Pontoise, France.

2007

Kopf an Kopf, Serielle Portraitfotografie. Kunsthalle Tübingen, Tübingen, Germany.

2006

Eldorado. Mudam Luxembourg, musée d'Art moderne Grand-Duc Jean, Luxembourg.

La Région humaine. Musée d'Art contemporain, Lyon, France.

A Curator's Eye: The Visual Legacy of Robert A. Sobieszek. Los Angeles County Museum of Art, Los Angeles.

Photo Show 1010. Gana Art Center, Seoul, Korea.

Réinventer le visible. Kunsthalle Erfurt, Erfurt, Germany.

Beyond Real: Surrealist Photography and the Sculpture from Bay Area Collections. San Francisco MoMa, San Francisco.

UK JACK, OK!. Colette, Paris. Dover street market, London. Isetan, Tokyo, Japan (August - September, 2006).

2005

Star Star: Toward the Center of Attention. Contemporary Arts Center, Cincinnati, USA.

Contenance, Fassung Bewahren. Württembergischer Kunstverein Stuttgart, Stuttgart, Germany.

(my private) HEROES. Marta Herford Museum, Herford, Germany.

Women by Women in Photography. Cook Fine Art, New York.

Paris à Shanghai, trois générations de photographes français. Musée des Beaux-Arts, Shanghai, China.

Suddenly Older. Clifford Art Gallery, Colgate University, Hamilton, USA.

Confrontation. FOAM, Amsterdam.

2004

Kurzdavordanach. Gegenwart als Zwischenraum. Die Photographische Sammlung/SK Stiftung Kultur, Cologne, Germany.

Histoire(s) parallèle(s). Institut néerlandais, Paris.

Je t'envisage, la disparition du portrait. Musée de l'Élysée, Lausanne, Switzerland.

About Face: the Death of the Portrait. Hayward Gallery, London.

2003

Cara a Cara. Culturgest, Lisbon, Portugal

Table Top Sculpture. Gorney Bravin + Lee Gallery, New York.

Fables de l'identité, œuvres photographiques et vidéos de la collection NSMVie/ABNAMRO. Centre national de la photographie, Paris.

Upon Reflection. Sean Kelly Gallery, New York.

2002

Face to Face. Portraits in Contemporary Photography. Fotohof Galery, Salzburg, Austria; Landesgalerie am Oberösterreichischen Landesmuseum, Linz, Austria.

Regard captif. Photographies de la collection Ordóñez-Falcón. Rencontres internationales de la photographie, Arles, France.

La Mirada Ajena. El Retrato en la Coleccion Ordóñez-Falcón de Fotografia. Artium, Centro-Museo Vasco de Arte Contemporáneo de Vitoria-Gasteiz, Vitoria-Gasteiz, Spain.

Augenblick. Sammlung Essl – Kunst der Gegenwart, Vienna, Austria.

Trade. Nederlands Foto Instituut, Rotterdam, Netherlands.

2001

La natura della natura morta – Fotografia. Galleria d'Arte Moderna, Bologna, Italy.

Arrêt sur image – Zeitgenössische Kunst aus Frankreich. Kunst-Werke, Berlin, Germany.

Trade – Waren, Wege und Werte im Welthandel heute. Fotomuseum, Winterthur, Switzerland.

Oublier l'exposition – Actuele fotografie uit Frankrijk. Huis Marseille, Amsterdam.

Altadis Prize. Durand-Dessert Gallery, Paris, France; Helga de Alvear Gallery, Madrid, Spain.

2000

Le Siècle du corps, le triomphe de la chair. Musée de l'Élysée, Lausanne, Switzerland.

Cultures physiques: record et performance. Soirées nomades, Fondation Cartier, Paris.

Mutations//mode 1960-2000. Musée Galliera, Paris.

Collection Agnès B. Centre national de la photographie, Paris.

Partage d'exotismes – 5ᵉ Biennale d'art contemporain de Lyon. Lyon, France.

1999

Un monde irréel. Thaddaeus Ropac Gallery, Paris.

1998

L'Envers du décor, dimensions décoratives dans l'art du XXᵉ siècle. Musée d'Art moderne de Lille Métropole, Villeneuve-d'Ascq, France.

Zeitgenossische Fotokunst aus Frankreich. Neuer Berliner Kunstverein, Berlin, Germany; Städtische Gallery, Göppingen, Germany; Städtisches Museum, Zwickau, Germany; Hallescher Kunstverein, Halle, Germany.

1997

État des choses, état des lieux. Musée des Beaux-Arts et de la Dentelle, Calais, France.

1996

Passions privées. Collections particulières d'art moderne et contemporain en France. Musée d'Art moderne de la Ville de Paris, Paris.

1995

Printemps de Cahors. Cahors, France.

Bibliothèque nationale de France, Paris.

The Capital Group Companies Inc., Los Angeles.

CCF (HSBC) Foundation for Photography, Paris.

Collection E.ON AG, Düsseldorf, Germany.

Fondation Cartier pour l'art contemporain, Paris.

Fondation NSM Vie/ABN-AMRO, Paris.

Fondation Ordóñez-Falcón, Donostia-San Sebastián, Spain.

Fonds national d'art contemporain, Paris.

Groupe Altadis, Paris.

Groupe Lhoist, Limelette, Belgium.

Huis Marseille, Amsterdam.

JP Morgan Chase Art Program, New York.

La Maison rouge, Fondation Antoine-de-Galbert, Paris.

Los Angeles County Museum of Art, Los Angeles.

Maison européenne de la photographie, Paris.

Mandalay Bay Resort, Las Vegas, USA.

Mudam Luxembourg, Musée d'Art Moderne Grand-Duc Jean, Luxembourg.

Musée d'Art contemporain du Val-de-Marne, Vitry-sur-Seine, France.

Musée de l'Élysée, Lausanne, Switzerland.

Musée des Beaux-Arts et de la Dentelle, Calais, France.

Musée Galliera, Paris.

Musée national d'art moderne, Centre Pompidou, Paris.

Museum of Modern Art, New York.

National Gallery of Australia, Parkes ACT, Canberra, Australia.

Neuberger Berman Inc., New York.

Norton Museum of Art, West Palm Beach, USA.

Pilara Family Foundation, San Francisco.

Progressive Corp., Mayfield Village, USA.

San Francisco Museum of Modern Art, San Francisco.

[1]

[2]

[3]

[4]

Solo Exhibition Catalogs

2004

Valérie Belin [Exhibition catalog] / Text by Michel Poivert: 'Morbidezza'. – Fundación Salamanca Ciudad de Cultura, Domus Artium 2002, Salamanca, 2004. [1]

2003

Valérie Belin [Exhibition catalog] / Texts by Hasier Etxeberria: 'The Compartment' and Javier San Martin: 'Black'. – Koldo Mitxelena Kulturunea, Donostia-San Sebastián, 2003. [2]

2002

Valérie Belin [Exhibition catalog] – Galerie Xippas, Paris, 2002. [3]

2001

Valérie Belin 1999-2001 [Exhibition catalog] – Galerie Xippas, Paris, 2001. [4]

Valérie Belin / Introduction by Guy Boyer; text by Philippe Piguet: 'Réflexions sur images'; artist's statement. – Actes Sud (coll. Altadis), Arles, 2001. [5]

2000

Valérie Belin / Text by Régis Durand: 'The Ceremony of Objects'. – Actes Sud (coll. CCF (HSBC) Foundation for Photography), Arles, 2000. [6]

1999

Valérie Belin, photographies 1997-1998 [Exhibition catalog] / Text by Pierre Wat: 'Memento Mori'. – Centre d'art contemporain de Vassivière en Limousin, Beaumont-du-Lac; Galerie Xippas, Paris, 1999. [7]

1996

Valérie Belin photographe, Fabien Durand couturier [Exhibition catalog] / Text by Daniel Dobbels. – Le crédac, Ivry-sur-Seine, 1996.

Valérie Belin [Exhibition catalog] / Text by Christine Buci-Glucksmann: 'Les Allégories animalières du crystal'. – Galerie municipale Édouard-Manet, Gennevilliers, 1996.

1994

Valérie Belin [Exhibition catalog] – Galerie Alain Gutharc, Paris, 1994. [8]

[5]

[6]

[7]

[8]

Books and Group Exhibition Catalogs

2006

Vitamin Ph, New perspectives in Photography | Phaidon, London, 2006. – text by Brian Sholis: 'Valérie Belin' p.30-31.

Eldorado [Exhibition catalog] / Mudam, Musée d'Art moderne Grand-Duc Jean. – Herausgeber, Luxembourg, 2006. – text by Paul di Felice 'Regards distanciés sur le Luxembourg' p.60-63.

Réinventer le visible | *20 ans de photographie contemporaine en France dans la collection de la Maison Européenne de la Photographie* [Exhibition catalog] / Kunsthalle Erfurt. – Kerber, Bielefeld, 2006. – cover page; text by Pascal Hoël: 'Valérie Belin' p.17-23.

2005

Les Vanités dans l'art contemporain | Anne-Marie Charbonneaux – Flammarion, Paris, 2005. – p.80-81, 164-165.

(my private) HEROES [Exhibition catalog] / Marta Herford Museum. – Kerber, Bielefeld, 2005. – Ill. p.104.

Paris à Shanghai, trois générations de photographes français [Exhibition catalog] / Musée des Beaux-Arts de Shanghai. – Actes Sud, Arles, 2005. – Ill. p. 98-103.

2004

Fondation Cartier pour l'art contemporain – Actes Sud (coll. Fondation Cartier pour l'art contemporain), Arles, 2004. – Photographs by Valérie Belin: p.100-101, 139; portfolio:p. 224-225, 247.

Kurzdavordanach. Gegenwart als Zwischenraum | Wilhelm Schürmann, Susanne Lange [Exhibition catalog] – Die Photographische Sammlung/SK Stiftung Kultur, Cologne, Frankfurt am Main: Revolver, 2004. – Ill. p. 129.

Le Prix Marcel Duchamp 2004 [catalog] – Un, Deux... Quatre Éditions Clermont-Ferrand, 2004. – Text by Régis Durand 'Valérie Belin' p. 6-13.

About Face. Photography and the Death of the Portrait [Exhibition catalog] – Hayward Gallery Publishing, London, 2004. – Ill. p. 34, 66-67.

Histoire(s) parallèle(s) [Exhibition catalog] / Institut néerlandais, Paris; FOAM, Amsterdam. – Filigranes Éditions, Paris, 2004. – Cover page; Ill. p. 11-13.

2002

La Photographie contemporaine | Michel Poivert. – Flammarion, Paris, 2002. – Ill. p 99.

Face to Face. Portraits in Contemporary Photography [Exhibition catalog] / Landesgalerie am Oberösterreich-ischen Landesmuseum, Linz. Fotohof Gallery, Salzburg. – Fotohof, Salzburg, 2002. – Cover page; Ill. p. 22-27.

Regard captif, collection Ordóñez-Falcón | Sam Stourdzé. [Exhibition catalog] /Rencontres internationales de la photographie, Arles. – Léo Scheer, Paris, 2002. – Ill. p. 148.

2001

The Nature of Still Life – From Fox Talbot to the Present Day [Exhibition catalog] / Galleria d'Arte Moderna, Bologna. – Electa, Milano, 2001. – Ill. p 153.

Augenblick – Foto/Kunst [Exhibition catalog] / Sammlung Essl Kunst der Gegenwart. – Sammlung Essl, Vienna, 2001. – Ill. p. 20-23.

Trade – Commodities, Communication and Consciousness | Thomas Seelig, Urs Stahel, Martin Jäggi. [Exhibition catalog] / Fotomuseum, Winterthur – Scalo Verlag, Zurich, 2001. – Ill. p.79-81.

2000

Partage d'exotismes – 5e Biennale d'art contemporain de Lyon [Exhibition catalog] – Éditions de la Réunion des Musées Nationaux, Paris, 2000. – vol.2: p.90-91.

1999

1 monde réel [Exhibition catalog] / Fondation Cartier pour l'art contemporain. – Actes Sud (coll. Fondation pour l'art contemporain), Arles, 1999. – Portfolio p. 118-125.

Robots, collection Rolf Fehlbaum | Dan Simmons. – Actes Sud (coll. Fondation pour l'art contemporain), Arles, 1999. – Portfolio: 16 p. black & white / Photographs by Valérie Belin: 29 p. color.

1998

Zeitgenossische Fotokunst aus Frankreich | Manfred Schmalriede, Régis Durand. [Exhibition catalog] / Neuer Berliner Kunstverein, Berlin. – Umschau / Braus Verlag, Heidelberg, 1998. – Ill. p. 38-43.

L'Envers du décor, dimensions décoratives dans l'art du XXe siècle [Exhibition catalog] – Musée d'Art moderne Lille métropole, Villeneuve-d'Ascq, 1998. – (cat.6).

1997

État des choses, état des lieux [Exhibition catalog] – Musée des Beaux-Arts et de la Dentelle, Calais, 1997. – Text by Charlotte Coupaye: 'L'Art de l'entre-deux' p. 11-27.

1995

Le Printemps de Cahors 1995 – Photographie et arts visuels
[Exhibition catalog] – Fragments Éditions, Paris, 1995. –
Text by Régis Durand: 'Valérie Belin' p. 20-21.
*Passions privées. Collections particulières d'art moderne et
contemporain en France* / Suzanne Pagé. [Exhibition
catalog] / Musée d'Art moderne de la Ville de Paris. – Paris
Musées, Paris, 1995.

Articles and Reviews

2007

New York Magazine 'Reshooting Marilyn Monroe',
May 14, 2007 – p.46, photograph by Valérie Belin.
L'INSENSE Photo, n°5, 'French Touch', May 2007 –
Ill. p.26-27.
Brigitte Ollier: 'Au-delà du reel'. – *Beaux-Arts éditions*,
'Qu'est-ce que la photographie aujourd'hui?', April 2007,
p.56-57; Cover page.
Élisabeth Couturier: 'Trop beaux pour être vrais'. – *Paris
Match*, n°3010, January 25-31, 2007, p.16.
Angelika Heinick: 'Das Figurenkabinett der Valérie Belin'.
– *Frankfurter Allgemeine Sonntagszeintung*, January 14,
2007, p.51.

2006

Gilles Renault: 'Les Transhumains de Belin'. – *Libération*,
n°7975, December 28, 2006, p.26-27.
Sophie Bernard: 'Les Apparitions de Valérie Belin'. –
Images magazine, n°20, December 2006-January 2007,
p.65-73.
Pierre Wat: 'Valérie Belin'. – *Beaux-Arts magazine*, special
issue '100 artistes, qu'est-ce que l'art contemporain en
France?', May 2006, p.32-33.
'Fokus stilleben, Valérie Belin'. – *Photonews, Zeitung für
Fotografie*, n°2, February 2006, p.18.
Exit, n°22, 'Living with Animals', May 2006 – Ill. p.150-151.

2005

Régis Durand: 'Valérie Belin's Deep Surfaces'. – *Art press*,
n°317, November 2005, p. 53-58.
Giorgia Losio: 'Valérie Belin, Galerie Xippas'. – *Tema
Celeste*, n°108, March-April 2005, p. 84-85.
Lynn Hirschberg: 'Sleeping Beauty'. – *New York Times
Magazine*, April 17, 2005, p. 64-65, photograph by Valérie
Belin.
Philippe Piguet: 'Valérie Belin, l'exception photographique'.
– *L'Œil*, n°565, January 2005, p. 72-73.

2004

Michel Guerrin: 'Les Enveloppes de Valérie Belin'. –
Le Monde, December 11, 2004, p. 30.
Emmanuelle Lequeux: 'Valérie Belin: Photo, ma chrysalide'.
– *Aden*, n°313, December 8-14, 2004, p. 27.
Camille Morineau: 'The Designer, the Valuer, the Artist
and Their Exhibitor'. – *art press*, n°305, October 2004,
p. 36-43.
Monopol, n°3, August-September 2004 – Cover page;

'Top 15' p. 126.

'Trompe l'œil 1/6: clones tristes'. – *Libération*, Jully 19, 2004, 'cahier été', p. IV.

Michel Guerrin: 'Le Portrait, photos en mal d'identité'. – *Le Monde*, May 11, 2004, p. 25.

Alexandra Koroxenidis: 'Alternative Ways of Seeing'. – KATHIMERINI, *International Herald Tribune*, supplement, March 18, 2004, p. 7.

2003

Influence, issue 01, 2003. – Portfolio 'Valérie Belin', p. 140-143.

Michel Poivert: 'Valérie Belin, expression minimale'. – *Le Bulletin*, n° 17, November 2003, Société française de photographie, p. 13-15.

Bomb Magazine, n° 83, Spring 2003. – Cover page.

Cary Levine: 'Valérie Belin at Brent Sikkema'. – *Art in America*, n° 3, March 2003, p.120.

2002

Frame, n° 10, January-March 2002. – Insert 'Valérie Belin', p. 86-97.

Dominique Baqué: 'Promesses de visages'. – *Art press*, n°284, November 2002, p.90.

Brigitte Ollier: 'En pleine face'. – *Libération*, October 5-6, 2002, p.34.

Michel Guérin: 'Les Visages de Valérie Belin'. – *Le Monde*, September 29-30, 2002, p.23.

Valérie Belin: 'Mariées marocaines'. – *Art absolument*, n° 1, May 2002, p.46-52.

L'Œil, n° 536, May 2002. – Cover page; Alain Dister: 'L'image de la mode' p. 38-41.

2001

Arno Haijtema: 'Sterfelijk'. – *de Volkskrant*, October 4, 2001, p.12-13.

Jhim Lamoree: 'Frankrijk slijt zijn visuele juweeltjes'. – *Het Parool*, September 5, 2001.

Laurie Attias: 'Valérie Belin'. – *Frieze*, issue 61, September 2001, p.100.

Brita Sachs: 'Salzburg Regen Bringt den Galerien zur Festspieltzeit Segen'. – *Frankfurter Allgemeine Zeitung*, n° 185, August 11, 2001, p.53.

Élisa Morère: 'Valérie Belin – Au-delà du miroir'. – Guides *Le Figaro*, March 13, 2001, cahier n°4, p. 17.

Frédérique Fanchette: 'Les Chasses marocaines'. – *Libération*, n°6156, March 1st 2001, p.42.

Patrick Remy: 'Hyménée'. – *Numéro*, n° 21, March 2001, p.82-84.

Natacha Wolinski: 'Les Mariées marocaines de Valérie Belin'. – *Le Journal du dimanche*, n°2824, February 11, 2001.

Myriam Boutoulle: 'Valérie Belin, célébration baroque'. – *Connaissance des arts*, n° 580, February 2001, p.33.

Christian Caujolle: 'Valérie Belin, le blanc du noir', *Beaux-Arts magazine*, n° 201, February 2001, p.46-47.

Valérie Marchi: 'Valérie Belin'. – *L'Œil*, February 2001, n° 523, p. 90-91.

2000

Liliana Albertazzi: 'Mirrors, Shimmers, Mirages and Photography'; Catherine de Smet: 'Valérie in Wonderland'. – EXIT n° 0, November 2000, p.90-110.

Laure Samuel: 'Six Faces of l'Hexagone'. – *Art & Auction*, special issue, September 2000, p.96-103.

1999

Dutch, n° 23, September-October 1999. – Portfolio p. 152-159.

Philippe Dagen: 'Sexe, violence, photo et video'. – *Le Monde*, February 7-8, 1999.

Didier Arnaudet: 'Valérie Belin'. – *Art press*, n° 244, March 1999.

Natacha Wolinski: 'Valérie Belin – Objets, êtes-vous là?'. – *Beaux-Arts magazine*, n° 178, March 1999.

1997

Brigitte Ollier: 'Calais, sens dessus dessous'. – *Libération*, n° 4960, May 2, 1997.

Caroline Smulders: 'Matière à risque'. – *Art press*, special issue n° 18 'spécial art et mode', 1997, p. 35-40.

1996

Régis Durand: 'Valérie Belin'. – *Creative Camera*, n° 337, December-January 1996, p. 14-19.

1993

La Recherche photographique, n° 15, 'Things', fall 1993, p. 64-65.

Contents

This book was published in conjuction with the exhibition *Valérie Belin* organized by Huis Marseille Museum for Photography in Amsterdam, the Maison européenne de la photographie in Paris and the Musée de l'Elysée in Lausanne

Exhibition curated by Els Barents, Nathalie Herschdorfer, Jean-Luc Monterosso, with the assistance of Saskia Asser and Pascal Hoël

Huis Marseille Museum for Photography, Amsterdam, September 1–November 26, 2007
www.huismarseille.nl

Maison européenne de la photographie, Paris, April 9–June 8, 2008
www.mep-fr.org

Musée de l'Elysée, Lausanne, November 6, 2008–January 4, 2009
www.elysee.ch

With the support of Culturesfrance, the French Embassy in The Hague (the Netherlands), the French Embassy in Bern (Switzerland), Maison Descartes-Institut Français des Pays-Bas

The exhibition was made possible by the following lenders fiedler contemporary (Cologne), Galerie Xippas (Paris), Huis Marseille (Amsterdam), Maison européenne de la photographie (Paris), Musée des Beaux Arts et de la Dentelle (Calais), Musée de l'Elysée (Lausanne)

Book edited by Patrick Remy
Graphic design Piet Gerards and Maud van Rossum (Piet Gerards Ontwerpers, Amsterdam)
Color separations Steidl's digital darkroom
Printing, production Steidl, Göttingen

Photographs © 2007 Valérie Belin
Introduction © 2007 Els Barents, William A. Ewing, Jean-Luc Monterosso
Text © 2007 Régis Durand
Interview © 2007 Nathalie Herschdorfer
English translation © 2007 Beth O'Brien (Introduction), Deke Dusinberre (Interview), Charles Penwarden (Text)
All rights reserved

Els Barents is director of Huis Marseille, Museum for Photography, Amsterdam
William A. Ewing is director of Musée de l'Elysée, Lausanne
Jean-Luc Monterosso is director of Maison européenne de la photographie, Paris
Régis Durand was head of the Centre national de la photographie and then Galerie nationale du Jeu de Paume, Paris. He is currently working as a critic and independent curator
Nathalie Herschdorfer is associate curator at the Musée de l'Elysée

Steidl
Düstere Straße 4
D–37073 Göttingen
Germany
T +49 (0) 551 49 60 60
F +49 (0) 551 49 60 649
www.steidl.de
www.steidlville.com

ISBN 978-3-86521-465-2
Printed in Germany